100

WAYS TO TAKE BETTER

NATURE & WILDLIFE

PHOTOGRAPHS

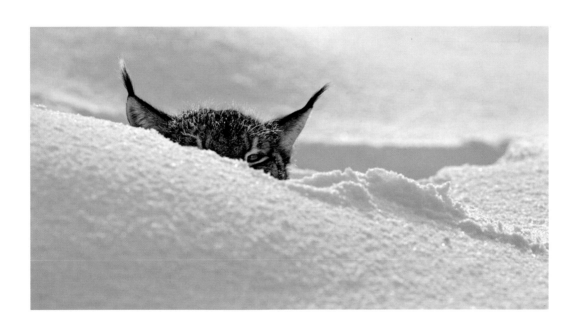

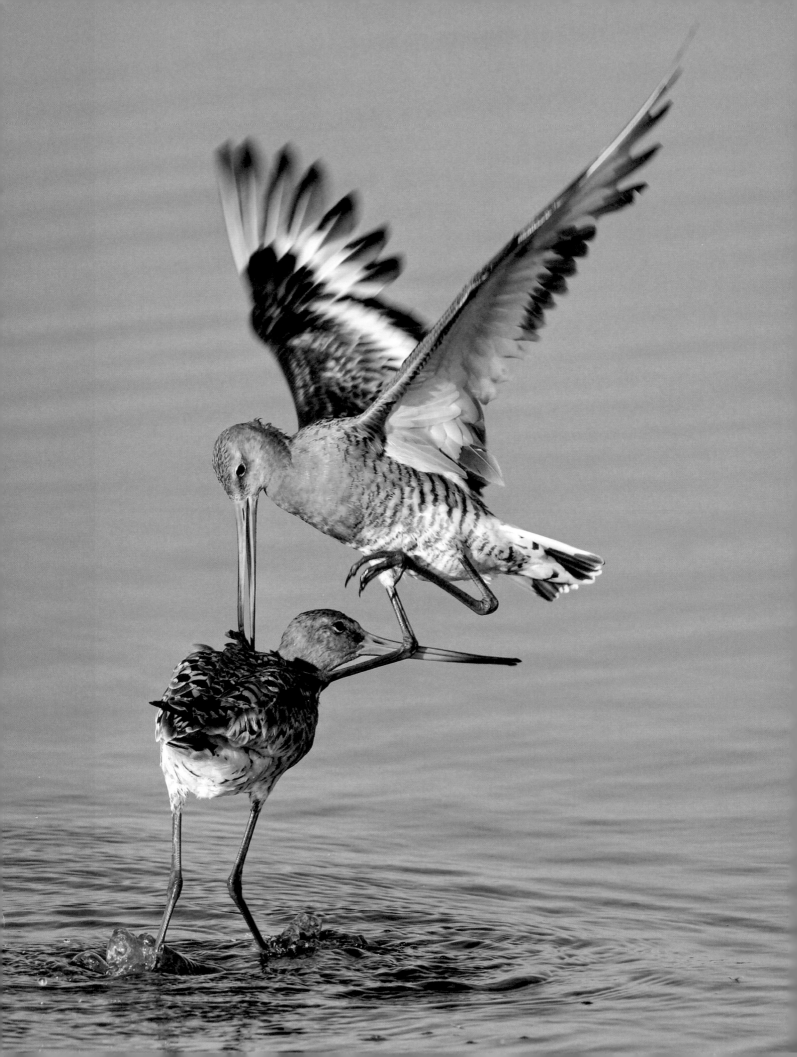

100
WAYS TO TAKE BETTER
NATURE & WILDLIFE
PHOTOGRAPHS

Guy Edwardes

D&C
David and Charles

To my wife, Cat. Thank you for your support and encouragement and for keeping me company during our treks into the wilds. I look forward to our future adventures together.

PAGE 1: EURASIAN LYNX HIDING IN A SNOW HOLE

Ranua Wildlife Park, Finland.

Canon EOS-1D MkII; EF500mm lens; 1/1250 sec at f/5.6; ISO 250; central focusing point; one-shot AF; tripod with fluid video head.

PAGE 2: BLACK-TAILED GODWITS FIGHTING

Lodmoor RSPB Reserve, Weymouth, Dorset, England.

Canon EOS-1D MkII; EF500mm lens; 1/1600 sec at f/5.6; ISO 250; central focusing point; AI Servo focus; tripod with fluid video head.

PAGE 4: GREAT EGRET

Estero Lagoon, Fort Myers Beach, Florida, USA.

Canon EOS-1D MkII; EF500mm lens; 1/1600 sec at f/8; ISO 250; single manually selected focusing point; one-shot AF; tripod with fluid video head.

A DAVID & CHARLES BOOK
Copyright © David & Charles Limited 2009

David & Charles is an F+W Media Inc. company
4700 East Galbraith Road
Cincinnati, OH 45236

First published in the UK in 2009
This paperback edition first published in 2011

Text and photographs copyright © Guy Edwardes 2009

Guy Edwardes has asserted his right to be identified as author of this work in accordance with the Copyright, Designs and Patents Act, 1988.

A catalogue record for this book is available from the British Library.

ISBN-13: 978-0-7153-3148-4 hardback
ISBN-10: 0-7153-3148-5 hardback

ISBN-13: 978-0-7153-3149-1 paperback
ISBN-10: 0-7153-3149-3 paperback

Printed in China by RR Donnelley
for David & Charles
Brunel House Newton Abbot Devon

Commissioning Editor: Neil Baber
Editor: Emily Rae
Indexer: Lisa Footitt
Project Editor: Ame Verso
Senior Designer: Jodie Lystor
Production Controller: Alison Smith

David & Charles publish high quality books on a wide range of subjects.
For more great book ideas visit: www.rubooks.co.uk

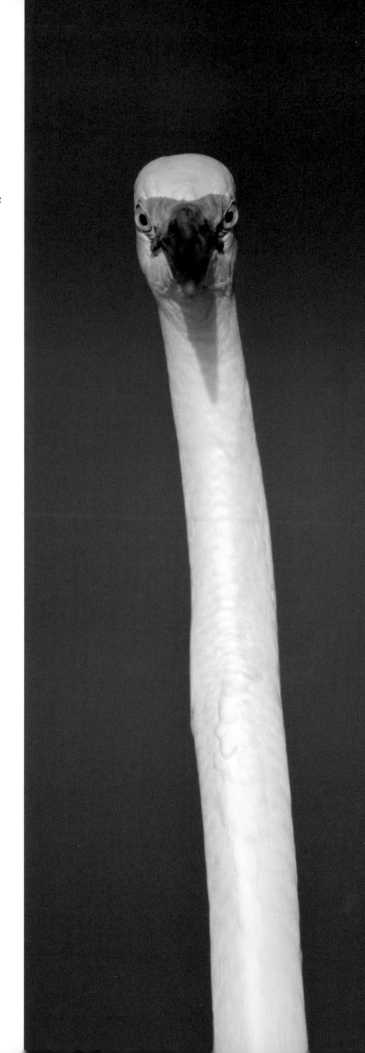

Contents

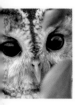

Introduction

Photographing wildlife is always a challenge, especially if you aim to shoot creative, dynamic and illustrative images rather than simple record shots. Capturing images of elusive and often uncooperative animals and birds can be very frustrating and requires tremendous dedication, patience and perseverance. However, when all the hard work pays off there can surely be no other subject that provides so much satisfaction for the photographer.

I have been photographing nature and wildlife for almost 20 years but relatively recently the introduction of digital cameras has revolutionized my work, and that of all photographers. There is no doubt that the latest photographic equipment means that capturing good photographs of wildlife is easier than it has ever been, and the learning process has been speeded up considerably. However, in order to achieve original images of familiar subjects, photographers have to work increasingly hard. The dream purchase of most nature and wildlife photographers is a long, fast telephoto lens but this book explains that a thorough knowledge and understanding of the subjects you are working with is far more important than the camera or the lens you are using. However, if you are lucky enough to own such a lens, this book also explains the best ways to fully exploit its advantages.

Feedback from my previous book, *100 Ways to Take Better Landscape Photographs* (D&C, 2005), made it clear that many readers like to be provided with the technical details for each image. Clearly this can be a valuable guide when learning how and when to apply specific camera settings and when to use different techniques in situations similar to those illustrated. Therefore, in this book I have provided detailed technical information for every image.

This book is aimed at photographers of all skill levels. It is not trying to be an all-encompassing guide to nature photography, as this has been done many times before. The main text describes the basic techniques for less-experienced photographers, while the captions describe the methods used and the thought processes behind the images. More experienced photographers will benefit from useful tips and suggestions throughout the book and I hope that the images will provide everyone with inspiration and new ideas.

Remember, the best way to improve as a nature photographer is to spend as much time as possible out in the field observing and working with your subjects. I wish you good luck and good light for all your future nature and wildlife photography.

Guy Edwardes

www.guyedwardes.com

TAWNY OWL
The Barn Owl Centre, Gloucestershire, England.
Canon EOS-1D MkII; EF500mm lens; 1/500 sec at f/5.6; ISO 400; single manually selected focusing point; one-shot AF; tripod with fluid video head.

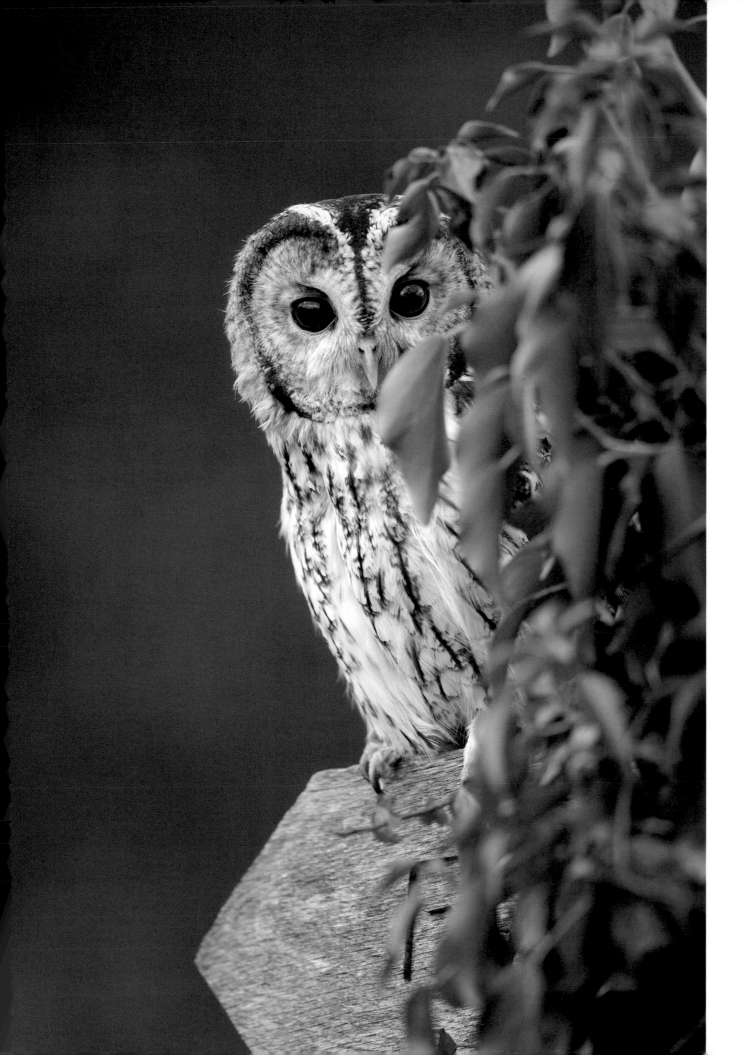

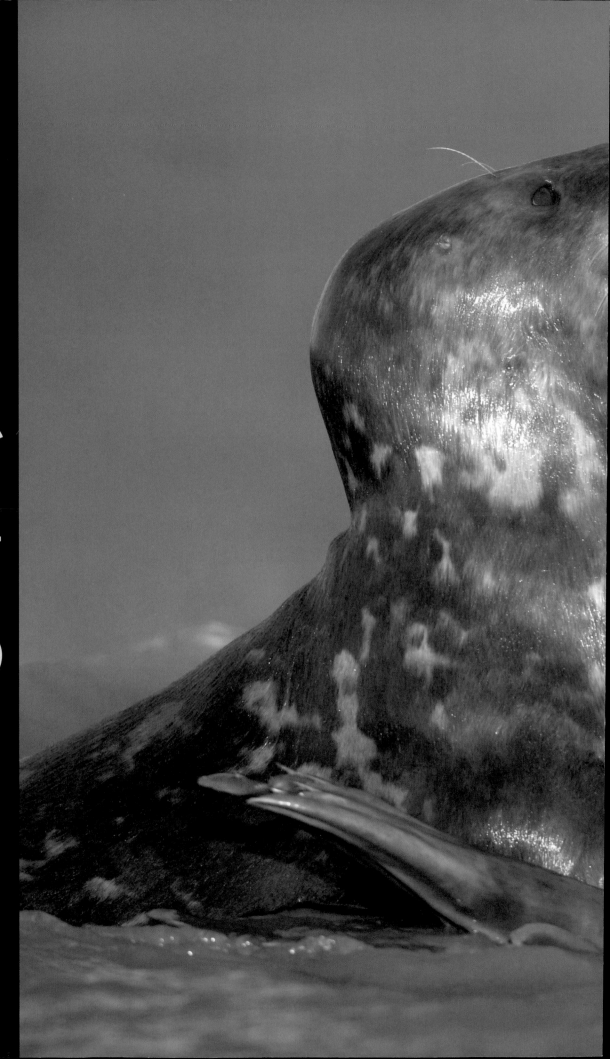

Nature & Wildlife
Photography Basics

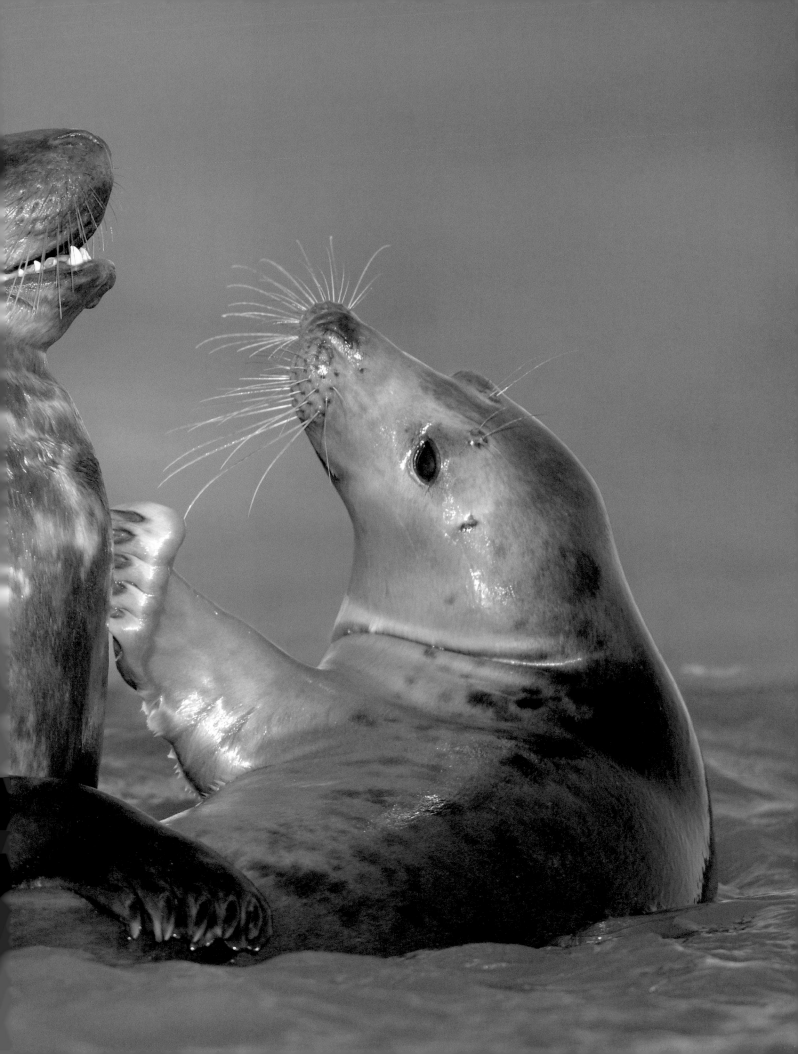

1 Keep a photographer's diary

Remembering exactly where locations are and when they are at their best can be difficult. To help with this task, try keeping a large page-per-day diary filled in with information about the locations and subjects you have photographed on that particular day of the year. Include location details such as tidal conditions, the best lighting angles, favoured weather conditions, exactly how to get there and where to head for when you arrive. It is also a good idea to include information relative to the species present, such as seasonal behaviour of animals, flowering times for plants, the date of emergence for butterflies and the photographic techniques that you have found to work well for each species. In my own diaries, I now have over ten years' worth of information to look back on, enabling me to see exactly when and where I should be working in the coming weeks and months. This is an invaluable tool, allowing me to plan my shoots well in advance.

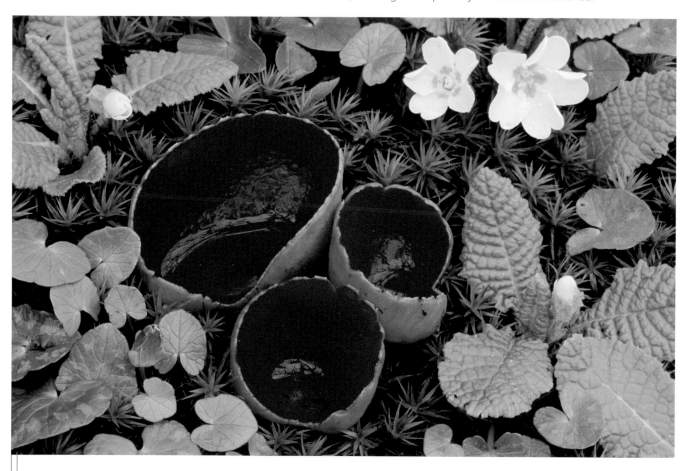

SCARLET ELF CUPS

Late March might seem like a strange time to be photographing fungi but my photographic diary reminded me that in previous years I had noticed a fine display of scarlet elf cups on a riverbank in a forest not far from my home. On an overcast afternoon I set out to find them and, sure enough, there they were among star moss, primroses and celandines. I hunted around to find the best specimens and found this group of three cups in perfect condition. I used a 100mm macro lens to enable me to include plenty of the surrounding vibrant green vegetation, which contrasted strongly with the bright red fungi. A polarizing filter was used to saturate the colours further. Axminster, Devon, England.
Canon EOS-1Ds; EF100mm macro lens with polarizing filter; 2 sec at f/16; ISO 100; manual focus; mirror lock-up; remote release; tripod with ball head.

Practise techniques

When you are first starting out in nature photography it is important not to expect too much too soon. Shooting great images of wildlife requires many different techniques, all of which take time to perfect. Books, magazines and websites can provide useful tips but nothing can beat simply getting out there and taking as many pictures as possible. This is the only way that you will become familiar with all your camera's controls. Gradually, you will become more confident in using them and, in time, it will become second nature. For example, try following birds in flight with a telephoto lens while keeping the focusing point on the bird – you need to become accustomed to the way birds move on the wing in order to keep them in the frame. You might also practise using fill-in flash on inanimate subjects to see how different settings affect the way that you can control contrast. You'll then know exactly what approach to take when you are faced with a situation that requires fill-in flash in the field.

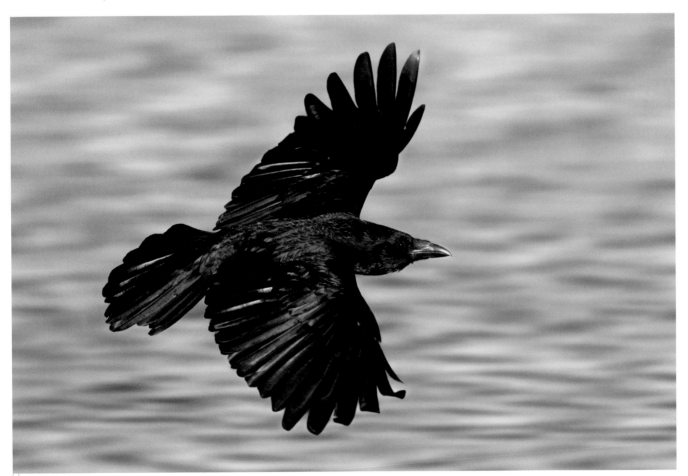

CARRION CROW IN FLIGHT

One of the most challenging aspects of photographing wildlife in action is simply following a subject smoothly in order to achieve a pleasing composition. This can prove particularly difficult when using a long telephoto lens. I regularly spend time practising this technique in order to be confident in my ability when I really need to use it. Birds in flight are notoriously unpredictable and therefore make a perfect subject to practise on. I normally head to a nearby nature reserve where people feed the birds daily. This brings in a variety of common species including mallards, coots, gulls and carrion crows. For this image I used a long telephoto lens supported on a heavy fluid video head and tripod. Lodmoor RSPB Reserve, Weymouth, Dorset, England.

Canon EOS-1D MkII; EF500mm lens; 1/1250 sec at f/5.6; ISO 250; AI Servo focus; central focusing point; IS off; tripod with fluid video head.

3 Have patience and persevere

It is often said that successful nature photographers must have lots of patience. While this is obviously true, I believe that a willingness to persevere is an even more essential requirement. You might be happy to sit in a hide for 12 hours waiting for a golden eagle to appear but you should also be willing to return day after day to perfect your images and record a variety of action and behaviour. Likewise, it might take ten minutes to take a decent photograph of an orchid flower but if you were to persevere and spend an hour experimenting with different lenses, lighting techniques and fine-tuning your composition, the result is likely to be significantly better, both technically and aesthetically.

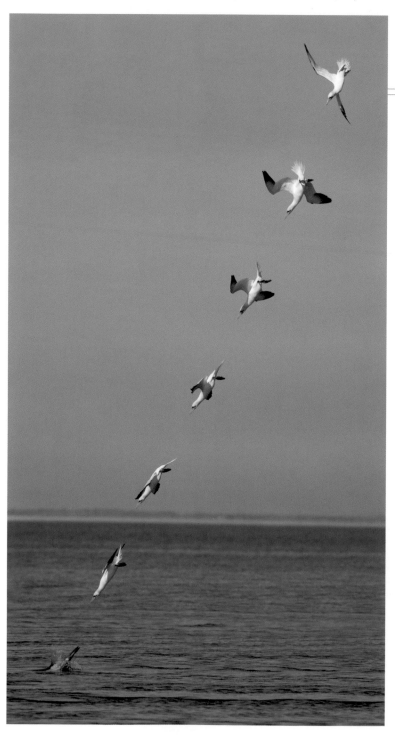

NORTHERN GANNET DIVING

This image is a digital montage of seven frames taken using a motor drive at eight frames per second. My aim was to illustrate the various stages of a gannet's dive into the ocean. It was taken from a boat following a group of feeding gannets in a tidal race between two islands. In order to record each image sharply it was essential to keep the focusing point located on the bird at all stages of its dive – much easier said than done in a moving boat. This was the single successful sequence from over 500 frames. It also happens to be one of the last sequences from the shoot, which is surely a testament to perseverance paying off in the end. The seven images were manually merged together in Photoshop. Skellig Islands, Co. Kerry, Republic of Ireland.
Canon EOS-1D MkII; EF500mm lens; 1/2000 sec at f/4.5; ISO 250; AI Servo focus; central focusing point; IS mode 2; handheld.

Consider ethics

Nature photography has seen a rapid increase in popularity over recent years, due in no small part to the advances in digital cameras. It is now easier and considerably less expensive to take good images of wildlife in the field. With this in mind, you must take care not to put too much pressure on individual sites and to keep disturbance of wildlife to a minimum. Learn to recognize signs of stress in your subject and back off as soon as these begin to show. Always remember that the welfare of any wildlife subject is more important than a photograph. This applies to all areas of nature photography, whether your subject is a rare bird of prey or a common wildflower. When contemplating a visit to a popular site, consider whether you really wish to stand alongside or vie for the best shooting positions with 20 other photographers. For me, part of the enjoyment of photographing wildlife is finding new sites and working out how to get the best from them.

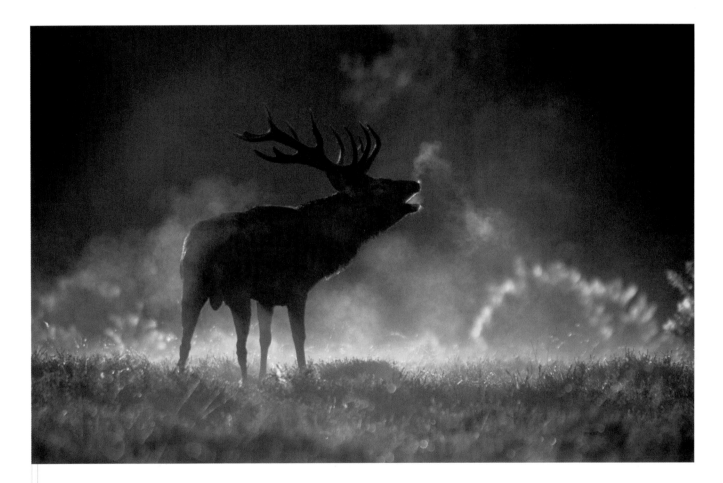

RUTTING RED DEER STAG

There used to be a couple of very good sites to photograph wild red deer in clearings within the New Forest. Unfortunately, in recent years the number of photographers present during the rut has led to the deer being disturbed too frequently, with many of them now rutting under the cover of the forest canopy. Occasionally, the most vocal and active stag could have up to a dozen photographers aiming their lenses in his direction, which has hindered his free movement around the rutting ground. As soon as I noticed the number of photographers becoming a problem, I decided to conduct my own red deer photography elsewhere. I can only hope that other photographers also realized the need to reduce pressure on the deer at this important time of the year. New Forest National Park, Hampshire, England.
Canon EOS-1D MkII; EF500mm lens; EF1.4X extender; 1/500 sec at f/5.6; ISO 250; AI Servo focus; central focusing point; IS mode 2; tripod with fluid video head.

5 Undertake long-term projects

Many wildlife photographers are tempted to travel from one well-known site to another, as they know that the chances of securing decent images will be relatively good. The downside of this approach is that you'll never really get the chance to learn about your subject. You may end up with a collection of good images but they are unlikely to be significantly different to those that have been taken many times before by the great number of photographers who have visited the same site. It is only by undertaking a long-term project concentrating on an individual species that you can expect to witness a whole variety of behaviour and come up with a collection of illustrative, interesting and creative images, which, when viewed together, actually tell a story about the subject and its environment. Furthermore, you will be forced to work harder and more creatively, which will help to enhance your photographic and artistic skills.

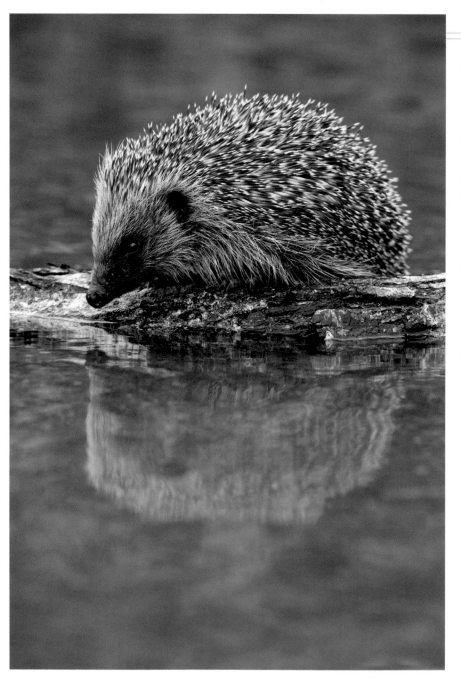

HEDGEHOG

I have several hides set up close to my home. Some are permanent and others are moved around as and when opportunities present themselves. This image was taken from a temporary hide that I had set up to provide a low shooting angle over a small woodland pond. I spent a period of two weeks using this hide to photograph woodland birds drinking and bathing. During one session I had an unexpected visitor in the form of a hedgehog, which appeared late one afternoon to drink at the water's edge. It is only by persevering with long-term projects that you can expect to witness the full potential of a location. Marshwood Vale, Dorset, England.

Canon EOS-1Ds; EF500mm lens; 1/30 sec at f/8; ISO 400; one-shot AF; central focusing point; IS mode 1; tripod with fluid video head; hide.

Record action and behaviour

When photographing birds and animals, the main aim should be to capture some form of action or behaviour. This instantly makes your images more interesting, engaging and dramatic. An impression or implication of movement will always help to portray the subject as a living creature more successfully than a static portrait. The more time you spend with your subject, the better your chances will be. In order to catch the 'decisive moment' it is essential to maintain concentration at all times. Try to anticipate behaviour – for example many birds will stretch their wings just prior to taking flight. Use your camera's motor drive to increase your chances of capturing the perfect composition and wing position. Experiment with different exposure times – some action shots will look better with the subject frozen using a fast shutter speed while others will benefit from panning using a slow shutter speed.

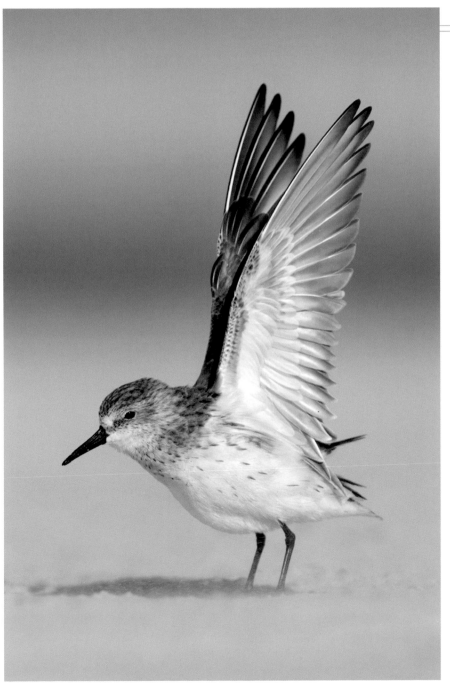

WESTERN SANDPIPER

This tiny wading bird was roosting on the edge of a large flock on a sandy beach. I selected it as my target subject because it was much easier to isolate than those further into the flock. I approached slowly and steadily, keeping as low as possible to minimize my outline against the horizon. I crawled across the beach on my belly for the final 20 metres (65 feet) until I was within range. The bird was undisturbed and continued to rest with its head tucked under its wing. I framed the shot with plenty of space around the subject to reduce the chance of clipping a wing when the bird began to move. After waiting for about 30 minutes, some of the birds were startled by an oystercatcher's alarm call and several of them performed a wing stretch, including the individual that I was focused on. Fort De Soto, Florida, USA.
Canon EOS-1Ds; EF500mm lens; EF1.4X extender; 1/1600 sec at f/5.6; ISO 200; one-shot AF; central focusing point; IS mode 1; groundpod with fluid video head.

7 Shoot close to home

Travelling to exotic destinations can certainly lead to some great wildlife encounters. However, you should not dismiss the nature photography opportunities close to where you live. Many of my most successful images have been taken within a 15-kilometre (10-mile) radius of my home. This is an area that I can explore easily throughout the year. I can keep an eye on seasonal changes and get to specific locations quickly whenever the weather conditions are favourable. Over the years I have learnt exactly when certain locations will be at their best. I have met with local landowners and have set up hides on their land to photograph various species of birds and mammals throughout the year. You don't have to live in the countryside either – in towns and cities there are many parks, gardens and nature reserves that can provide plenty of potential for nature photography. Compile a list of good locations within easy reach and visit them regularly to record the changing seasons.

ORANGE PEEL FUNGI

I always keep a close eye on seasonal developments in the woodland that surrounds my home. I discovered this colourful fungi on a hedge bank just a few minutes' walk from my door. The overcast lighting conditions were ideal for recording maximum detail and accurate colour. I positioned my tripod directly over the fungi to enable the camera to be set up parallel to the subject. By focusing carefully on the upper edge of the fungi, I was able to record the whole scene sharply using an aperture of f/16. A polarizing filter helped to saturate the colours by removing unwanted reflections from the glossy surfaces of both the fungi and the surrounding moss. Lyme Regis, Dorset, England.

Canon EOS-1Ds; EF100mm macro lens with polarizing filter; 4 sec at f/16; ISO 100; manual focus; mirror lock-up; remote release; tripod with ball head.

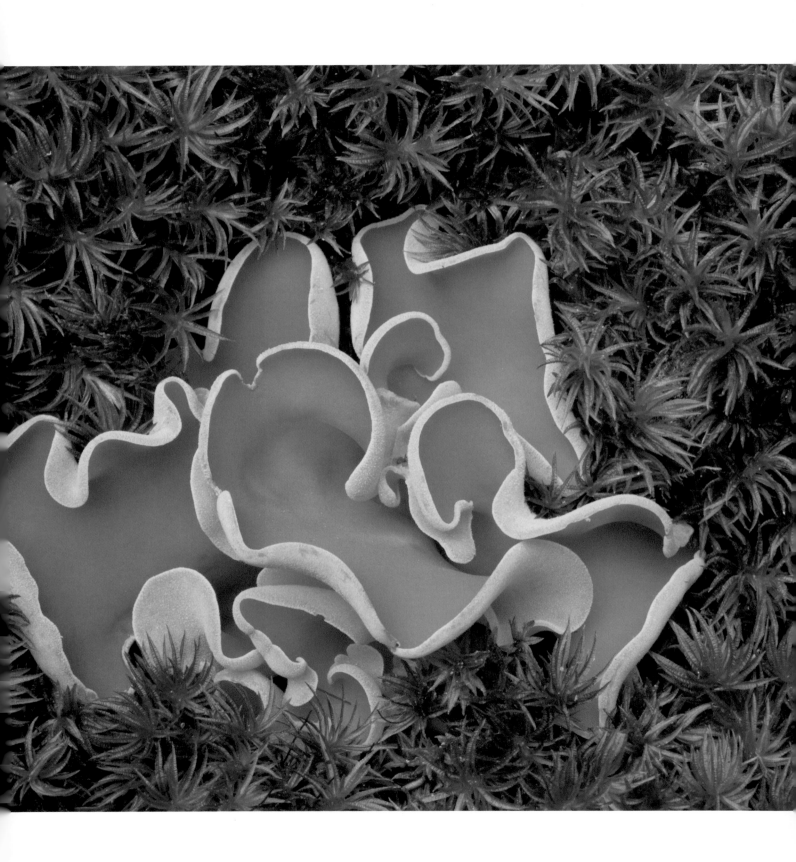

8 Be aware of legal issues

Wildlife law varies from one country to another so you should always check the relevant laws in the country in which you are working. In the UK, it is illegal to disturb a number of rare and threatened species of bird and animal. It is also illegal to cause damage to a number of rare plants or to disturb surrounding habitat. Full details and a species list can be found in the Wildlife and Countryside Act 1981. When dealing with such species, if possible, I prefer to travel overseas to photograph them where they are more common. Even then, I maintain the same discipline as I would when working with the similar species in the UK. In the USA, there are fewer laws that effect nature photography. However, in national parks there are restrictions imposed on photographing species at the nest or den and the distance at which you can approach wild animals on foot. Failure to be aware of and respect these issues could seriously damage your reputation as a nature photographer and affect the reputation of nature photographers as a whole.

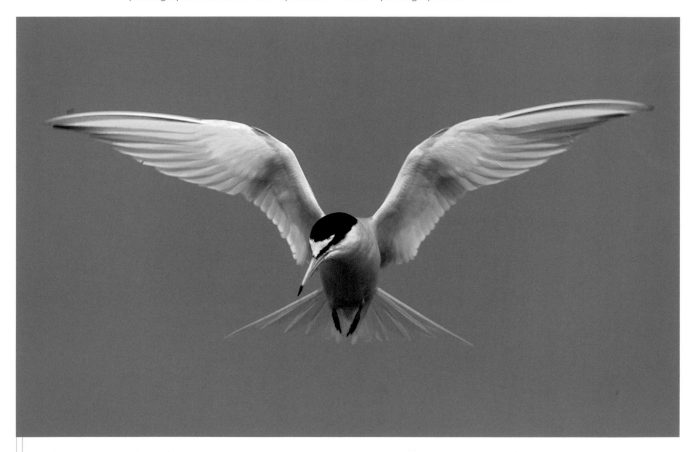

LITTLE TERN IN FLIGHT

In the UK, the little tern is protected under Schedule 1 of the Wildlife and Countryside Act 1981. This means it is illegal to photograph it at or near the nest during the breeding season without a licence. This image was taken during the breeding season beside a tidal pool about one and a half kilometres (one mile) from the tern colony itself. The adult birds were returning to the pool all day to catch small fish to take back to their chicks. I was able to shoot from my car window from a public car park next to the pool. This caused no disturbance to the bird whatsoever and it enabled me to secure a number of images showing the tern hovering and diving. I supported my 500mm lens on a heavy beanbag filled with grain using the window itself to adjust the height of the lens to eye level. Ferrybridge, Weymouth, Dorset, England.

Canon EOS-1D MkII; EF500mm lens; EF1.4X extender; 1/1600 sec at f/5.6; ISO 250; AI Servo focus; central focusing point; IS mode 2; beanbag.

Consider your equipment needs 9

Building a camera system should be thought of as a long-term investment and should be carried out over a period of time, allowing you to be sure which areas of nature photography you wish to specialize in. Carefully consider your requirements and investigate all the options before making expensive investments in specialized pieces of equipment. Try not to overlap lens focal lengths and think about the overall weight of your kit – do you really need all your lenses to be heavy and bulky f/2.8 versions? Don't skimp on a tripod system as your expensive cameras and lenses rely on a sturdy support in order to deliver the results that they are capable of. It always used to be the case that the lenses were more important than the camera body and, although this is still true in some respects, continuing advances in digital cameras – especially in terms of resolution, digital noise and dynamic range – have levelled things out somewhat.

BUSH CRICKET

I noticed this cricket crawling across a hotel-room ceiling one evening. Before releasing it outside I took a few photographs making use of a small flash unit that I had recently purchased to take advantage of opportunities just like this. I carefully placed the cricket on the leaf of a spider plant in the room. A dark jacket acted as a makeshift background and disguised any obvious indoor elements. I positioned the flash behind the subject to provide backlighting, which helped to highlight the length of the insect's antennae. The flash light was reflected off a small gold reflector positioned close to the camera. This softened the harsh light and helped to reveal a little detail on the shadow side of the cricket. The exposure was determined by taking test shots and examining the histogram (see page 25). I made sure the camera body was parallel to the insect and used an aperture of f/16 to record sufficient sharpness in the antennae. Southampton, Hampshire, England.
Canon EOS-1Ds; EF180mm macro lens; 1/15 sec at f/16; ISO 100; manual focus; Speedlite 220EX with off-camera cord; gold reflector; remote release; tripod with ball head.

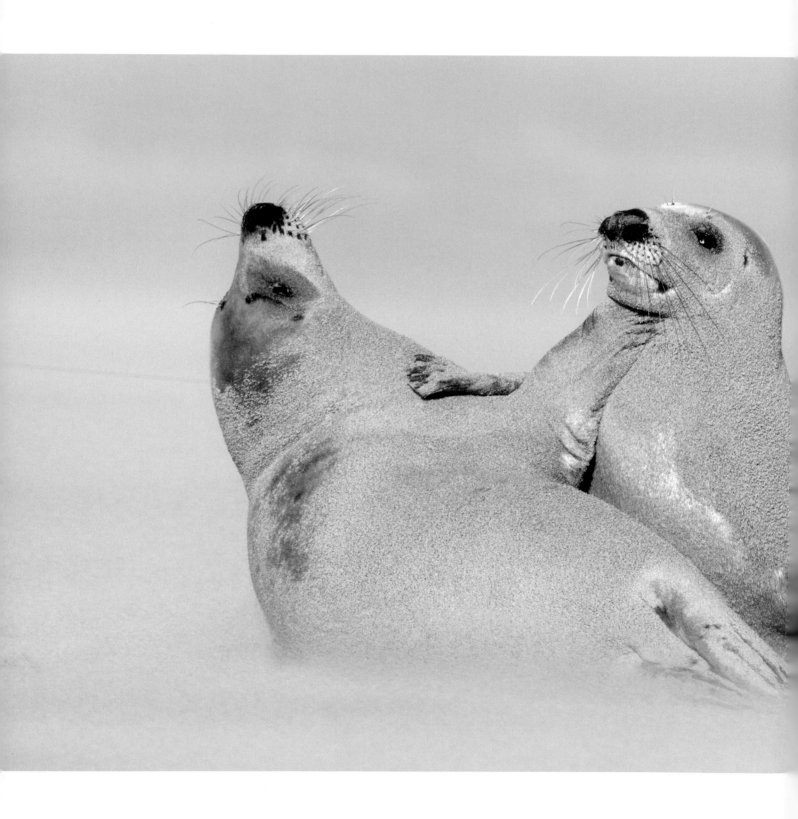

Protect your equipment

At times, you will inevitably be working in harsh weather conditions while photographing wildlife. This could be in the form of salt-water spray, blowing sand, heavy rain, high humidity or freezing temperatures. It is important to be prepared to work in these situations, as they can lead to atmospheric and often highly successful images that illustrate the type of environmental conditions faced by your subject. Many of the latest digital SLR cameras and lenses offer some form of weather sealing and while this can help, it is always a good idea to protect your valuable camera equipment further from the elements as much as possible. This is usually best achieved using a temporary waterproof camera cover that provides adequate protection from the atmosphere without restricting the use of camera functions or impairing the handling of your camera too much. Tripods take more abuse than other items of equipment and should be stripped down and cleaned regularly – especially after use in sand or salt water – to avoid corrosion.

YOUNG GREY SEALS PLAYING

Sand is perhaps the most damaging substance that your camera equipment is likely to encounter in the field. These playful young seals were photographed while a strong wind constantly blew sand across the beach. It was vital to use a camera cover to prevent sand from gaining access to vulnerable areas such as focusing rings and buttons. On this occasion, I used a clear plastic cover that allowed full control of all camera functions while protecting the whole camera set-up from the worst of the weather. It would have been foolish to attempt to change lenses in these conditions. I used a 16GB CompactFlash card so that I would not need to change cards all day. The seals took little notice of the conditions, even though some of them were slowly being buried! Lincolnshire, England.

Canon EOS-1D MkII; EF500mm lens; 1/1600 sec at f/7.1; ISO 250; AI Servo focus; single manually selected focusing point; IS off; Op-Tech camera cover; tripod with fluid video head.

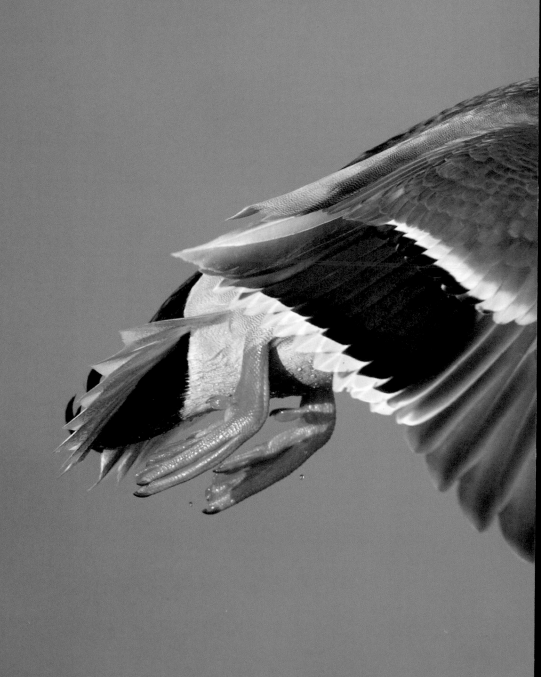

Technical Considerations

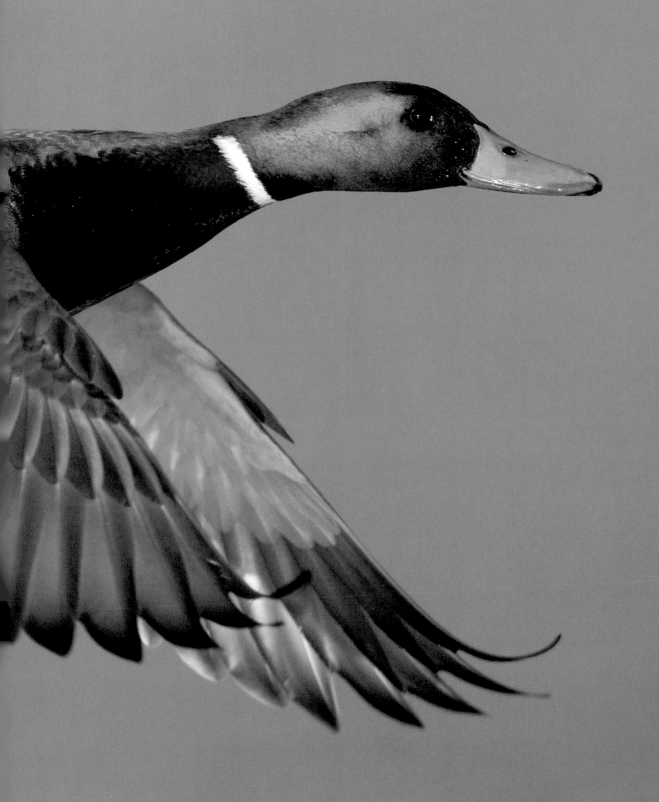

11 Master metering and exposure

Digital SLR cameras have better dynamic range than transparency film and are therefore able to capture a greater range of contrast in a single image. However, it is still important set the exposure as accurately as possible in-camera, rather than relying on adjustments that can now be made in software during post-production. It is essential to understand the basics of exposure theory. All in-camera meters assume that the subject being photographed is a midtone so you must learn how to compensate for this in order to correctly expose a full range of tones from black to white. For example, when photographing a grey bird against a grey rock face, the camera's suggested exposure value should be correct, whereas for a white bird standing in a snow-covered field you would need to increase the exposure by around 1½ stops to prevent the whole scene also recording grey. Likewise, for a black bird standing in a newly ploughed field you would need to reduce the suggested exposure by 1 or 2 stops if the subject is to be exposed correctly. This is true regardless of the metering mode used.

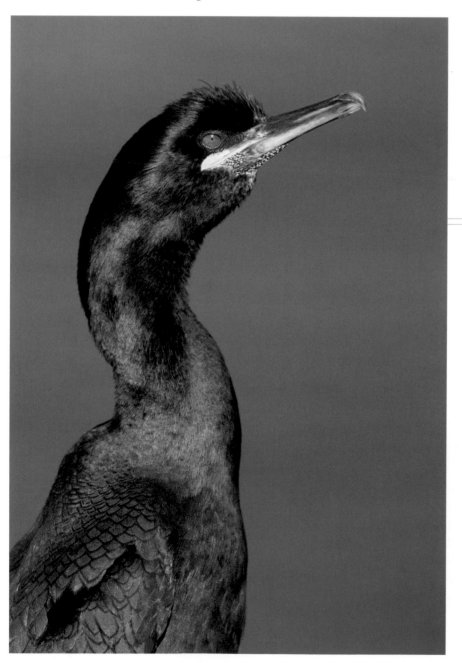

PORTRAIT OF A SHAG

Seabirds are a great subject on which to practise your exposure control, as many of them have either black or white plumage or a mixture of both. I always use the spot meter in my camera, as this allows me to take an exposure reading from a tiny portion of the scene. I then set the shutter speed and aperture manually based on the suggested exposure. Matrix and evaluative metering patterns can work equally well, especially when using an automatic exposure mode such as aperture priority (Av) or shutter priority (Tv). Then the suggested exposure values can be quickly adjusted, according to the tone of the subject, using the exposure compensation dial. In the case of the dark plumage of this shag, I needed to reduce the suggested exposure value by 1½ stops to prevent it recording as a much lighter tone than it actually was and to prevent its much brighter beak from burning out. Isle of May, Firth of Forth, Fife, Scotland. **Canon EOS-1D MkII; EF500mm lens; EF1.4X extender; 1/1000 sec at f/8; ISO 200; AI Servo focus; single manually selected focusing point; IS mode 1; tripod with fluid video head.**

Understand the histogram

All digital SLR cameras are able to display a histogram. This is a graphical representation of the distribution of tones within an image. On the horizontal axis, the left side of the histogram represents dark tones, the centre represents midtones and the right side represents light tones. The vertical axis shows the number of pixels recorded at that tone. How the information is distributed across the graph enables you to see whether the image requires more or less exposure. If the majority of the pixels are displayed towards the left side of the graph then, depending on the tone of your subject, you may need to increase the exposure. Likewise, if the information is biased towards the right you might need to reduce the exposure. Providing no pixels are actually touching either edge of the graph, you will be able to retain detail throughout the image. The histogram has become the single most important function of my camera when determining correct exposure. Whenever possible, I take a test shot, review the histogram, make any necessary adjustments and then continue shooting. View your histogram regularly and you can be confident of consistently accurate exposures.

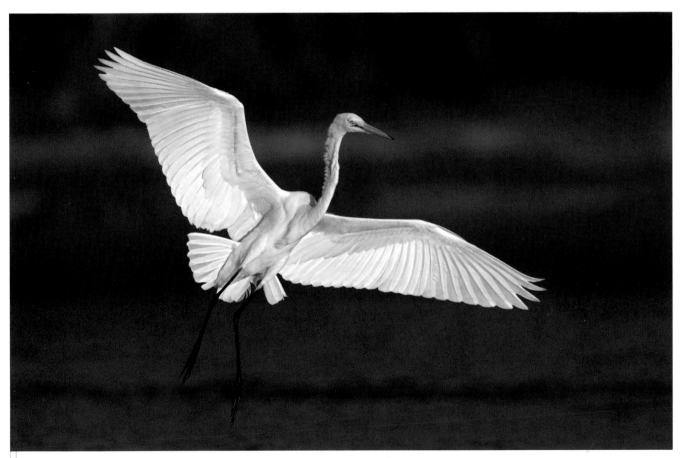

GREAT EGRET

The brilliant white plumage of this egret is a classic example of a difficult exposure situation. Had I relied on my camera's suggested exposure, this shot would certainly have been quite severely underexposed. Earlier, while photographing the bird as it fed, I had determined the correct exposure of the sunlit white plumage by examining the histogram. When the egret took flight, I knew that the correct exposure was locked in manually and I was able to concentrate fully on composing the image. I had been following the bird around as it fed, making sure to keep the sun directly behind me. This provided even illumination when the bird spread its wings. AI Servo mode kept the bird in sharp focus as it flew towards me. Fort De Soto, Florida, USA.

Canon EOS-1D MkII; EF500mm lens; 1/1250 sec at f/5.6; ISO 250; AI Servo focus; central focusing point; IS off; tripod with fluid video head.

13 Decide which exposure mode to use and stick with it

I have always used manual exposure mode for all of my photography. This is not to say that automatic exposure modes don't work, because they do, they simply require a different approach to exposure control. In automatic exposure modes (I would recommend aperture or shutter priority over fully automatic modes) you must constantly dial in exposure compensation according to the tone of both your subject and its surroundings. However, you do not need to compensate for changing light levels, as the camera will do that for you automatically. I prefer fully manual control of exposure because I know that my chosen exposure is locked in and will not change with the tones in the viewfinder as I pan the camera around. The downside to this is that I need to alter my exposure settings to compensate for changing light levels. Whichever technique you decide to use, stick with it and the necessary adjustments will eventually become second nature.

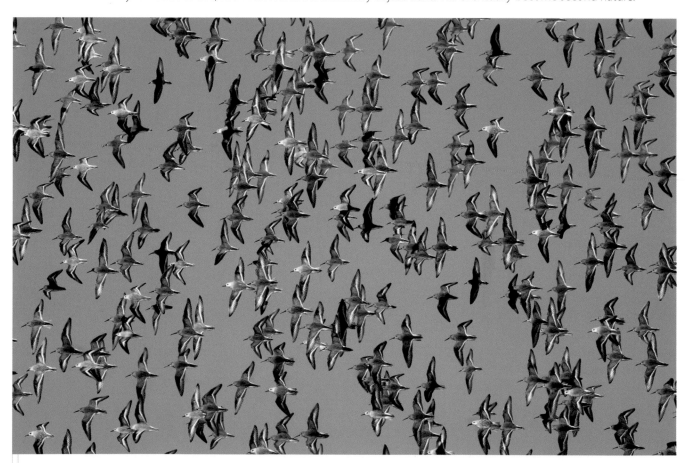

SHOREBIRDS IN FLIGHT

This mixed flock of wading birds was circling around the beach after being alarmed by a passing peregrine falcon. As the mass of birds passed in front of me, they crossed a number of differently toned backgrounds including dark conifer trees, white sand, dark blue water and pale blue sky. This would have caused any automatic metering system to constantly change the exposure settings according to the overall brightness of the scene, resulting in either over- or underexposed birds. I already had the correct exposure locked in manually, as I had been photographing the same birds when they were resting on the beach. Therefore, providing I continued to shoot with the sun behind me, I was confident that they would be exposed correctly. I set the camera to use all 45 focusing points and made my exposures as the flock turned, at which point they all held the same profile with wings outstretched. Fort De Soto, Florida, USA.

Canon EOS-1Ds; EF500mm lens; 1/2000 sec at f/5.6; ISO 200; AI Servo focus; 45 active focusing points; IS off; tripod with fluid video head.

Utilize depth of field

Depth of field refers to how much of a scene is recorded sharply in front of and behind the actual point of focus. This zone of apparent sharpness is affected by the focal length of the lens, the aperture set and the height and angle at which you are working. If you wish to record a whole field of wildflowers in sharp focus using a wide-angle lens, then it would be necessary to use a small aperture of around f/11 to f/22. Telephoto lenses exhibit less depth of field, which can be a great advantage when you wish to isolate a subject from its background – in which case use a wide aperture of around f/2.8 to f/5.6. When shooting frame-filling images of small to medium-sized animals and birds, you may need to stop down the lens aperture a little in order to achieve sufficient sharpness on the subject itself. The Live View function of many modern digital SLR cameras is a great help, as it enables you to zoom in to check the focus on the rear LCD screen.

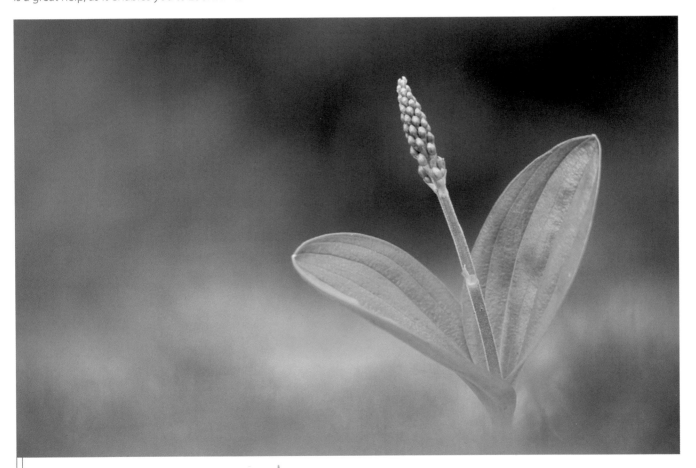

TWAYBLADE

This member of the orchid family is not the most colourful plant in the world and tends to blend in well with surrounding green vegetation. Finding some growing among bluebells was a bonus and by shooting from a low angle using a long telephoto lens, I was able to isolate one plant in a soft sea of blue. This was achieved by setting a wide aperture, which restricted depth of field to only a few millimetres – just enough to record the twayblade in sharp focus. Accurate focusing is critical when using small apertures with telephoto lenses. I could have achieved the same composition using a straight 300mm lens but by fitting a 2X extender I was able to utilize the much more limited depth of field associated with a 600mm lens. Marshwood Vale, Dorset, England.
Canon EOS-1Ds; EF300mm lens; EF2XII extender; 1/8 sec at f/5.6; ISO 100; manual focus; IS off; white reflector; mirror lock-up; remote release; angle finder; beanbag.

15 Prioritize aperture, shutter speed or ISO

There is often a compromise to be made between aperture, shutter speed and ISO settings, particularly when working in low light. You will need to decide which is more important to the final image. A small aperture will provide greater depth of field while a large aperture will give a smoother background. A fast shutter speed will freeze subject movement while a slow shutter speed will record motion blur. A high ISO setting will facilitate higher shutter speeds and smaller apertures while a low ISO setting will record less digital noise. In wildlife photography, shutter speed has to take priority more often than not because the subject is moving. However, if you need extra depth of field to record the subject sharply, you could choose to increase the ISO setting in order to select a smaller aperture while maintaining the same shutter speed. If depth of field is less important, you might decide to use a wider aperture, which permits the use of a lower ISO setting and thus reduces the amount of digital noise in the image.

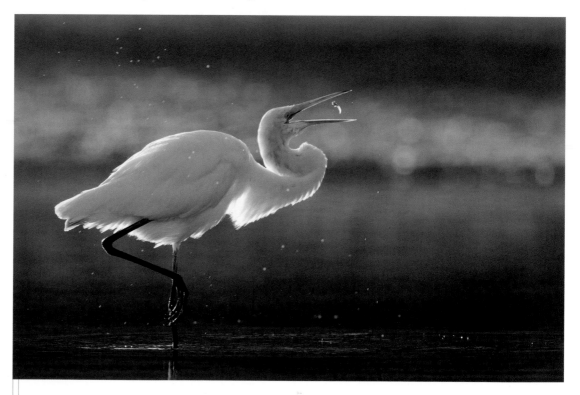

GREAT EGRET

I found this egret fishing for shrimp in a shallow pool early one morning. Sunlight was just beginning to reach the pool over the surrounding treetops so I set up on the shoreline and waited. The bird quickly became accustomed to my presence and carried on fishing. The egret's white plumage looked great rim-lit against the dark background. However, I needed to maintain a fast shutter speed to freeze the bird's movement in what was still a relatively low-light situation. My camera produces excellent image quality with little digital noise up to ISO 400 so I set this first. Depth of field was not a concern, as this was a large bird about 20 metres (65 feet) away, therefore I was able to shoot with the lens aperture wide open at f/4. For a correct exposure, this left me with a shutter speed of 1/500 sec, which was just enough to freeze the egret's head as it tossed another shrimp back. Sanibel Island, Florida, USA.
Canon EOS-1D MkII; EF500mm lens; 1/500 sec at f/4; ISO 400; AI Servo focus; single manually selected focusing point; IS mode 2; tripod with fluid video head.

Perfect your focusing technique

All digital SLR cameras have multiple focusing points of varying numbers and patterns. You have a choice whether to use all, some or just one of these. Although subject matter can dictate this choice to some degree, on most occasions I have found a single focusing point to give more consistently sharp images. On many cameras, the central focusing point is the most accurate and this is the one I tend to use most when photographing birds and animals in action. Keeping a single focusing point on a moving subject takes a lot of practice and perseverance so you should not become discouraged by early failures. Once mastered, this technique will allow you to maintain focus on the most important part of your subject rather than relying on the camera to determine this for you, which inevitably leads to a sharp wing tip and an out-of-focus eye!

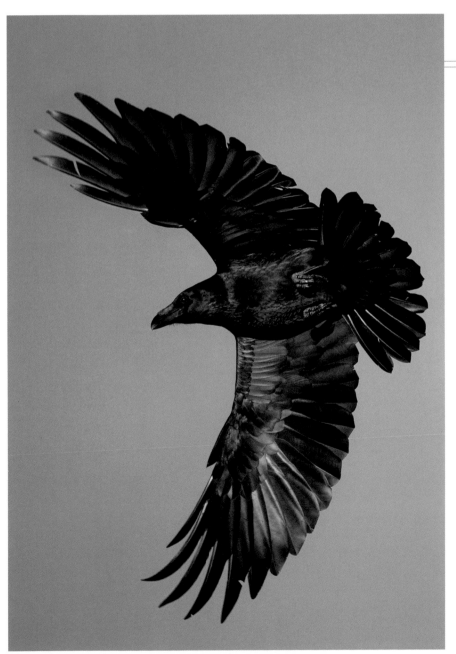

RAVEN

This shot was taken from a permanent wooden hide at the Gigrin Farm Red Kite Feeding Station in Wales. Some of the hides here have been thoughtfully designed with photographers in mind and provide plenty of room to set up a sturdy tripod while maintaining enough clearance to pan a large telephoto lens across the sky through 180 degrees. Many large birds have quite predictable flight patterns but it is always worthwhile spending a few minutes observing how the birds are being affected by wind conditions on the day. There were around 400 birds – ravens, jackdaws, rooks, crows, buzzards and red kites – in front of the hide. In such situations, it is always best to pick an individual bird and follow its movements through the viewfinder, keeping the focusing point on the bird rather than 'snapping' at multiple birds as they fly by. This way, you have a much better chance of capturing the best possible wing spread as the bird turns into the light. Gigrin Farm, Rhayader, Powys, Wales.
Canon EOS-1D MkII; EF500mm lens; 1/640 sec at f/4.5; ISO 250; AI Servo focus; central focusing point; IS off; tripod with fluid video head; hide.

17 Use long telephoto lenses

Long telephoto lenses are cumbersome, heavy and very expensive pieces of equipment. Unfortunately, they are also essential if you wish to photograph small birds and wary mammals in the wild. It can be surprising how little these huge lenses actually magnify. A 500mm lens magnifies only 10X and a 600mm lens only 12X. Their bulky design is due to the fact that they let in lots of light, which improves focusing speed considerably and enables the use of faster shutter speeds in low light. The magnification combined with a wide aperture produces a nice smooth background, which helps to concentrate attention on your subject. These lenses can actually be used to photograph any number of subjects. I use mine as much as possible and particularly like the fact that it provides a different perspective for photographing wildflowers and landscapes. Long telephoto lenses are especially prone to vibration so choose one that has image stabilization, an extremely useful feature that helps to reduce camera shake and vibrations.

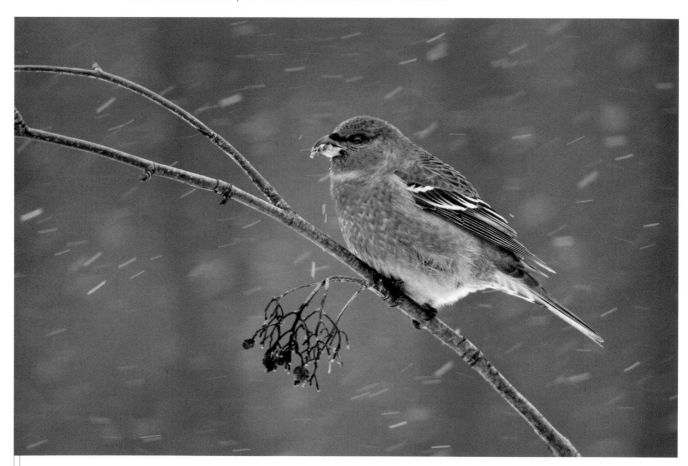

PINE GROSBEAK

It is not necessary to spend a fortune on a telephoto lens. My first telephoto lens was a Sigma 400mm f/5.6 APO Macro and I took many nice images with it. However, the relatively short focal length, poor focusing speed and limited ability to use extenders meant that I was restricted to working from a hide when photographing wild birds and mammals. Eventually, I took the plunge and invested in a 500mm f/4 lens so that I could benefit from the wider aperture and significantly faster focusing it offered. This lens is ideal for stalking wild birds. I can use it with a 2X extender and be confident that the images will be sharp. This image was taken in very low light during a snowstorm. The image stabilizer removed vibrations that would have almost certainly softened the image at such a slow shutter speed. Oulu, Northern Ostrobothnia, Finland.

Canon EOS-1D MkII; EF500mm lens; EF1.4X extender; 1/125 sec at f/4.5; ISO 400; one-shot AF; central focusing point; IS mode 1; tripod with fluid video head.

Use wide-angle lenses

Focal lengths between 16mm and 35mm (or 10mm and 22mm on APS-format SLR cameras) may not seem the obvious choice in nature photography. However, they can be particularly useful when photographing wild birds and animals within their environment. Even though a single animal may be recorded very small in the frame, it can form a distinct focal point among the surrounding habitat. Wide-angle lenses are particularly prone to flare so it is important to keep the front element spotlessly clean. Lens hoods cannot be relied on to prevent flare with these lenses so try to prevent sunlight directly striking the front element, either using your hand or a piece of card. Wide-angle lenses can also provide a unique and unusual perspective when shooting close-ups. When used in this way, you are likely to be very close to your subject so take great care not to cause any undue stress or disturbance.

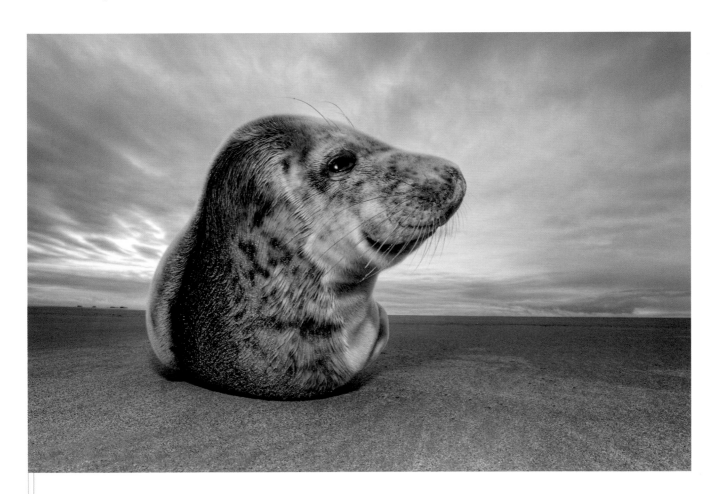

GREY SEAL

I had been photographing this young seal for some time using a long telephoto lens. After a while, I moved a little closer and used a 70–200mm zoom. It became clear that this particular seal did not perceive me as a threat so I switched to a 16–35mm lens and, keeping as low as possible, carefully worked myself closer. Still the seal showed no sign of alarm so I carried on taking photos with the camera body resting on the ground. Eventually, I was at the 16mm end of the zoom with the front element up close to the seal. By this point the seal had begun to fall asleep and I had to wait for moments when it opened its eyes! I used a very weak burst of fill-in flash to compensate for the poor light and focused manually to ensure the animal's eye was pin sharp. When I knew I had the shot I was after, I slowly backed away leaving the seal asleep on the beach. Lincolnshire, England.

Canon EOS-5D; EF16–35mm lens; 1/60 sec at f/11; ISO 400; Speedlite 550EX (manual mode at 1/64 sec); manual focus; handheld.

19 Use zoom lenses

The greatest benefit of zoom lenses is the compositional freedom they allow. With a zoom, it is easy to fine-tune your composition to remove unwanted elements without physically having to move backwards and forwards, as you would do with a fixed focal length lens (known as a 'prime'). Many modern zoom lenses are capable of excellent results and the best are on a par with fixed focal length lenses in terms of optical quality. Zooms are particularly useful when photographing subjects that move erratically, as you can quickly change the focal length as the subject moves closer or further away. They are also ideal for times when you are unable to change your shooting position, such as when working from a hide or vehicle. One zoom lens can take the place of several primes so the weight savings can be considerable. However, when opting for a single zoom in place of multiple lenses, bear in mind that damaging your main lens could leave you with no lens at all!

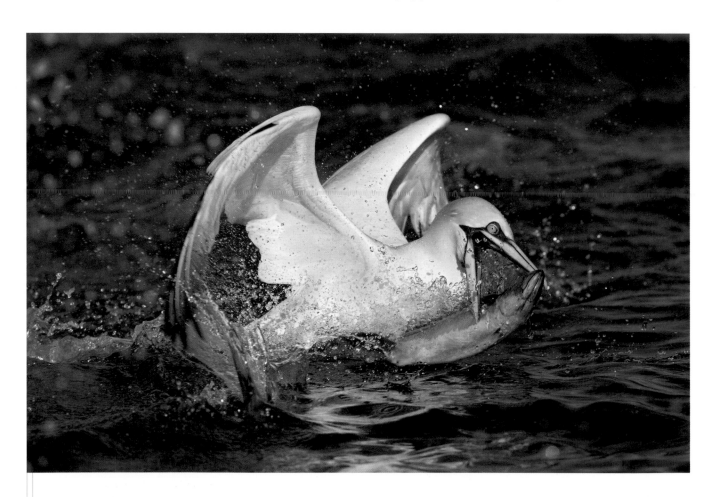

NORTHERN GANNET

This gannet was photographed from a boat off the west coast of Ireland. I had arranged for a local fisherman to take me out to an island that is home to a large gannet colony. Gannets and other seabirds are used to following trawlers in the open ocean, where they feed on the chum that is discarded over the side for the boat. I knew it wouldn't take long to attract the birds' interest if I threw in some fresh mackerel. Within seconds, I had birds circling over the boat and diving into the water very close to me. Using a zoom lens I was able to shoot at the correct focal length regardless of where the birds were diving or which way the boat was pitching and rolling. The most difficult part was explaining to the fisherman that I needed him to position the boat so that the sun remained behind me. Skellig Islands, Co. Kerry, Republic of Ireland.
Canon EOS-1D MkII; EF100–400mm lens; 1/1600 sec at f/5.6; ISO 250; AI Servo focus; central focusing point; IS mode 2; handheld.

Support your camera

Camera support is the most important factor when it comes to image sharpness, as the slightest movement of the camera during the exposure can cause blurring of the image. Very few of the images in this book were taken without the camera supported either on a tripod or a beanbag. You will never see the full potential of your expensive camera equipment if you don't support it properly. Always buy the sturdiest tripod and head you can afford and make sure it is capable of supporting your heaviest camera-and-lens combination. A good tripod set-up is likely to cost as much as a decent lens or camera body, although savings can be made when buying second-hand. The humble beanbag provides possibly the best camera support providing it is filled with suitable material. I use wild birdseed in my beanbags as it provides a rock steady support, as well as sometimes being useful if I need to entice a subject a little closer!

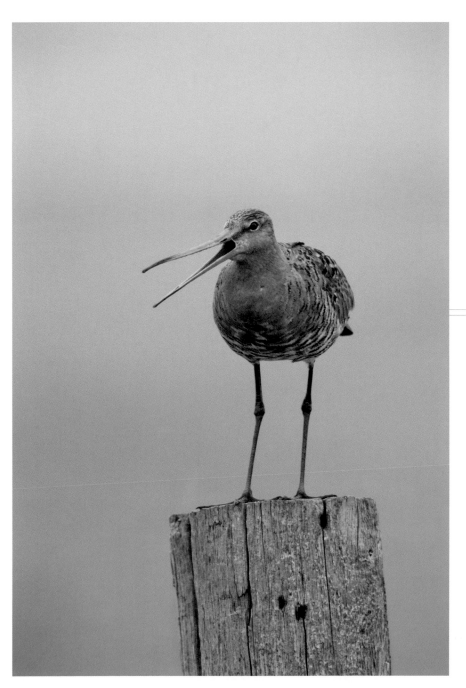

BLACK-TAILED GODWIT

During a trip to the island of Texel in Holland, I noticed that this godwit had a favourite perch on a gatepost close to the road. I returned one morning and parked my car so that I was within range with my 500mm lens. I normally support this lens on a large tripod with a fluid video head. However, when shooting from a car window using a tripod is impractical so I choose to use a beanbag instead. Even though the beanbag provides a very stable platform, which also helps to soak up vibrations, I still make use of the image stabilizer on my 500mm lens. The godwit returned to the post every few minutes while defending its territory from rivals. It was calling incessantly so I timed my exposures to catch its beak wide open. Texel, Holland.
Canon EOS-1Ds; EF500mm lens; EF1.4X extender; 1/500 sec at f/8; ISO 250; one-shot AF; single manually selected focusing point; IS mode 1; beanbag.

Fieldcraft

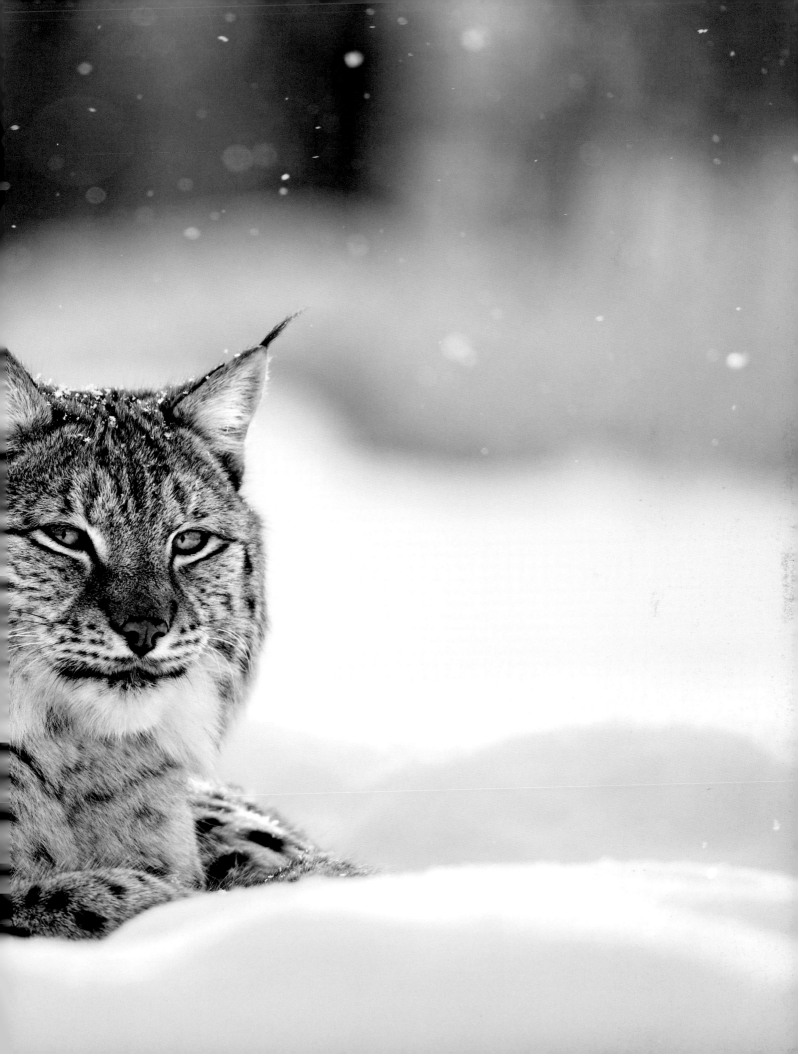

21 Research locations

Thorough planning and research can make the difference between a successful photography trip and a failure. Always check whether a location is accessible in good light. For example, the Farne Islands off the north east coast of England are famous for their seabird colonies but they can only be accessed via boat trips that run between 10am and 2pm, missing the good light early and late in the day. This tells you that the best chances for photography will be during overcast weather when the lighting will exhibit less contrast. You also need to be aware of many other factors that may affect your photography, such as tidal conditions, seasonal variations and wind direction. Good planning, perhaps combined with a recognisance visit, will ensure that you arrive at the best time to make the most of the location.

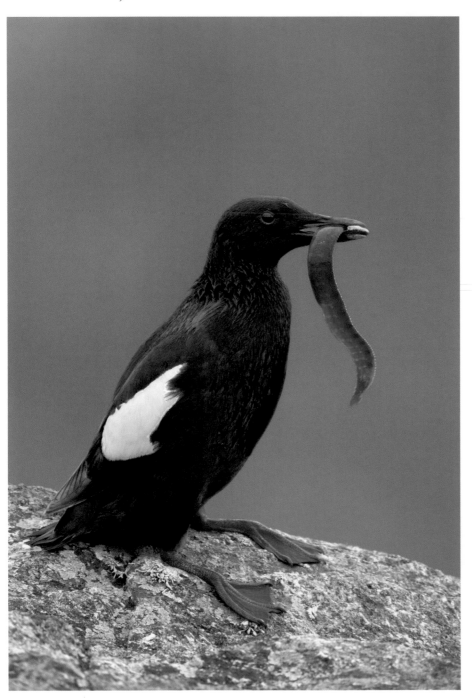

BLACK GUILLEMOT

When I decided to photograph black guillemots, an Internet search revealed that one of the best locations to find them is a remote group of islands in the Outer Hebrides called the Monarchs. I found a local boatman who was prepared to take me out on his RIB. After a high-speed, bumpy and rather wet journey, I finally made it to the islands. I found a good number of black guillemots and many of them were holding bright red butterfish in their beaks. Unfortunately, the light was very poor and I was struggling to obtain a fast enough shutter speed. Thankfully, the image stabilizer on my lens enabled me to record a sharp image even at a shutter speed of only 1/125 sec. Monarch Islands, Outer Hebrides, Scotland.
Canon EOS-1D MkII; EF500mm lens; EF1.4X extender; 1/125 sec at f/5.6; ISO 400; one-shot AF; single manually selected focusing point; IS mode 1; tripod with fluid video head.

Get to know your subject

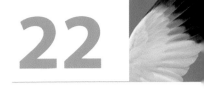

One of the most important tasks for the nature photographer is getting to know the subject. Time spent learning its behaviour, habits, calls and movements will be rewarded with a much greater chance of securing images that exhibit natural behaviour. Many animals show clues that can provide advance warning of behaviour you might wish to photograph, such as fighting, hunting and mating. It is also important to recognize the signs of stress in different species so that you know when to back off in order to prevent your actions from causing undue disturbance. Books and other reference sources can provide useful information regarding animal behaviour. However, the only way to gain sufficient knowledge about your subject is to spend as much time as possible observing it in the field. This can often be achieved on days when the weather or lighting isn't ideal for photography.

MATING AVOCETS

The Dutch Island of Texel is a great place to photograph many species of birds without the need for a hide. A variety of wading birds can be found, along with spoonbills, terns and hen harriers. Spring and autumn migration times offer the greatest potential. This pair of avocets was photographed from the roadside using a 500mm lens. It is important to be vigilant at all times when attempting to photograph aspects of animal behaviour. Avocets have a distinctive courtship ritual, which provides an early indication that mating is imminent. It is essential to be aware of this, as the moment of mating is very brief and can easily be missed if you fail to spot the signs. I also remembered to continue shooting after mating had occurred because the birds then performed their characteristic post-mating dance. Texel, Holland. **Canon EOS-1D MkII; EF500mm lens; 1/1250 sec at f/5.6; ISO 250; AI Servo focus; central focusing point; IS off; tripod with fluid video head.**

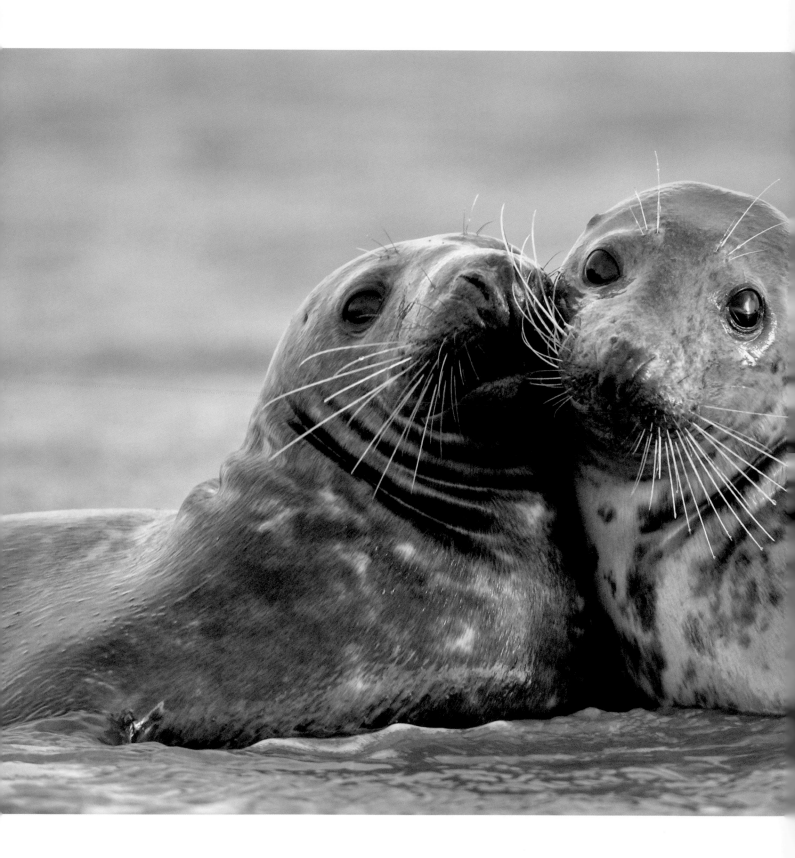

Gain your subject's trust

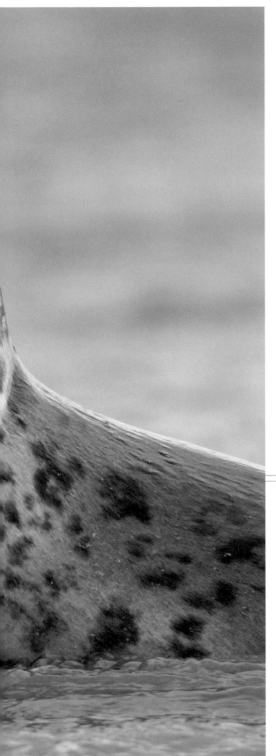

There are two approaches to take when you want to get close to your subject. The first is to conceal yourself so that the subject never knows you are there. The second is stalking, which takes a lot more patience and skill. There are many species of birds and mammals that will allow you to approach closely if you are careful and use the correct techniques. Don't make the mistake of walking directly towards your subject until you're close enough to take a photograph, as the chances are the animal will have fled long before you press the shutter. Approach slowly and disguise your profile – this is often best achieved by keeping as low as possible. Most importantly, don't make any sudden movements when approaching your subject or when handling camera equipment. Some species will accept human presence quite quickly but it may take hours, days or even weeks to gain the trust of more wary subjects.

RELAXED GREY SEALS

Even though this particular seal colony is used to seeing people and photographers, they will still flee into the sea if approached too quickly. Walking out to the colony at dawn meant that I was the first person on the beach that day. It was therefore important to approach slowly. Each time the seals lifted their heads to look at me I stopped walking for a few minutes, before walking slowly towards them again. Eventually, I was about 50 metres (160 feet) from the edge of the colony, at which point I sat down and set up my camera and 500mm lens. I waited for around 20 minutes before starting to take pictures – slowly moving forwards in stages until I was within range. It wasn't until midday that the majority of seals were comfortable with my presence. I was then able to approach some individuals close enough to take frame-filling images with a wide-angle lens. Lincolnshire, England.
Canon EOS-1Ds; EF500mm lens; EF1.4X extender; 1/500 sec at f/5.6; ISO 400; AI Servo focus; single manually selected focusing point; IS mode 1; groundpod with fluid video head.

24 Work from a hide

I have never particularly enjoyed working from hides due to the relative lack of compositional freedom they permit. However, with species that are notoriously shy – such as birds of prey and larger mammals – this can be the only option. A thoughtfully positioned hide should provide you with good light early or late in the day and a shooting angle at eye-level to the subject. Be aware of trees and branches that might block sunlight at certain times of the day. A permanent or semi-permanent hide can be used when working at a feeding station or regularly baited site. Where this is not possible, and for short-term projects, a collapsible dome hide disguised with natural materials is a good option. Always keep movements within the hide to a minimum – many species have exceptional eyesight and hearing, particularly some mammals, birds of prey and members of the crow family. Less shy animals and birds can be photographed at quite close range from a hide using a moderate telephoto lens. Telephoto zoom lenses are particularly useful as they allow you to photograph a wider variety of species at varying distances.

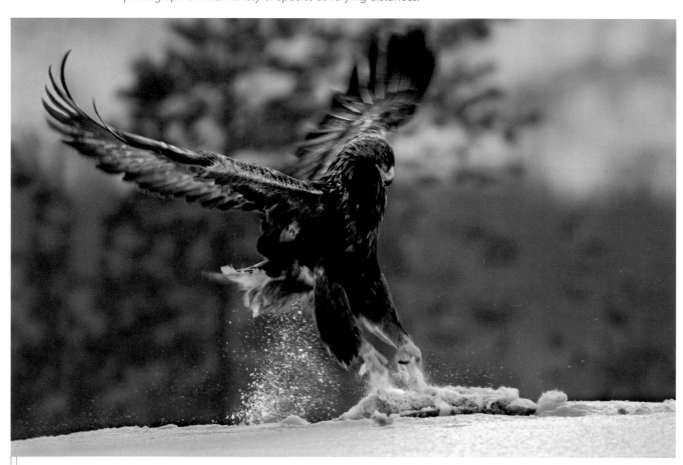

GOLDEN EAGLE

I photographed this eagle from a well-established hide in a Finnish national park. It was vital to enter and vacate the hide in darkness so that the birds would never see people in the vicinity. After a short snowmobile ride through the forest I was concealed in the hide for the next 12 hours. The area in front of the hide was baited with road-kill. After eight hours of waiting, the eagle finally turned up and fed briefly on the bait. It was soon joined by its mate and they both sat in a tree with their backs to me before flying off. During the 12 hours that I was in the hide, the eagles were present for no more than ten minutes. The whole process was repeated the next day when the eagles did not put in an appearance at all – such is wildlife photography! Oulanka National Park, Kuusamo, Finland.

Canon EOS-1Ds; EF500mm lens; EF1.4X extender; 1/500 sec at f/5.6; ISO 400; AI Servo focus; central focusing point; IS mode 2; tripod with fluid video head; hide.

Set up a feeding station

Encouraging wildlife to use a feeding station enables you to control the photographic situation. In most cases you will be working from a hide, which makes this a particularly useful technique if you don't possess a long, fast telephoto lens. When photographing woodland and garden birds, place attractive perches against colourful diffused backgrounds and change these perches regularly to avoid shooting different birds in the same situation. Use seasonal perches such as a branch with catkins or cherry blossom in spring and berries during the autumn. It may be possible to move your hide from time to time to enable you to experiment with both front lighting and back lighting. Feeding stations depend on using the correct bait for your target species. It is vital to maintain feeding at all times – both to keep the feeding station active and also for the welfare of your subjects. When shutting down a feeding station, do it gradually so that the food supply is not halted suddenly.

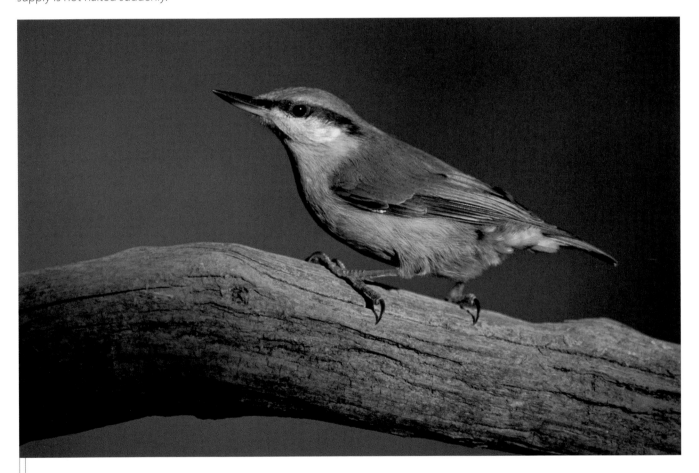

NUTHATCH

I took this image many years ago before I became a professional photographer and could afford to invest in expensive long telephoto lenses. Back then, my longest lens was a Sigma 400mm f/5.6 APO Macro. Stalking small birds with this lens was very difficult so my best option was to set up a feeding station and photograph from a hide. This enabled me to obtain frame-filling images of woodland and garden birds. These days, I continue to use the same feeding station albeit with the perches placed further away from the hide to facilitate the use of a 700mm lens. By increasing the shooting distance, I have reduced the chances of the birds being spooked by lens movements. I now have two cameras set up at the same time – the other with a 300mm lens to enable me to photograph larger birds such as crows, buzzards and sparrowhawks. Marshwood Vale, Dorset, England.
Canon EOS-3; Sigma 400mm f/5.6 APO Macro lens; 1/500 sec at f/5.6; Fuji Sensia 100; AI Servo focus; central focusing point; tripod with ball head; hide.

26 Approach your subject with care

As a wildlife photographer you need to take great care not to disturb your subject as your aim is to get close and to photograph natural relaxed behaviour. It is equally important to take care and to avoid causing disturbance for the sake of the subject itself. Many animals and birds are very shy and particularly wary of humans, therefore a carefully positioned hide may be the only way to get close enough to certain species. However, by using the correct fieldcraft it is possible to approach a great variety of wild animals and birds on foot. In many cases, a stalk will be most successful when your subject can see you approaching and has time to accept that you pose no threat. Other species, such as deer, often need to be stalked with extreme care by concealing your presence as much as possible. When visiting locations where other photographers are already working, bear in mind that it might have taken them a considerable amount of time to approach their subject so never assume it is a tame animal and will accept you walking straight up to it.

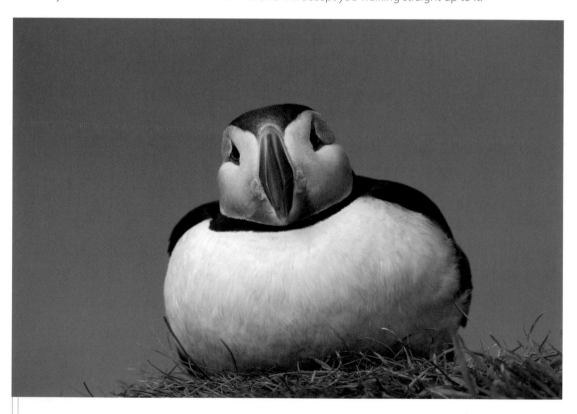

ATLANTIC PUFFIN

Atlantic puffins are notoriously tolerant of human presence. However, care still needs to be taken when approaching very closely. This individual was resting on a cliff edge with a group of other puffins and some razorbills. It was important to keep an eye on all the birds there to make sure none of them were showing any sign of alarm. If one bird becomes spooked and flies away, the others will inevitably follow. I have always felt it to be important to take just as much care when leaving a subject as I do when approaching. When I have finished photographing I always leave slowly, keeping as low as possible so as not to cause my subject to run or fly away. Isle of May, Firth of Forth, Fife, Scotland.

Canon EOS-1D MkII; EF300mm lens; 1/250 sec at f/8; ISO 250; one-shot AF; single manually selected focusing point; IS mode 1; camera resting on ground.

Wear suitable clothing

Is camouflage clothing really necessary? I have seen photographers dressed from head to toe in leafy camouflage while working on a sandy beach and even in snow! How does that work? All you really need to do is dress appropriately for the conditions and terrain that you will be working in. Avoid materials that rustle and don't wear expensive clothing as it may get torn. It can sometimes be useful to wear a hat to help disguise the human outline. I have never worn camouflage to conceal myself when photographing wildlife and I'm fairly certain that I never will. After 12 years as a professional nature photographer, I'm quite sure that by simply wearing colours that blend in with the environment and by using good fieldcraft I stand an equally good chance of close wildlife encounters.

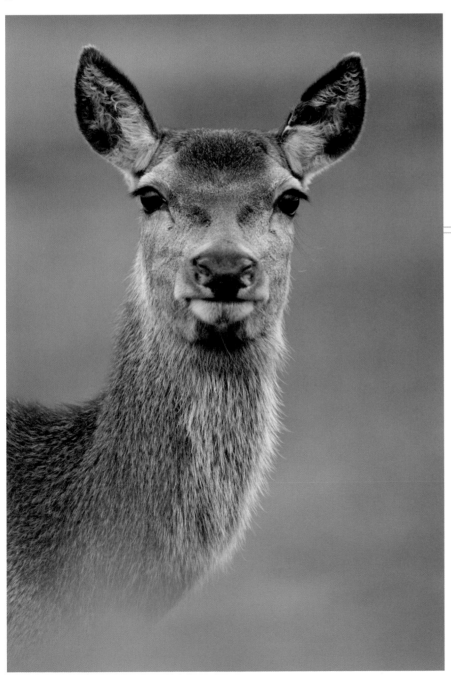

RED DEER HIND

I spotted this lone hind from my car. She was about 300 metres (1000 feet) away on an area of open moorland. I left my car by the roadside where a small hill concealed my presence. Keeping the wind in my face I slowly made my way through the heather, keeping low and using the undulating ground to conceal me as much as possible. Eventually, I was within shooting distance with a 500mm lens. I found a low grass bank on which to rest the lens and it wasn't long before the hind began to move closer to me. I waited until she was close enough for a portrait in vertical format. A grass bank in front of me provided a diffused foreground that helped to frame the subject. She was intrigued by the sound of the shutter firing but soon carried on feeding. After a while, she moved far enough away for me to retreat without causing her to flee. This was all possible without the need for camouflage clothing. Glen Torridon, Highland Region, Scotland.
Canon EOS-1D MkII; EF500mm lens; 1/250 sec at f/5.6; ISO 400; AI Servo focus; single manually selected focusing point; IS mode 1; beanbag.

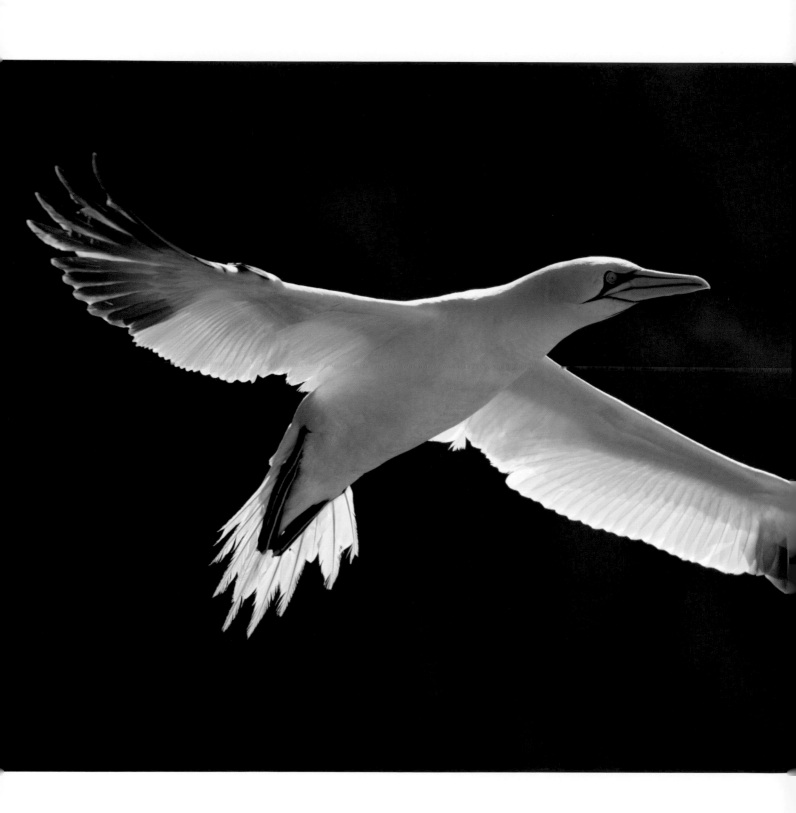

Carry your equipment in comfort

It is important to remain comfortable when photographing in the field otherwise your determination, patience and creative thought processes can diminish. This extends to wearing the right clothing for the conditions and terrain and to carrying your heavy photographic equipment in comfort. Traditional photo backpacks are great most of the time and there is a huge choice available to allow you to select one that works best for your needs. However, there are occasions when alternative backpacks can be a better choice. I normally use a large Tamrac 787 backpack but when I am working in particularly demanding terrain over long distances, I switch to a traditional climbing rucksack with a frame. This is a much lighter bag when empty and is much more comfortable for extended use. Cameras and lenses are protected in individual neoprene sleeves so overall weight savings are considerable.

BACKLIT GANNET

When visiting seabird colonies, a whole variety of lens focal lengths can often be used – from extreme wide-angle to long telephoto. However, accessing some of these colonies can be a challenge so a large amount of equipment can be restrictive. Therefore, I tend to set myself goals for each day and only carry the lenses I will need to meet those goals. For example, the day I took this image I was concentrating on securing some images of gannets in flight at a site where I knew I would be able to shoot against a dark shaded rock face for much of the morning. I knew I would only need a 400mm lens so that is all I took with me. When I'm working mainly with the large 500mm lens, I use a Viper Photo Rucksack that is capacious enough to take the lens with lens hood extended and camera body attached ready for use. Bass Rock, Firth of Forth, Fife, Scotland.
Canon EOS-1D MkII; EF400mm lens; 1/2000 sec at f/5.6; ISO 200; AI Servo focus; central focusing point; handheld.

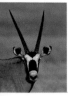

29 Go on organized trips

Organized photography trips can be a great way of shooting a variety of images over a short period. They can be a good option when you are restricted in time, as a decent guide should be able to take you straight to the best locations. However, the success of these trips depends on several factors so make sure the itinerary is suitable for your needs. It should take place at the ideal time of the year for the target species. You should be able to access the necessary areas for photography at dawn and dusk and be out and about when the light is at its best. Ensure there will be plenty of space in the vehicle you travel in – ideally you need to have room to photograph from both sides. Most importantly, you need to ensure your guide is very knowledgeable and is able to understand your requirements as a nature photographer. For the best opportunities, consider organizing a bespoke trip with a group of photographers that have similar goals.

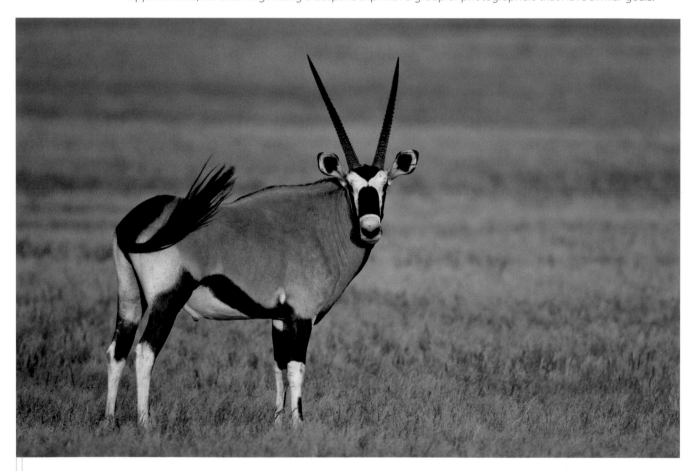

ORYX

For my first trip to Namibia, I organized a bespoke self-drive tour that included private drivers in several parks and reserves. The knowledge of the drivers was invaluable and I learned an awful lot about the country during my three-week trip. This will help me to plan a return visit where I can target the best locations I encountered first time round. This image was taken in a remote area of the Namib-Naukluft Park in the west of Namibia. An exceptionally wet rainy season had turned the barren rock desert into lush grassy plains where herds of antelope grazed. The wildlife here is not accustomed to tourists so many of the animals are difficult to approach, even in a vehicle. Nevertheless, I managed to secure several images of this oryx before the sun went down. Namib-Naukluft Park, central Namib Desert, Namibia.
Canon EOS-40D; EF500mm lens; 1/250 sec at f/5.6; ISO 400; one-shot AF; central focusing point; IS mode 1; beanbag.

Be ready to capture the decisive moment

The majority of great wildlife photographs are the result of many hours of dedicated research, skilled photography, knowledge of the subject, patience and perseverance. However, there are many great images that are also the result of a very lucky encounter, where the fast reactions of the photographer have succeeded in capturing the decisive moment. Regardless of your level of photographic skill, you still need to be in exactly the right place at the right time if you wish to shoot a unique image and you will increase your chances by spending as much time in the field as possible. The decisive moment, when the subject is in the optimum position or when the action is at its height, might only last for a split second. By remaining vigilant at all times you will reduce the chance of missing that killer shot and increase the chance of detecting some aspect of behaviour that could alert you to an impending opportunity. Set your motor drive to high-speed mode to further increase the likelihood of securing a winning image.

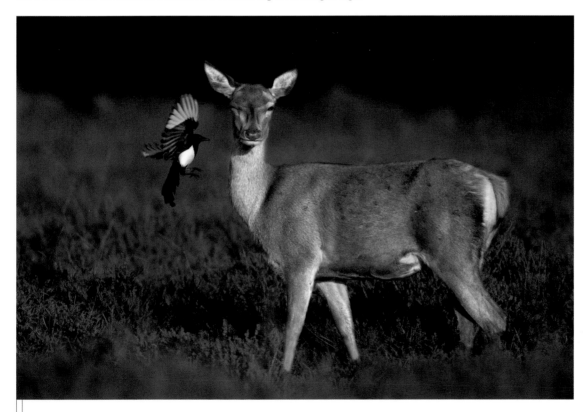

RED DEER AND MAGPIE

On this occasion, I had been photographing red deer at dawn during the rut. I wanted to capture the stags roaring in the atmospheric misty conditions that occur just after sunrise. An hour after the sun had risen, all the mist had burnt away and the light was becoming quite harsh. I began to make my way back to the car but stopped for a while to talk to the park warden. There happened to be a group of hinds grazing nearby and I noticed a pair of magpies feeding on the ground beneath them. Suddenly, one magpie flew up on to the back of a hind and began picking parasites from around its neck. My camera was still set up on the tripod so I quickly set the correct exposure and fired off a few frames. This ended up being my favourite image from the whole morning. New Forest National Park, Hampshire, England.

Canon EOS-1Ds; EF500mm lens; 1/1600 sec at f/5.6; ISO 250; AI Servo focus; central focusing point; IS off; tripod with fluid video head.

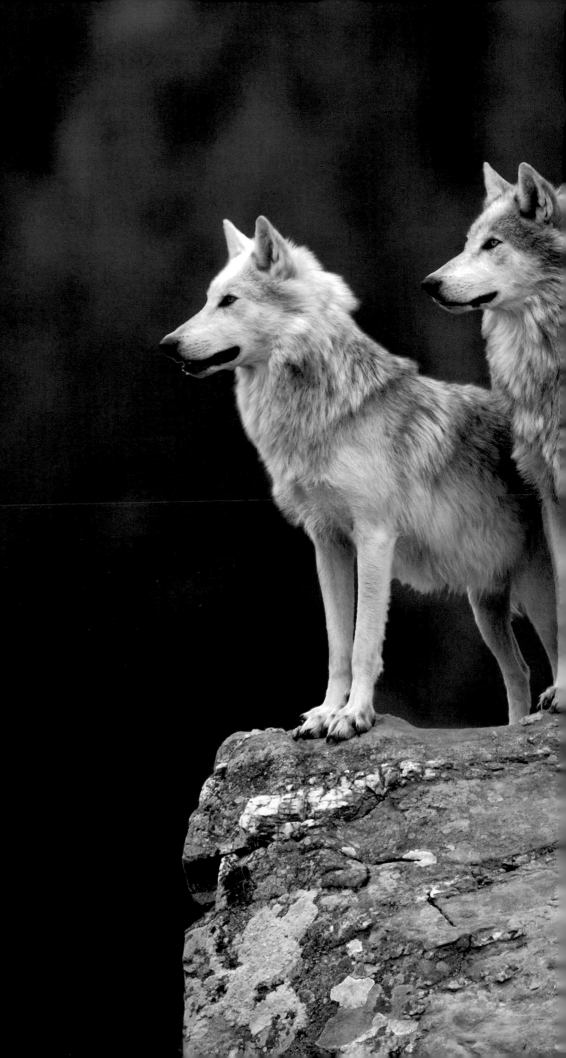

Composition

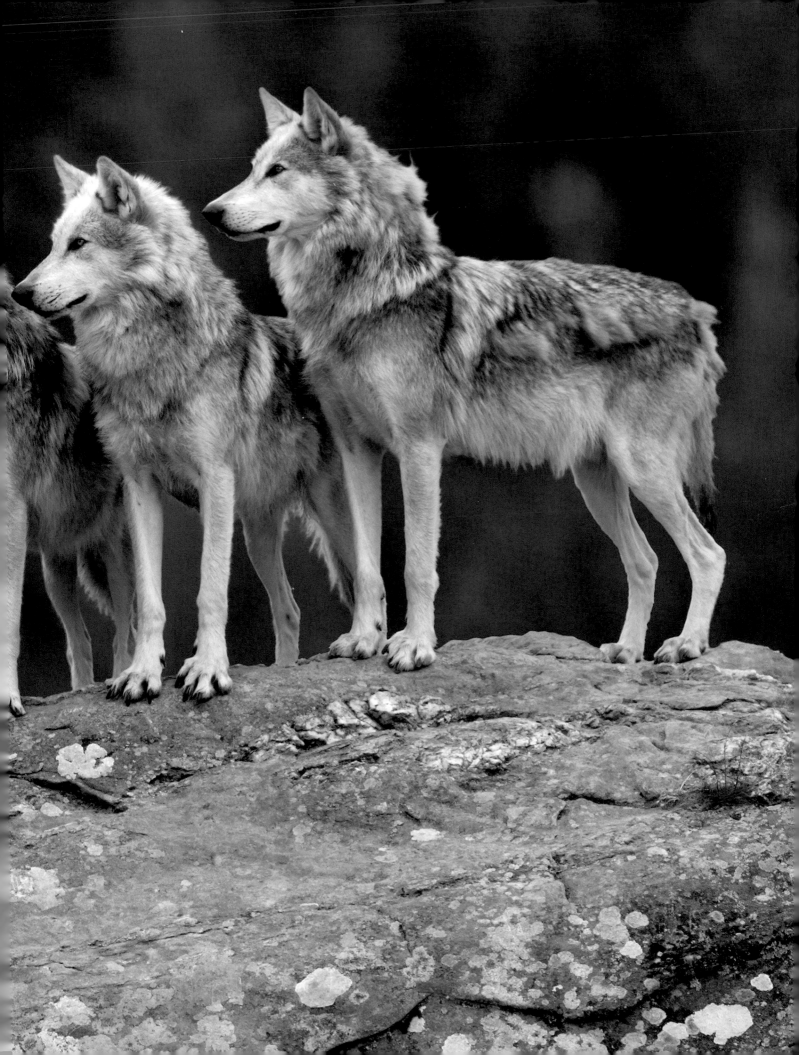

31 Search for the best composition

When photographing active animals and birds, it is often necessary to make compositional decisions very quickly. If you need to conceal your presence, your movement may also be limited. However, when photographing less mobile subjects such as insects, plants and natural features, the more time you take over image composition the better. When you find a good subject, don't immediately extend the legs of your tripod and fix the camera to it. A tripod-mounted camera is very restrictive when attempting to choose the best composition and discourages you from moving very far or from altering the height from which you shoot. Explore the subject as much as possible. Walk around it with the camera handheld to see which angle works best, where the cleanest background can be achieved and which lighting angles are preferable. Try both vertical and horizontal formats. Only when you are happy with what you see should you reach for your tripod, which then becomes the perfect aid for fine-tuning your chosen composition.

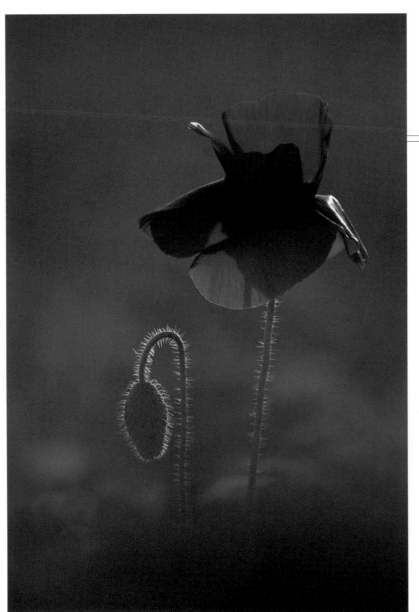

POPPIES

I am always on the lookout for fields of poppies during the summer months. The best technique for finding them is to get up high and scan the landscape with a pair of binoculars. The South Downs in southern England offer a perfect vantage point. For this image, I decided to isolate a single poppy bloom and bud against a sea of crimson. To achieve this effect, I used a long telephoto lens, which compressed the background as much as possible. This allowed me to completely fill the frame with diffused red colour, avoiding any patches of green between the poppy flowers. I shot into the light to make the petals really glow and used a white reflector to help retain detail by bouncing light back on to the shaded side of the flower. South Downs, East Sussex, England. **Canon EOS-1Ds; EF300mm lens; EF2XII extender; 1/500 sec at f/11; ISO 100; manual focus; IS mode 1; white reflector; tripod with ball head.**

Choose the best focal length

When you find a good subject, it is often worth experimenting with a range of lens focal lengths to see what different effects can be achieved. Remember that on 35mm film cameras and full-frame digital SLRs, a 50mm lens provides a very similar angle of view and perspective to that of the human eye. Move in closer using a wide-angle lens of between 16mm and 24mm to exaggerate perspective and increase the sense of depth. You can also include some of the surrounding habitat to provide a sense of place. Move further away with a long telephoto lens of between 300mm and 600mm to isolate the subject from its surroundings, using a wide aperture to restrict depth of field. In some cases, a whole range of lens focal lengths can be used successfully with the same subject, all providing a very different visual effect so experimentation is the key.

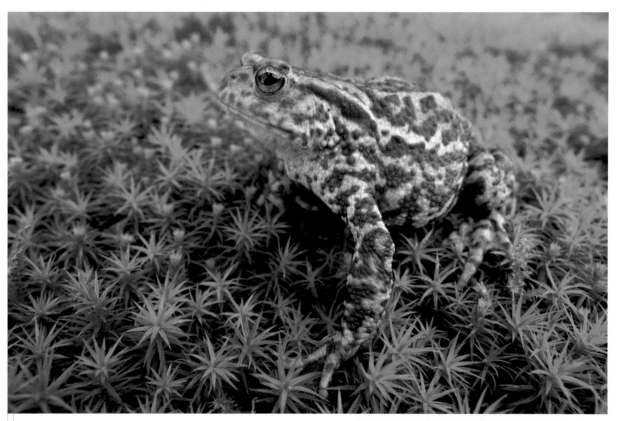

COMMON TOAD

I found this particularly nicely patterned toad trapped in a drain by the side of my house. Before releasing it, I decided that it should pay for its rescue with a brief spell of modelling. I placed it on a nice carpet of dark green star moss, which contrasted well with the toad's light skin. To begin with, I photographed it from close range using a very close-focusing 24mm lens, which exaggerated the perspective quite nicely. I used an aperture of f/16 to record the whole toad and plenty of the surrounding star moss in sharp focus. I then switched to a 180mm macro lens, which I used at a wide aperture of f/5.6 to restrict depth of field. This produced the opposite effect to the wide-angle lens, helping to isolate the toad from the surrounding environment. Lyme Regis, Dorset, England.
Larger image: Canon EOS-1Ds; Sigma 24mm lens; 1/8 sec at f/16; ISO 100; manual focus; mirror reflector; beanbag.
Smaller image: Canon EOS-1Ds; EF180mm macro lens; 1/60 sec at f/5.6; ISO 100; manual focus; mirror reflector; beanbag.

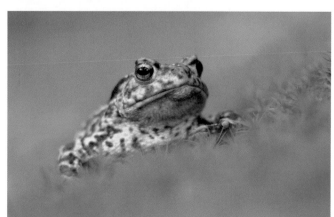

33 Keep your composition simple

Simplicity is often the key to composing a successful photograph. A thoughtfully composed image should never look cluttered and the main subject or focal point should be obvious. When framing an image, decide which parts of the scene are most important and work hard to exclude any elements that don't have a role to play or detract from the composition. Try to keep all major elements well separated from the edges of the frame. Try not to include large areas of dense shadow or featureless space. Shooting from a very low angle with a long telephoto lens can instantly simplify your composition by throwing all but the main subject out of focus. This can be particularly effective when photographing many species of wildflower, animal or bird. When photographing patterns in nature, simple graphic compositions always exhibit greater impact.

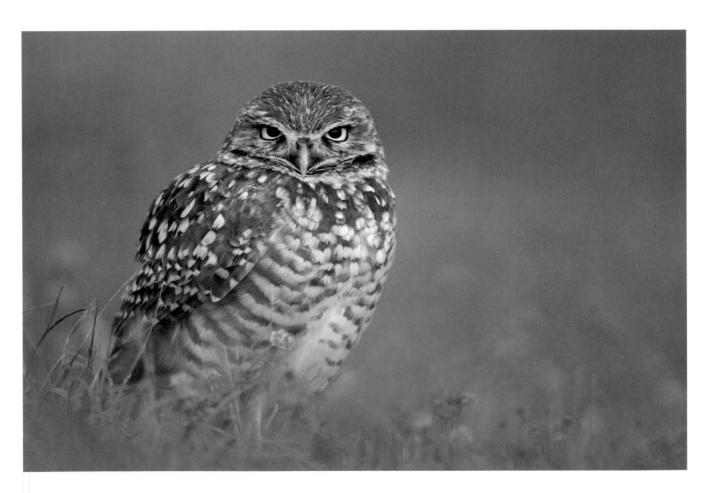

BURROWING OWL

These birds can be very trusting and a careful approach will often be rewarded with frame-filling images with even a moderate telephoto lens. However, for this shot I chose to use a 500mm lens simply to benefit from its restricted depth of field. By shooting from ground level I was able to frame the owl with diffused grasses. This low shooting angle also achieved an eye-level perspective with the bird, which, when combined with direct eye contact, makes for a particularly engaging image. It was essential to maintain the point of focus on the bird's eyes so I selected the appropriate focusing point manually. I used one-shot focusing mode as I find it provides much more consistent results when focusing on static subjects. I took this image late in the day when the sun was just above the horizon. By keeping the sun behind me the owl's bright yellow eyes were perfectly illuminated. Cape Coral, Florida, USA.
Canon EOS-1D MkII; EF500mm lens; 1/250 sec at f/6.3; ISO 250; one-shot AF; single manually selected focusing point; IS mode 1; beanbag.

Leave space in front of your subject

A common mistake when photographing animals and birds is to frame the shot in a way that shows the subject looking or facing out of the frame. Whichever way the subject is looking or facing implies interest and possible movement in that direction and the viewer's eye will be naturally drawn that way. Therefore, it is important to leave extra space in that direction. A good way of achieving the right effect is to employ the 'rule of thirds'. This is a reliable way of arranging the elements in your picture to form the strongest possible composition. Imagine a grid of lines drawn through the viewfinder to split the frame into nine equal parts. The subject should be placed roughly where two lines cross. These intersections are known as 'power points'. They are areas within the rectangular frame where the eye tends to fall naturally. This may not be possible if your subject is quite large in the frame, in which case try placing the subject's eye dead centre. This can lead to a successful composition with more room in front of the subject than behind it.

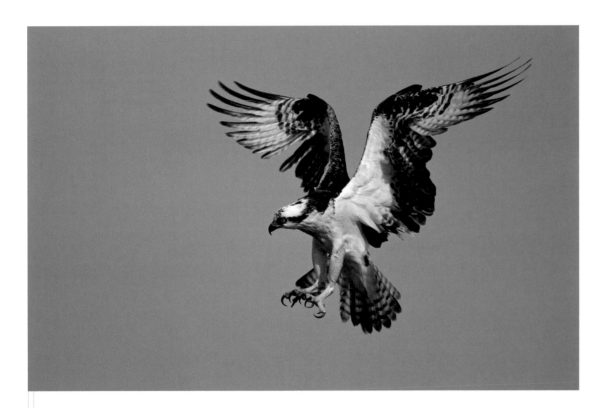

OSPREY

During my first visit to Florida, I rented a condo on Sanibel Island. There happened to be an osprey's nest just across the road in the top of a pine tree. Frustratingly, the nest was too high to achieve a decent shooting angle from the ground. However, I decided to return to the same estate the following year and booked a second floor condo directly opposite the nest. Thankfully, the nest was in use again and I managed to take many nice images of the birds coming and going from the nest. The female bird was incubating most of the time. Her harsh cries gave plenty of warning that the male was about to bring in a freshly caught fish. This particular frame was taken from the balcony while operating the camera with one hand and sipping a glass of wine with the other. Now that's what I call wildlife photography! Sanibel Island, Florida, USA.

Canon EOS-1D MkII; EF500mm lens; 1/2000 sec at f/5.6; ISO 250; AI Servo focus; central focusing point; IS off; tripod with fluid video head.

Composition

35 Control the background

A key element of successful image composition is control over the background and the way it affects and influences the subject. Very often images are ruined by messy or highly detailed backgrounds, which don't allow the subject to be seen clearly or which compete for attention. One simple solution is to switch to a longer focal length lens. Long telephoto lenses have a very narrow angle of view. This can be a great help if you wish to achieve clean, diffused backgrounds. For example, when using a 100mm macro lens to photograph a woodland butterfly on a grass stem, you may find sections of green grass, dark tree and bright sky all appearing in the background. However, if you used a 400mm lens positioned to record the butterfly at the same size in the frame, you will easily be able to fill the background with the dark tree alone. Small adjustments in position would also allow you to change the tone of the background.

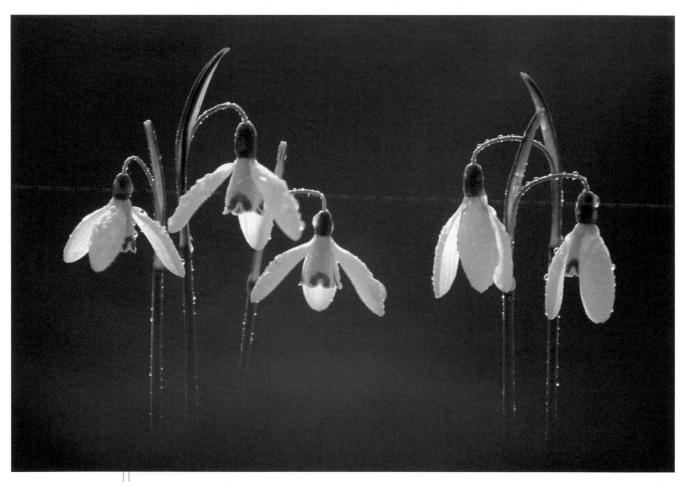

SNOWDROPS

This image was taken using a 400mm telephoto lens with the aperture wide open at f/5.6. By supporting the lens on a beanbag at ground level, I was able to throw all the surrounding vegetation well out of focus, providing a soft, uncluttered frame for the flowers. When using this technique, it is vital to keep the back of the camera parallel to the subject otherwise the very shallow depth of field available will result in some of the flowers recording out of focus. In this case, I had to make sure that the majority of the snowdrops were in line so I used small sticks to temporarily fine-tune the position of each stem. The overcast light was ideal, as the reduced contrast allowed me to retain plenty of detail in the white petals without the background recording too dark. I used two small mirrors to reflect light both behind and in front of the blooms. Marshwood Vale, Dorset, England.

Canon EOS-1Ds; Sigma 400mm f/5.6 APO Macro lens; 1/125 sec at f/5.6; ISO 100; manual focus; mirror reflectors; mirror lock-up; cable release; beanbag.

Avoid merges and convergences

Allowing important elements in a photograph to merge together can be very distracting and will usually compromise image composition. Try to provide plenty of space around your subject and any other dominant elements within the frame. This may mean shifting your shooting position slightly but with active birds and animals you can simply wait for the subject to move. The same applies to inanimate subjects. When photographing wildflowers, it is equally important to provide a little space between flower heads so that the shape of the bloom can be clearly seen. Similarly, a pair of trees silhouetted against a colourful sunset will make a stronger image if a little space is left between them. There are exceptions to this rule though and on occasions you may wish to allow important elements to touch, such as when photographing certain types of animal behaviour like courtship rituals or mating.

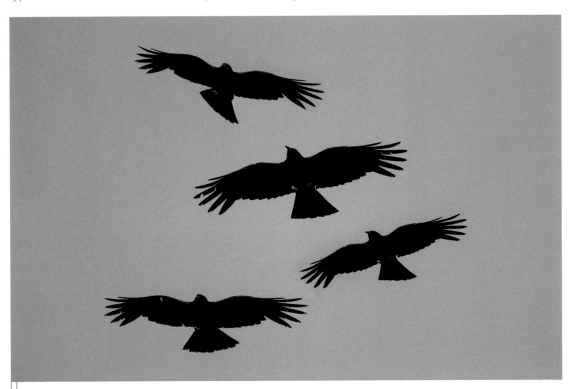

CHOUGHS

These charismatic members of the crow family are normally seen travelling up and down the coast in small groups, searching for fresh molehills or dung in which they dig around for grubs and worms. They are inquisitive birds and will often come and check you out when you first appear in their territory. This group made several passes directly overhead. By making use of my camera's motor drive, I was able to take a sequence of 20 images as they passed by. This increased my chances of capturing the birds in a pleasing formation with plenty of space between each individual. If one bird was partially obscured by another, their dark plumage would result in the loss of the outline of both birds and the resulting shape would be very distracting. Also note that none of the birds are too close to the edges of the frame. South Stack, Anglesey, Wales.

Canon EOS-1D MkII; EF500mm lens; 1/1000 sec at f/8; ISO 250; AI Servo focus; 45 active focusing points; handheld.

37 Look for graphic compositions

Always keep an eye out for graphic and abstract compositions where line and form play a key role. Look for a small number of elements that work well together and complement each other, such as natural patterns and textures or light and shadow. Contrasting colours can add impact to your image whereas complementary colours offer a more subtle effect. Silhouettes of birds, animals and plants can all make very effective graphic images, particularly at sunrise and sunset. Sometimes, you may need to compose the subject quite tightly in the frame so a macro or telephoto lens may be necessary. However, providing the subject itself is easily recognizable, it can also be recorded quite small in the frame using elements of its habitat to complete the composition. This type of image can be appreciated solely for its aesthetic and graphic qualities but it is still possible to capture the character of your subject along with some aspects of natural behaviour.

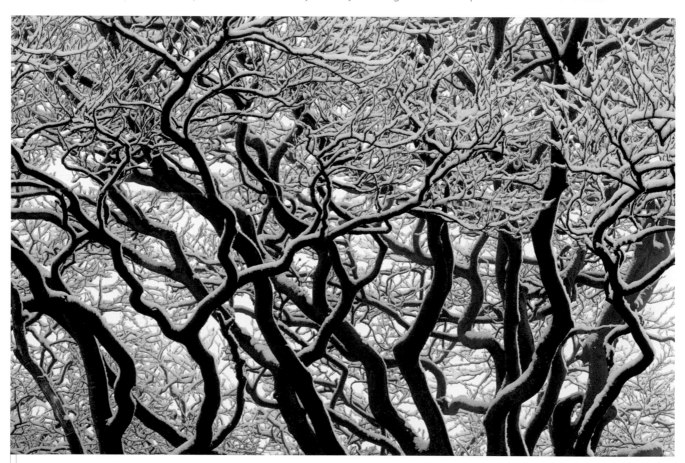

BEECH BOUGHS IN SNOW

This image shows a section of a tree. It was taken with a zoom lens set to 180mm looking straight up into the twisting boughs against an overcast sky after a light snowfall. The elements combined to create an abstract and slightly Oriental effect. Had the weather or lighting conditions been any different, this shot would not have been successful. It was essential to fill the frame with the branches and to maintain the overall pattern by avoiding any larger areas of bright sky or dense sections of dark branch. The zoom lens was perfect for fine-tuning the composition, as I was unable to move myself closer or further away. This is technically a colour image but the lack of any strong colours helps to strengthen the graphic effect. Beaminster, Dorset, England.

Canon EOS-1Ds; EF70–200mm lens; 1/60 sec at f/11; ISO 100; manual focus; mirror lock-up; cable release; tripod with ball head.

Look for natural patterns

Patterns can be found everywhere in nature, from an intricately detailed area of plumage on a bird's wing to a patch of star moss on a decaying tree trunk. The trick is learning to see potential in often easily overlooked subjects. Composing patterns is relatively simply – your goal should be to fill the frame with the most effective area of detail. Try to eliminate any elements that don't form part of the pattern and make sure the pattern extends to all four corners of the frame. Many cameras do not show 100 per cent of the image in the viewfinder so take a test shot and examine it on the rear LCD screen. A whole variety of lenses can be employed when shooting patterns. A macro lens can be particularly useful, especially when dealing with very small details. Zoom lenses offer precise control over image composition but they don't tend to focus close enough by themselves and may require the use of an extension tube (see page 102).

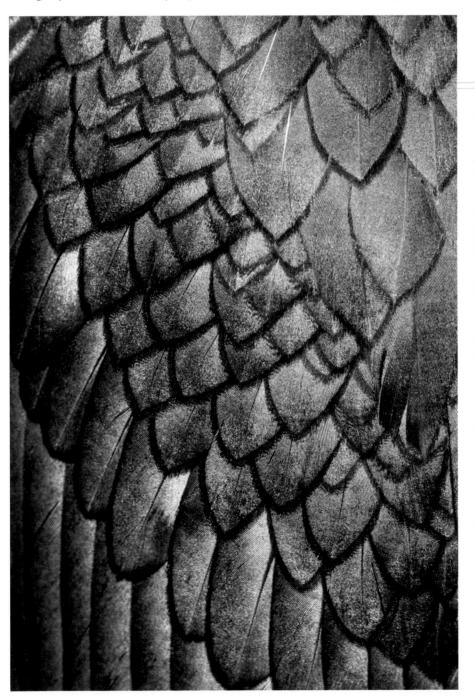

SHAG PLUMAGE

I had been photographing this shag for some time as it rested on a rock drying its wings and preening itself. The sun was getting quite high in the sky and the rather harsh light was helping to reveal the glossy green sheen on the bird's plumage. I attached a 2X extender to my 500mm lens and moved a little closer. Eventually, I was able to completely fill the frame with the most interesting pattern of feathers on the shag's wing. I extended the tripod legs so that I was roughly parallel to the wing and I stopped the lens down to provide a little extra depth of field. I focused the lens manually to make sure I had placed the point of focus in the optimum position. There were no bright highlights so I exposed the image as far to the right of the histogram as possible and compensated for this when converting the RAW file. This helped to keep digital noise to a minimum. Craigleath, Firth of Forth, Fife, Scotland.
Canon EOS-1D MkII; EF500mm lens; EF2XII extender; 1/250 sec at f/16; ISO 250; manual focus; IS mode 1; tripod with fluid video head.

39 Use symmetry in your composition

Symmetrical compositions can be very effective but should be used with care. The subject matter itself will often dictate whether a symmetrical approach is appropriate. There is a surprising amount of symmetry to be found in the natural world from the radial symmetry of some wildflower blooms to the lateral symmetry displayed on a butterfly's wings. Repetitive patterns such as leaf veins, feathers and ice formations can work particularly well in close-up photography. Images where the subject is reflected can be very powerful and have a strong eye-catching effect. Photographing animals and birds drinking or bathing at a pool can provide the perfect opportunity to capture great reflections. Arranging a symmetrical composition is relatively easy. The line of symmetry should be placed centrally, either vertically or horizontally, for the balance of the composition to appear correct.

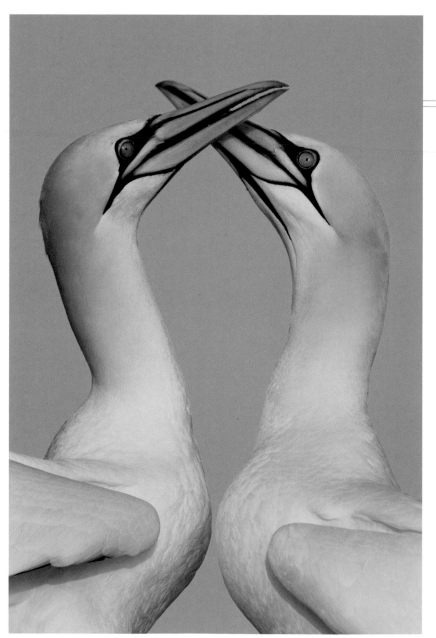

GANNET PAIR

Northern gannets mate for life and always come back to the same nest site. When the birds return to the nest site the pair performs an elaborate bonding ritual. Part of the display involves both birds pointing their beaks to the sky and tapping them together, rather like swordsmen. This is very characteristic gannet behaviour and was something I was keen to photograph. Being very close to the colony, I didn't want to move quickly to photograph whichever pair happened to be performing, as this would have spooked the birds closest to me. Therefore, I set up on one particular pair and waited for them to perform. This allowed me to take some test shots to determine exposure. I could then be confident that I would achieve the results I wanted when the birds began their display. Bass Rock, Firth of Forth, Fife, Scotland.
Canon EOS-1D MkII; EF500mm lens; EF1.4X extender; 1/1000 sec at f/7.1; ISO 250; one-shot AF; single manually selected focusing point; tripod with fluid video head.

Use extenders

Extenders generally come in multiplication factors of 1.4X and 2X (Nikon also offers a 1.7X). They increase the versatility of some lenses by adding extra magnification. This is achieved without affecting the close-focusing distance of the lens. However, less light will be transmitted through the lens resulting in a 1- or 2-stop decrease in speed. When paired with a fast telephoto lens, you essentially have three different focal lengths at your disposal with a very minimal increase in weight, bulk and cost. It is essential to buy the best extender you can afford. In reality, this means the same make as the lens you are using. The best 1.4X extenders don't have a noticeable effect on image quality when used with good prime lenses and can be used with the lens aperture wide open. 2X extenders don't fare quite as well and I would recommend stopping the lens down by at least 1 stop in order to maintain sharpness.

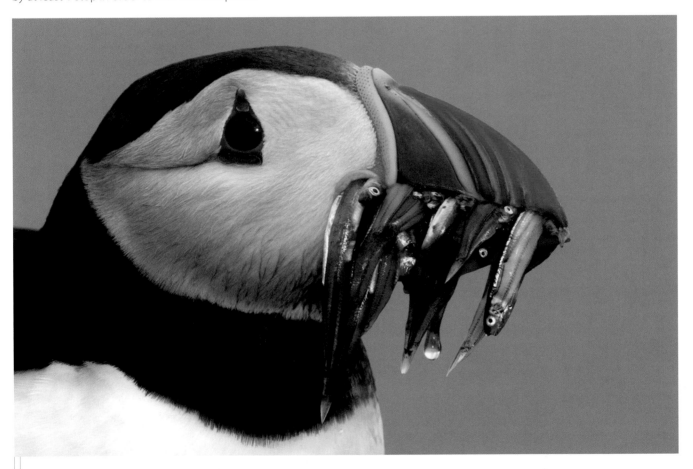

FEEDING PUFFIN

This was an experimental shot taken on a rather unproductive overcast day. The puffin landed some distance
away with a beak full of sand eels. I thought I would see how my 500mm lens would cope with two 2X extenders.
This provided an effective focal length of 2600mm and magnification of 52X. I stopped the lens down to f/22 to try
and extract a little extra sharpness and I used ISO 400 to gain an exposure time of 1/60 sec. I was using a heavy tripod
and my fluid video head was locked in position. A burst of fill-in flash and the image stabilizer in the lens also helped
to retain sharpness. Nevertheless, I was astounded by the result. The image was as sharp as any other I had taken that
day. Even when printed in large-format the detail is incredible. Isle of May, Firth of Forth, Fife, Scotland.
Canon EOS-1D MkII; EF500mm lens; two EF2XII extenders; 1/60 sec at f/22; ISO 400; manual focus;
IS mode 1; Speedlite 550EX at -2 stops; Better Beamer flash extender; tripod with fluid video head.

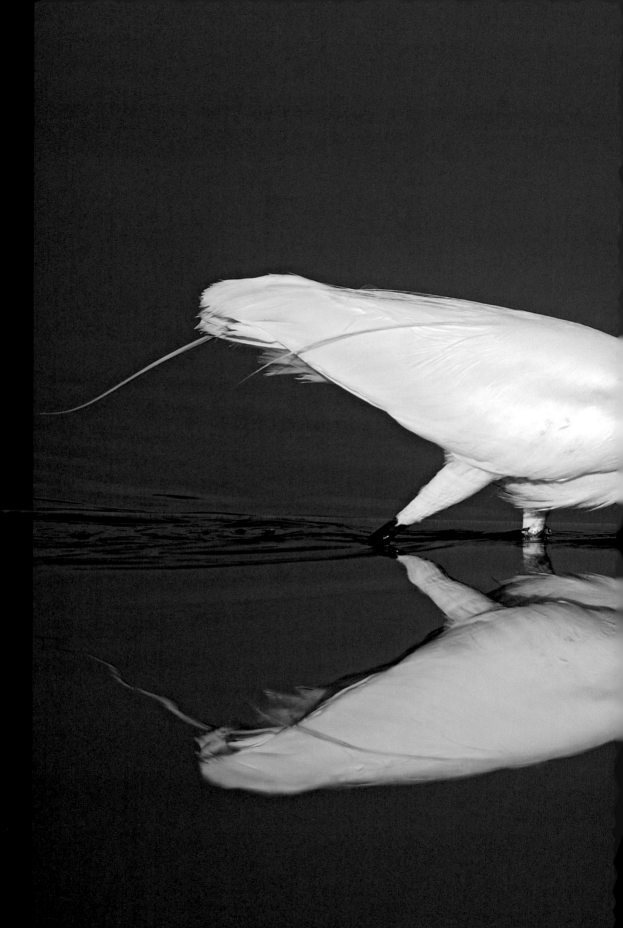

Lighting

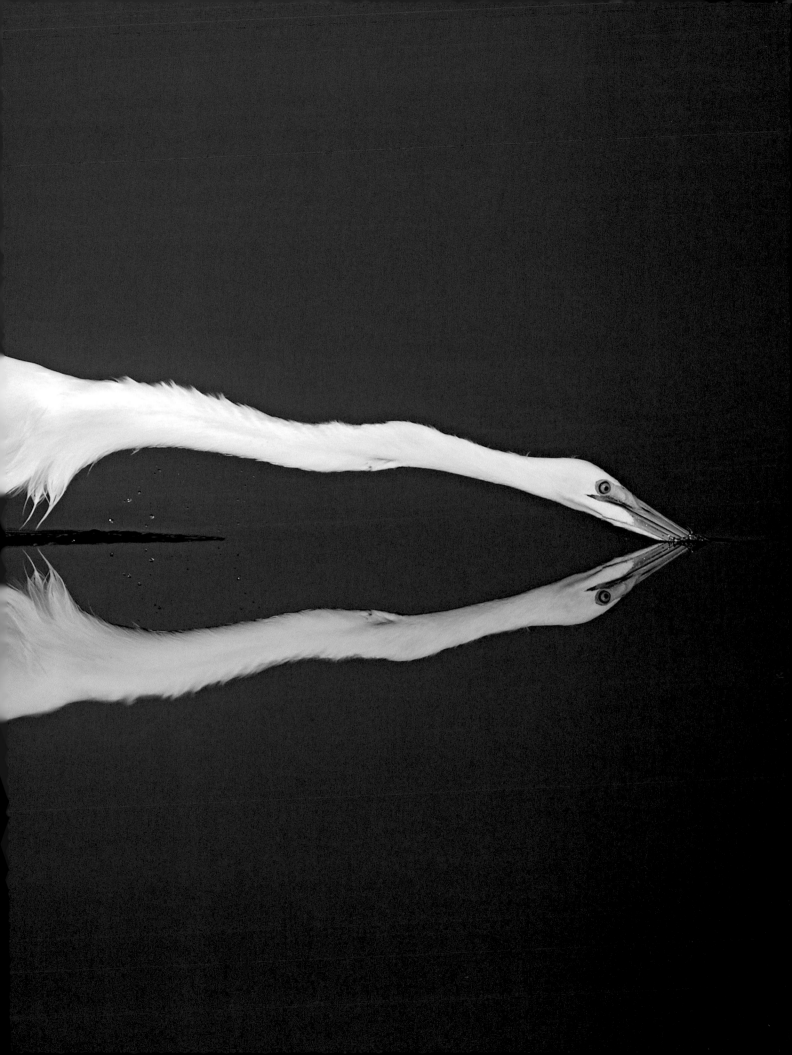

41 Use front lighting

Front lighting provides even illumination of the subject and will help you to record fine detail and colour accurately. To gain maximum benefit from front lighting, make sure your shadow points directly towards your subject, even if this requires you to adjust your shooting position regularly. Providing light levels stay constant, it is possible to set your exposure manually and be confident that your exposures will remain good. A significant benefit of front lighting is that animals and birds will always have a catchlight in their eyes when they are looking in the direction of the camera. A potential disadvantage is the lack of modelling light, which results in a more two-dimensional image. However, the even lighting minimizes variations in tone, particularly in the background of your shot, helping to simplify the overall composition.

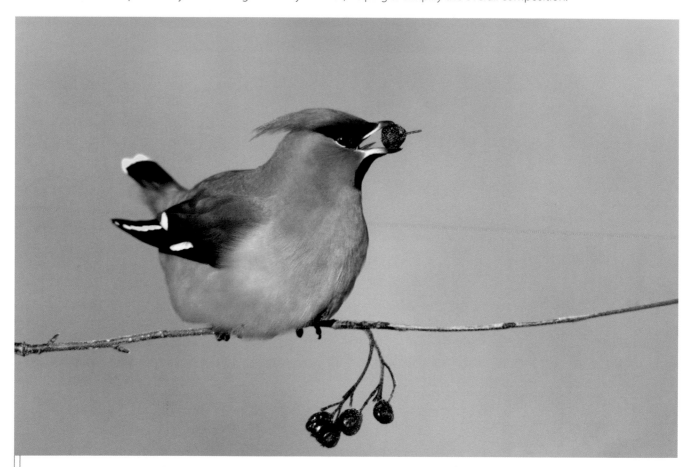

WAXWING

I came across a small flock of waxwings feeding on berries by the side of a road in central Finland. The temperature was -20ºC and some of the birds were covered in frost. Most of the time the flock was feeding low down in a bush where it was impossible to compose an image with a clean background. I waited patiently for one to move into a position where I could photograph it against the clear blue sky. Fortunately, I was able to shoot with the sun directly behind me. This provided perfectly even illumination, helping to reveal the texture and subtle colours of the bird's plumage. I had pre-selected a focusing point that covered the bird's eye when it was in the correct position in the frame. AI Servo mode kept the eye in sharp focus while the bird moved around on the thin branch. Oulu, Northern Ostrobothnia, Finland.

Canon EOS-1D MkII; EF500mm lens; EF1.4X extender; 1/1000 sec at f/6.3; ISO 250; AI Servo focus; single manually selected focusing point; IS mode 2; tripod with fluid video head.

Use side lighting

Side lighting emphasizes texture and form and, when used carefully, can produce dramatic and atmospheric images with a three-dimensional effect. However, it only tends to provide good results when the sun is low in the sky. At other times of the day the contrast can be too high, making accurate exposure problematic due to extremes of highlight and shadow. Side lighting does not work well if the subject is set against a highly detailed or cluttered background. Try to select a background with very little tonal contrast, such as an area of dense shadow or smooth sand. Always expose for the sunlit side of your subject, even if this is at the expense of shadow detail – the human eye tends to accept blocked shadows more easily than blown highlights. It is sometimes possible to reduce the contrast of sidelit subjects with the use of fill-in flash or reflectors.

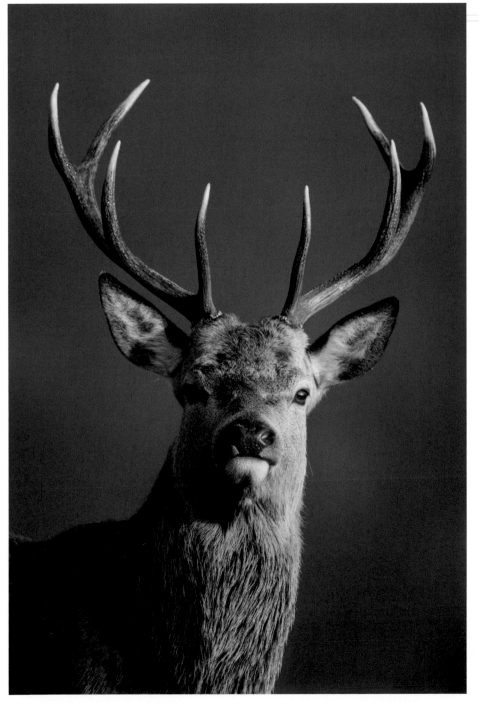

RED DEER

Side lighting can be particularly effective when shooting close-up portraits of wild animals and birds. The contours of the face are revealed and the texture of fur and feathers is emphasized. The red deer in this London park are very tolerant of people and often approach closely, leading to some excellent opportunities for portrait photography. I was able to make use of a distant background of shaded trees for this shot. Had these trees been sidelit the detail in their branches would have merged with the deer's antlers leading to a rather confusing image. The wide aperture of the telephoto zoom lens rendered the trees completely blurred, and shade under a clear blue sky has given them a blue tone. The flexibility of this lens allowed me to compose a tight portrait while making sure the deer's antlers were kept away from the edges of the frame. Bushy Park, London, England.
Canon EOS-1D MkII; EF100–400mm lens; 1/1000 sec at f/5.6; ISO 400; one-shot AF; single manually selected focusing point; tripod with fluid video head.

43 Use backlighting

Back lighting provides the most atmospheric illumination and the greatest sense of depth. It can give your images an air of mystery and, when used well, a great deal of impact. Keep your composition simple and allow the basic outline shape of your subject to form the main feature. Back lighting works best when the sun is low in the sky and positioned directly behind your subject, so great care needs to be taken to prevent or reduce the effects of flare. You must keep your lens spotlessly clean and free from dust and smears. Lens hoods are practically useless when the sun is shining directly into the lens but in some situations you may be able to use your hand or a piece of card to block the sun's rays from directly striking the front element. At times, it is simply a case of accepting that some of your images will exhibit the effects of flare to some degree – all you can do is minimize their impact as much as possible.

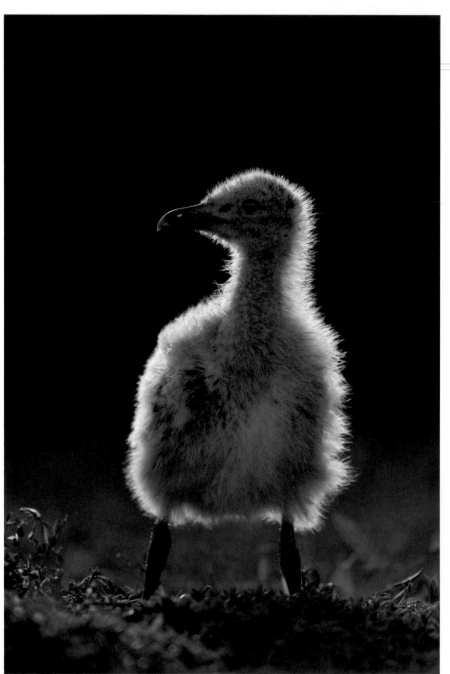

LESSER BLACK-BACKED GULL CHICK
Animals with fur or down are perfect subjects to photograph backlit, as a particularly strong outline is normally revealed. This gull chick is a good example as its shape is easily recognizable. The image was taken shortly after sunrise when the sun was high enough to allow my lens hood to cast a shadow across the front element of the lens, avoiding any issues with flare. I made sure the sun remained directly behind the chick so that it would be evenly rim-lit. The correct exposure for backlit subjects can be subjective so it is worth experimenting with lighter and darker exposures to see how they affect the overall mood of the image. For this shot, I took a spot meter reading from the chick's breast and set the exposure 1½ stops lower than the camera's recommended reading. This allowed plenty of detail to be retained in the chick's face and breast without overexposing the rim-lit down. Isle of May, Firth of Forth, Fife, Scotland.
Canon EOS-1D MkII; EF500mm lens; 1/250 sec at f/5.6; ISO 400; AI Servo focus; single manually selected focusing point; IS mode 2; tripod with fluid video head.

Shoot in overcast light

On bright sunny days, harsh lighting can result in blown highlights and dense shadows. This excess contrast can conceal the subtle textures and details of your subject. There can also be an undesirable blue colour cast in areas not directly illuminated by the sun. Overcast conditions overcome these problems, as the light is soft and well-diffused providing even illumination, which is ideal for photographing a whole range of wildlife subjects. Overcast light may lack the atmosphere and drama of side lighting and back lighting but it makes up for this by helping to record rich, accurate colours and exceptional textural detail. It is particularly suitable for photographing close-ups and wildflowers but be aware that the blooms of some species of wildflower will not open fully without direct sunlight. Overcast light is also well suited to photographing subjects with strongly contrasting tones, such as some species of seabirds with glossy black-and-white plumage.

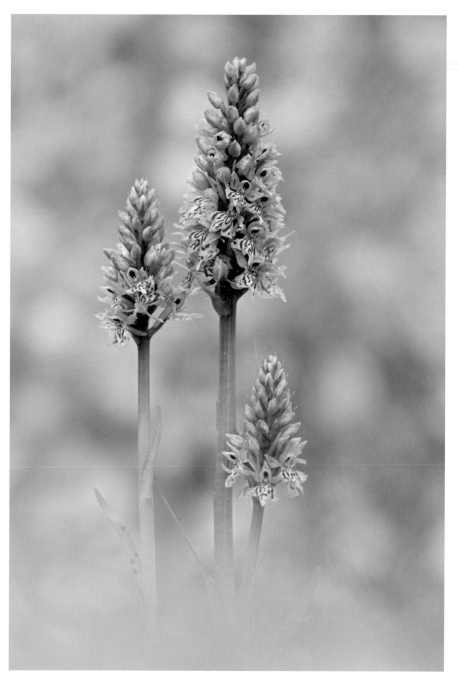

COMMON SPOTTED ORCHIDS

This image was taken in heavily overcast light and persistent drizzle – not particularly comfortable conditions to work in but ideal for capturing accurate colour in wildflowers. These orchids were growing in a particularly dense patch of buttercups on the edge of a hay meadow. I set up so that the camera back was roughly parallel to the line of three orchids, ensuring they would record sharply with the very limited depth of field afforded by a 600mm lens. I used my camera's Live View function to fine-tune the focusing by zooming in 10X on the rear LCD screen. I could easily have used a 100mm macro lens for this shot but the much wider angle of view and increased depth of field associated with the shorter focal length would have increased the definition of the surrounding buttercups. As a result, the orchids themselves would have been less prominent in the composition. Hardington Moor, Somerset, England.

Canon EOS-40D; EF300mm lens; EF2XII extender; 1/30 sec at f/11; ISO 100; manual focus; IS off; mirror lock-up; 2 sec self-timer; tripod with ball head.

45 Use artificial light

It is enjoyable to experiment with artificial light sources and mix them with ambient light exposures, always under the proviso that the effect must not be noticeable to the viewer. Artificial light can provide very natural-looking results when used with care and can allow you to make images that would otherwise be impossible. I use a variety of different rechargeable torches as light sources, from a tiny Maglite to an 18 million candle-power spot lamp. By 'painting' with artificial light you are able to carry on shooting when light levels are very low, while maintaining contrast and colour in the subject. The warm tungsten light can sometimes enhance the image but if the colour appears too strong it is possible to correct it using a blue filter over the torch. This technique is restricted to use with static subjects such as close-ups of fungi, woodland interiors and geological formations. A torch can also be used very successfully to provide subtle backlighting when photographing wildflowers and insects.

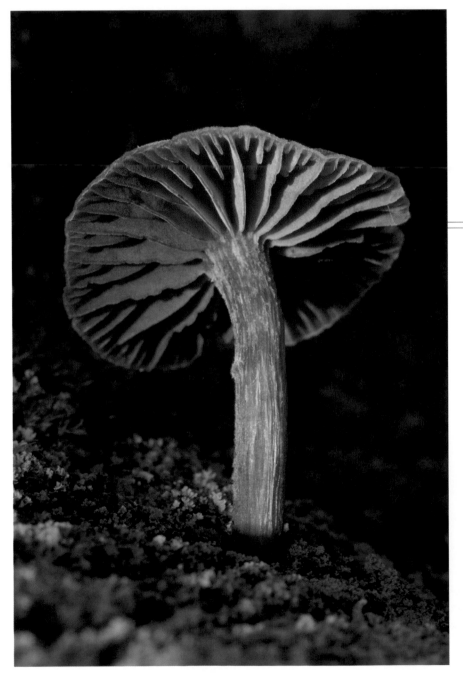

AMETHYST DECEIVER

I found this colourful fungus just inside the hollow stump of a fallen oak tree. It was late in the day and the light levels were very poor with the sky creating an undesirable blue colour cast. The solution was to use artificial light to 'paint' the fungus with side lighting. I used a small torch to illuminate the fungus from the left-hand side. I also used a small gold reflector to bounce light from the torch back on to the right side of the subject, which helped to reveal detail and remove the blue colour cast. The shadows created by the torchlight also emphasized the gills on the underside of the fungus. The low light levels meant that my exposure time was eight seconds. This provided plenty of time to move the torch slowly up and down during the exposure to provide even illumination with no obvious hot spots. New Forest National Park, Hampshire, England.
Canon EOS-1Ds; Tamron 90mm macro lens; 8 sec at f/16; ISO 100; manual focus; gold reflector; mirror lock-up; cable release; torch; tripod with ball head.

Shoot silhouettes

Silhouettes work best around sunrise and sunset when the fiery red and orange tones present in the sky create a colourful and dramatic background. The same effect can often be achieved when these colours are reflected in still water. When searching for silhouetted subjects, locations need to be chosen carefully and shoots planned in advance. Bear in mind that your subject must be positioned or pass directly in front of the rising or setting sun. Good locations include roosting sites for birds and regular watering holes for mammals. It is worth returning to good locations, as the colours will often vary from day to day. Suitable conditions can last for up to two hours at either end of the day. Make sure you are at an appropriate location at least an hour before sunrise and stay until at least an hour after sunset. Correct exposure for a silhouette relies on maintaining the subject as a solid black shape – this is easily achieved by metering for the brightest area of sky and then increasing the suggested exposure by 1 to 1½ stops.

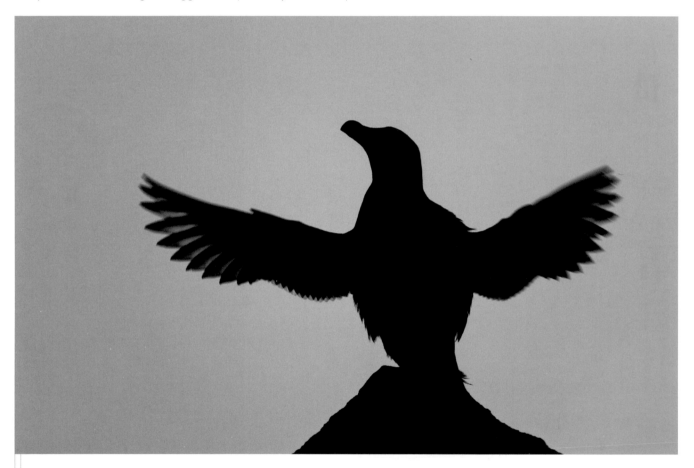

RAZORBILL

It can be difficult to find locations to photograph seabirds at sunrise or sunset so I always try to make the most of any opportunities that present themselves. When I took this image, I had been working among a colony of razorbills nesting under boulder scree. As the sun began to dip below the horizon, many of the adult birds appeared from beneath their rocks to soak up the last rays of warm sunlight. I framed this bird with plenty of space around it and waited for it to flap its wings. Metering for a shot like this is easy – I simply took a spot reading from the brightest area of sky next to the bird and increased the suggested exposure by 1½ stops. This kept the sky as a very light tone while recording the bird as an almost solid silhouette. I took a number of images using the camera's motor drive and selected the one with the most dynamic wing position, making sure that the bird's beak was pointing into the frame. Saltee Islands, Co. Wexford, Republic of Ireland.
Canon EOS-1D MkII; EF500mm lens; EF1.4X extender; 1/500 sec at f/6.3; ISO 250; one-shot AF; central focusing point;
IS mode 2; tripod with fluid video head.

47 Use fill-in flash

Daylight-balanced fill-in flash can be a useful tool in nature photography. When used correctly, its effects are subtle, providing a natural result where its use is undetectable. It can be used to balance the overall brightness of an image, such as where the subject is in shade against a sunlit background. It can also be used to reduce contrast in sidelit situations by filling in shadows. On overcast days, weak fill-in flash can bring a subject to life by creating a catchlight in the eye. By using through-the-lens (TTL) metering, modern flash units are capable of delivering consistently good exposures. Simply set the correct exposure on your camera for the ambient light as you normally would, then set the flash to provide roughly 1 to 2 stops less exposure using the flash compensation settings. The exact amount to deduct depends on the tone of your subject. For example a black subject, due to its low reflectance, would require 2 stops less exposure whereas a white subject, due to its high reflectance, would require only 1 stop less exposure.

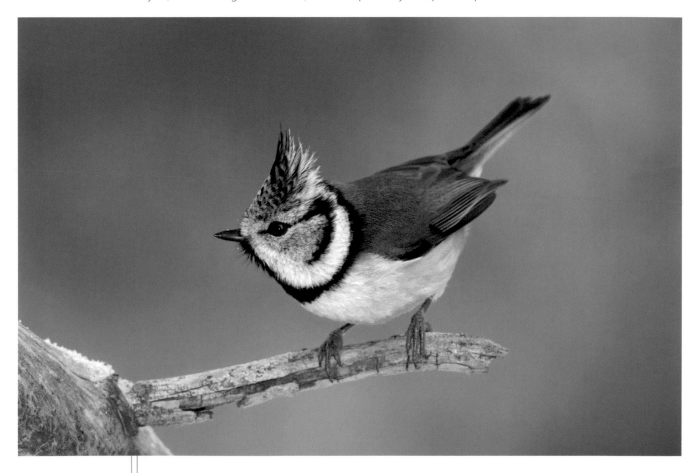

CRESTED TIT

This tit was photographed at a woodland feeding station in mid-winter at a temperature of -10ºC. The birds making use of the feeders were very tolerant of my presence so there was no need to use a hide. There were only a few decent natural perches and the birds landed on these for just a second or two before jumping on to a nearby feeder. The light levels were poor, especially for photographing such fast-moving subjects. I used a burst of fill-in flash to help arrest subject movement and also to record a catchlight in the bird's eye. I took a spot meter reading from the bare wood and increased this by ½ stop to set the correct exposure for the ambient light. I then set the flash to -1⅔ stop, which provided just enough extra illumination to record a decent catchlight but not enough for the use of flash to be too obvious. Helsinki, Finland.
Canon EOS-1D MkII; EF500mm lens; EF1.4X extender; 1/250 sec at f/5.6; ISO 400; AI Servo focus; central focusing point; Speedlite 550EX at -1⅔ stop; Better Beamer flash extender; tripod with fluid video head.

Use flash as the main light source

I have always disliked the use of flash as the main source of illumination in nature photographs. In many cases its use is too obvious and unnatural with harsh shadows and horribly dark backgrounds. There are, of course, occasions when flash is the only option, such as when photographing nocturnal animals, cave-dwelling species and active subjects in very poor light. The appearance of electronic flash light can often be improved by using multiple flash heads set up at different angles to the subject to control contrast and reveal texture. Some flash heads can also be positioned to illuminate the background. This very time-consuming technique must be a considered a long-term project as a significant amount of fine-tuning will be required especially when photographing active nocturnal animals.

CAVE MILLIPEDE

I photographed this two-and-a-half-centimetre (one-inch) long millipede deep underground in a cave system in Slovenia. The cave was partially flooded so most of the journey underground was taken in a small inflatable boat. At times I could get out and explore the cave and my guide had no trouble finding a variety of cave-dwelling wildlife (known as troglobites) for me to photograph. The use of flash was essential here. Initially, I used a head torch to illuminate the millipede in order to achieve focus. I was only able to take one flashgun with me into the cave so I had to improvise my lighting technique in order to achieve a well-lit image. I positioned the flash behind and to the right of the subject and reflected the flash light into the shadow side using a silver reflector. The correct exposure was judged by taking test shots and examining the histogram. Krizna Jama Cave, Loska Dolina, Slovenia.

Canon EOS-5D; EF100mm macro lens; 1/125 sec at f/16; ISO 400; manual focus; Speedlite 550EX at -$\frac{2}{3}$ stop; off-camera flash cord; silver reflector; tripod with ball head.

49 Shoot in low light

Advances in digital cameras mean that you are no longer restricted to shooting in ideal lighting conditions. Many modern digital SLRs are capable of delivering excellent results up to ISO 1000 – something that was unheard of in the days of transparency film. This has opened up new opportunities, allowing you to shoot successful images, even of active animals and birds, in the beautiful soft light that occurs just before sunrise and just after sunset. At these times of the day any breeze tends to die down allowing reflections to form on the surface of still water, creating a perfect opportunity to photograph water birds and a variety of other wildlife set among the subtle pastel colours of twilight. Even with high ISO settings you will still be using relatively long exposure times so great care needs to be taken to minimize camera shake. A sturdy tripod and head is essential and an image-stabilized lens will increase your chances of recording a pin-sharp image.

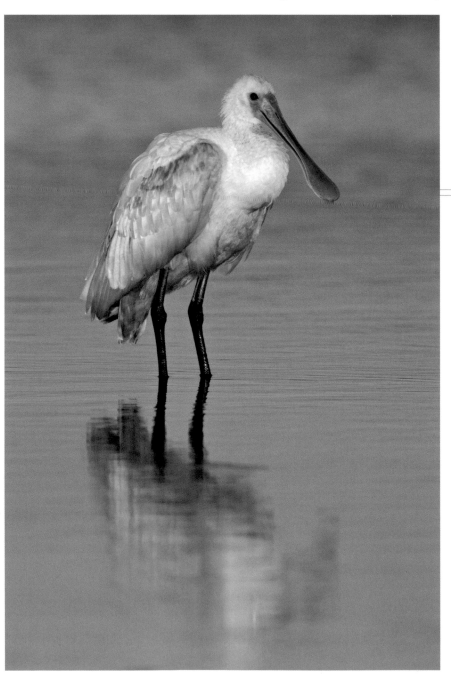

ROSEATE SPOONBILL

At Estero Lagoon in Florida, spoonbills regularly roost overnight but they often leave before dawn. I was determined to photograph them so I got down by the water's edge an hour before sunrise. The light was very poor but there was a strengthening pink glow on the horizon and a good reflection of the birds in the still water of the lagoon. I didn't want to spook the birds by approaching too closely straight away so I fitted a 2X extender to my 500mm lens. Even though my lens has image stabilization, I was forced to use ISO 800 just to obtain a fast enough shutter speed to eliminate camera shake. The high ISO setting allowed me to expose for the ambient light, using fill-in flash to enhance the colour of the spoonbill's plumage. I had my flash set to full power in manual mode and the output was magnified by a flash extender. In low light the fresnel lens of a flash extender can extend flash output dramatically. Estero Lagoon, Fort Myers Beach, Florida, USA.

Canon EOS-1D MkII; EF500mm lens; EF2XII extender; 1/60 sec at f/10; ISO 800; one-shot AF; single manually selected focusing point; Speedlite 550EX; Better Beamer flash extender; tripod with fluid video head.

Include the sun

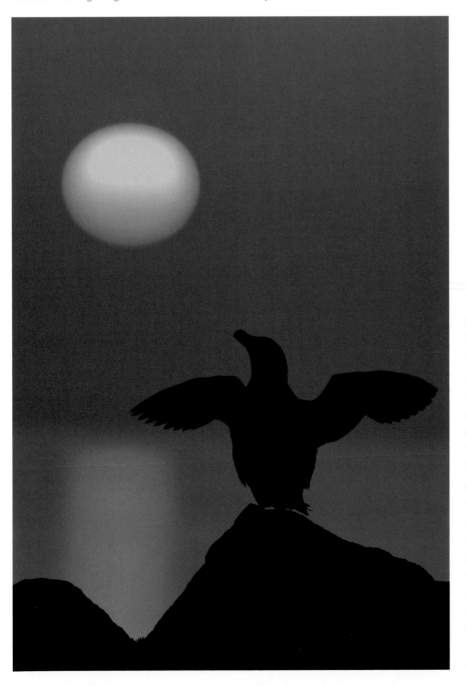

Shooting into the light always adds drama and atmosphere to a photograph. However, actually including the sun in the frame can enhance the mood even further. Extreme care needs to be taken to avoid flare as much as possible, so make sure you keep your lenses perfectly clean. It is only safe to use this technique when the sun is very low in the sky and when its brightness is well filtered by the thicker atmosphere close to the horizon. Hazy conditions help to reduce glare and will normally provide the best results. However, this technique rarely works well when the sun is partially obscured by thin cloud. Never look directly at the sun through your viewfinder if these conditions don't exist as you could easily damage your eyes. A camera with Live View function will allow you to utilize this technique without looking through the viewfinder at all, but be aware that strong direct sunlight can also damage the camera's sensor. Switch to manual focus, as extreme backlighting can confuse the autofocus systems of some cameras.

RAZORBILL AT SUNSET

Shooting directly at the sun means that exposure can be very difficult to determine. For this image, I took a test shot and referred to the histogram to establish the correct exposure, which was then set manually. In most cases your subject is likely to record as a silhouette so don't be concerned if the histogram peaks on the left-hand side. In order to maintain sufficient brightness in the image as a whole, I sacrificed a little detail in the centre of the sun. This was easily rectified in Photoshop using the Healing tool. The sun is always going to be the most prominent element in your composition so remember the rule of thirds (see page 53) and try to position it away from the centre of the image. In this shot I tried to balance the two main elements by positioning them diagonally opposite. Runde Island, Møre og Romsdal, Norway.

Canon EOS-1D MkII; EF500mm; EF1.4X extender; 1/1000 at f/11; ISO 200; manual focus, IS mode 1; tripod with fluid video head.

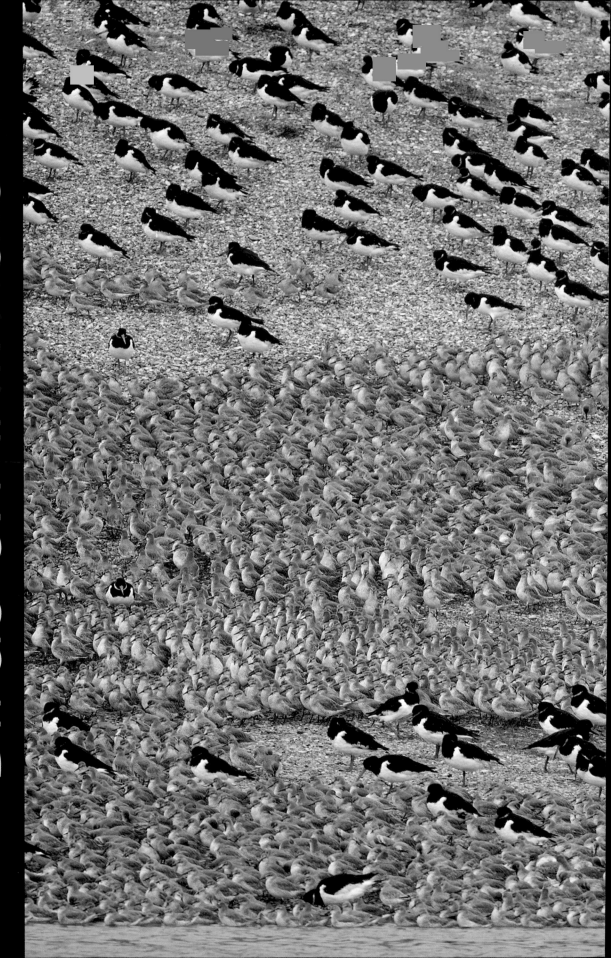

Photographing
Birds & Animals

51 Perfect your portraits

Many people consider portraits of wild animals and birds as being relatively easy to achieve but in many cases they are not. If your portrait shots are to be admired, they need to be perfectly executed and also capture the character and dynamism of the subject. Portraits tend to work best when composed vertically but your subject will dictate whether a horizontal composition is preferable. Telephoto lenses provide the necessary magnification to allow you to work well away from your subject, helping it to remain relaxed and express natural behaviour. The subject's eyes will normally form the focal point of the image so make sure they are critically sharp. Shoot as close to the subject's eye level as you can and try to capture eye contact, with a catchlight if possible. Select your subject carefully – look for birds in pristine breeding plumage and mammals in prime condition, such as a deer with an impressive set of antlers.

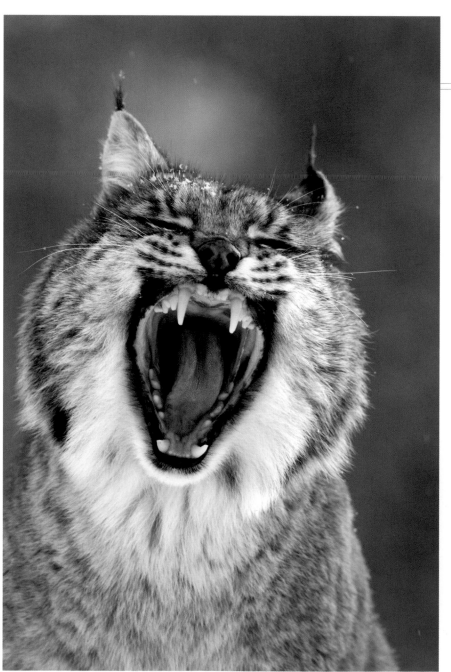

EURASIAN LYNX

I photographed this lynx in the depths of winter at a Finnish wildlife park. Although the animal was in a very large enclosure, I still wanted to make sure I showed no obvious evidence of its captivity in my shots. When the lynx moved close to one of the fences, I decided to concentrate on portrait images and switched to a long telephoto lens to throw the background well out of focus. I set up at a distance that allowed me to obtain a frame-filling image without the subject looking too constrained. I watched the cat through the viewfinder for half an hour and when she began to yawn I was ready. The camera's motor drive enabled me to shoot a sequence of images, of which this was my favourite. The wide open mouth accompanied by sharp teeth and slight snarl captures some of this predatory cat's character. Ranua Wildlife Park, Finland.

Canon EOS-1D MkII; EF500mm lens; 1/500 sec at f/8; ISO 400; one-shot AF; single manually selected focusing point; IS mode 1; tripod with fluid video head.

Photograph birds in flight

One of the most challenging techniques to master in wildlife photography is photographing birds in flight. Don't expect success straight away, as it takes a considerable amount of time to acquire this skill and to make consistently sharp images. This is one area of wildlife photography where your choice of equipment is very important. Your success rate will increase when using lenses with a fast maximum aperture and camera bodies with the most advanced and accurate autofocus systems. Use AI Servo focusing, which continually tracks the subject and keeps it in sharp focus. Practise using the central focusing point for single birds in flight, as this is generally the most accurate and responsive (multiple focusing points are more useful when photographing several birds against less detailed or distant backgrounds). Pan smoothly, following the bird and keeping the focusing point centred over its head. I tend to use my motor drive set to low speed as this helps the autofocus system retain focus on the subject. Autofocus systems are not foolproof by any means so don't expect all images in a sequence to be razor sharp. With small, fast-flying birds, a shutter speed of at least 1/2000 sec will be required. With larger birds such as herons and pelicans it is possible to freeze the action with a shutter speed of 1/500 sec.

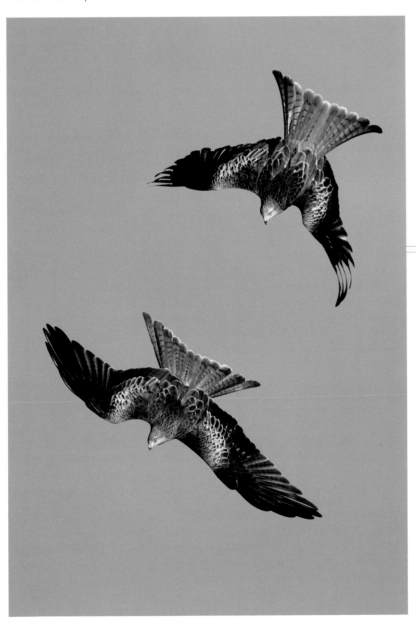

RED KITES

This image was taken at the Gigrin Farm Red Kite Feeding Station in mid-Wales, which was established in 1992 to aid what was then one of the UK's rarest birds. Feeding continues daily and during the winter months up to 400 red kites gather, providing a superb opportunity to photograph these beautiful raptors in flight. On this occasion, I noticed how one bird was particularly keen to steal food from others and was often in hot pursuit of those carrying chunks of meat. It is always good to record interaction in wildlife photographs and this presented a good opportunity. I set my camera to expand the focusing points around the central sensor, which increased the chance of acquiring sharp focus on the birds. My tripod's fluid video head enabled me to follow the birds smoothly as they circled around, gently squeezing off frames when they were in the best positions. Gigrin Farm, Rhayader, Powys, Wales.

Canon EOS-1D MkII; EF500mm lens; 1/1600 sec at f/5.6; ISO 250; AI Servo focus; central focusing point (expanded); tripod with fluid video head.

53 Photograph birds at the nest

Most species of bird, with the exception of some seabirds, require the use of a hide in order to photograph them at the nest. This means you will have limited control of shooting angles, lighting and background selection, and the use of flash will often be required. Inevitably, this can lead to a typically standard record shot of the subject, which can be a little boring. There are also risks associated with photographing birds at the nest such as nest desertion, opening the nest up to predation or exposing the nest to egg thieves. Disturbance must therefore be kept to a minimum and the hide must be well concealed from passers-by. Only begin work after the eggs have hatched, as parent birds are less likely to desert once they have chicks. The hide should be introduced in stages, gradually moving closer to the nest over a period of days or weeks while making sure the birds continue to feed the chicks. Remember that in some countries a licence will be required to photograph certain species at or near their nests.

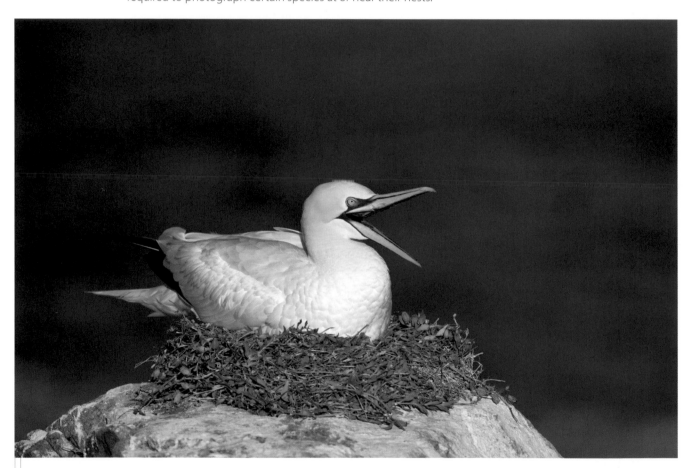

NORTHERN GANNET

I have never been keen on photographing birds at the nest due to the relative lack of artistic and compositional freedom it permits. However, some species of seabird, such as gannets, are an exception as they are surprisingly tolerant of human presence. It is quite unusual to find a gannet on a nest built with such fresh and colourful vegetation so this was an opportunity not to be missed. I took great care when first approaching the gannet colony, observing behaviour to spot any signs of unease among the birds. Any actions that result in a bird leaving the nest, even for a short period, could cause the eggs or young to chill and will leave them open to predation by gulls. Fortunately, this gannet and its neighbours showed no sign of alarm, which allowed me to continue photographing various aspects of nesting behaviour. Saltee Islands, Co. Wexford, Republic of Ireland.
Canon EOS-1Ds; EF500mm lens; 1/1000 sec at f/11; ISO 250; one-shot AF; single manually selected focusing point; IS mode 1; tripod with fluid video head.

Perfect your long lens technique

Fast, long telephoto lenses are large, heavy and expensive pieces of equipment that require perfect technique in order to achieve the best possible results. Camera movement and vibration is magnified and, if not countered, will cause image softness. Image stabilization helps but a sturdy tripod is still essential – do not skimp on this or you will not obtain the sharpness that your lens is capable of delivering. A specialized tripod head makes it much easier to follow moving subjects. Gimbal heads are a good option but my personal preference is a heavy fluid video head, which is dampened to provide an adjustable amount of resistance to work against – ideal for panning with a sprinting cheetah and for keeping the central focusing point on a bird in flight. Unless you are trying to record motion blur, always use the fastest shutter speed possible and when working from a tripod, use your hands, arms and face to brace the set-up and help dampen vibrations.

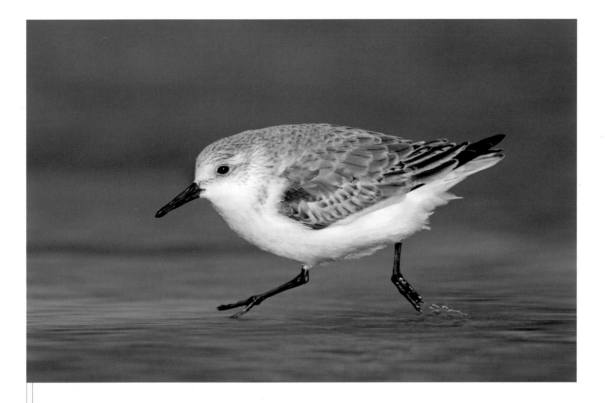

SANDERLING

These very fast-moving shorebirds can be easy to approach closely as they scurry up and down along the water's edge. I wanted to capture an image of the bird with both feet off the ground so a lot of trial and error was involved. I set up my tripod very low to the ground and levelled the fluid head (a fluid head sits in a bowl, which allows it to be levelled independently of the tripod) so that all my images would be level regardless of where I pointed the lens. I set my camera to use only the most sensitive central focusing point along with AI Servo mode to provide continuous predictive autofocusing. The image stabilization was set to mode 2, which only stabilizes vertical movement – allowing me to pan the camera horizontally. I waited for a group of birds to pass by and fired off a sequence of images using the motor drive. The smooth action of the fluid video head made it much easier to keep the bird in the frame and in sharp focus. Texel, Holland.

Canon EOS-1Ds; EF500mm lens; EF1.4X extender; 1/2500 sec at f/7.1; ISO 400; AI Servo focus; central focusing point; IS mode 2; tripod with fluid video head.

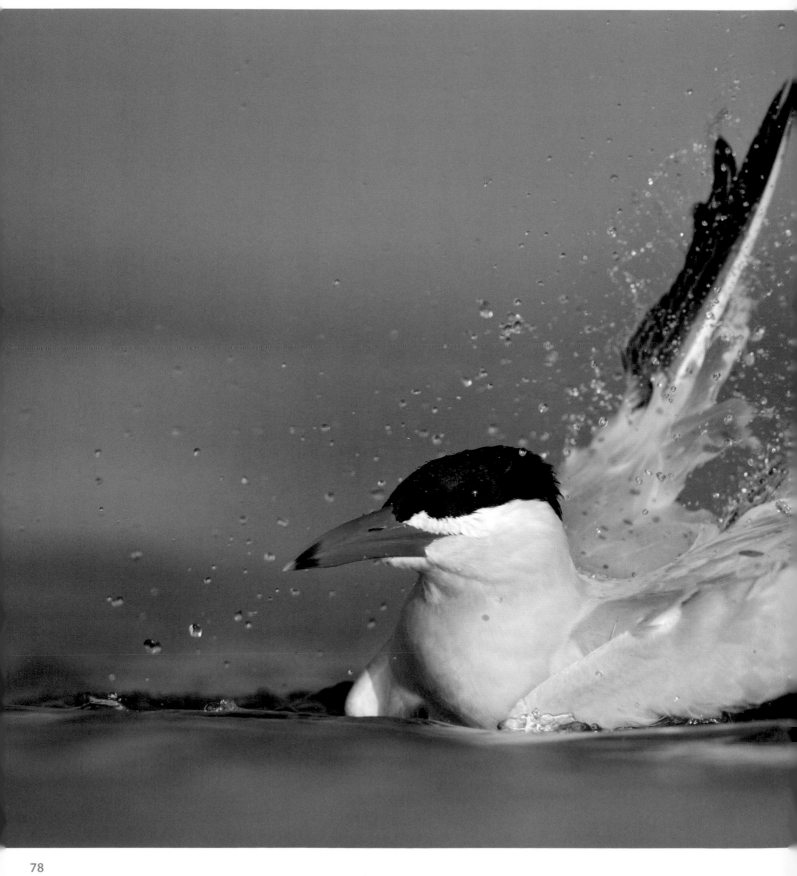

Capture a catchlight

Capturing the sparkle of a catchlight in the eye of an animal or bird will instantly inject life into your image and can often be the difference between a successful photograph and a failure. It is especially important with black-headed subjects, where the outline of the eye may not be obvious and can become lost in dark plumage or fur. On sunny days, a catchlight occurs naturally when the subject is front-lit or sidelit but you may need to wait until the head turns in the right direction for it to be revealed. In overcast lighting conditions, there can sometimes be a subtle catchlight present and this can be emphasized in post-production (see pages 136–137). It is also possible to use a weak burst of fill-in flash to add a subtle catchlight on overcast days and this can be softened in post-production to achieve a more natural result. Do not, however, try to add a catchlight where there wouldn't naturally be one, such as with a backlit subject.

CASPIAN TERN

By keeping the sun directly behind me, I knew that whenever this tern was looking in the direction of the camera there would be a natural catchlight in its eye. This was essential in preventing the bird's dark eye from merging with the jet-black plumage on its head. The image was taken with a 500mm lens resting on the sand at the edge of a lagoon. This provided the lowest possible shooting angle, which, when combined with a wide aperture, threw the foreground and background water well out of focus. This helped to reveal the flying water droplets that would otherwise have been partially concealed among the detail of rippled water in the background. I used an angle finder accessory (see page 93) to enable me to watch through the viewfinder for the optimum moment to press the shutter. Fort De Soto, Florida, USA.

Canon EOS-1D MkII; EF500mm lens; EF1.4X extender; 1/1600 sec at f/5.6; ISO 250; AI Servo focus; central focusing point; angle finder; camera and lens resting on ground.

56 Photograph birds in your garden

Gardens can be a great place to photograph wildlife, particularly when you have limited time or family constraints. However, getting really good images isn't easy and requires a lot of thought, creativity and patience. If you have bird feeders in place then some species will already be attracted into your garden. The food that you put out will determine which species put in an appearance. Peanuts and sunflower seeds appeal to a variety of birds, Nyjer seeds attract finches, corn is a favourite of doves and pheasants, and mealworms are irresistible to robins. You may be able to shoot from a window in your house or garden shed but the likelihood is that you will need to erect a hide. Front lighting and back lighting tends to work best with small garden birds so bear this in mind when positioning your hide. Also make sure that any shrubs or fences behind the feeder are as far away as possible so that you can throw them out of focus and achieve a clean background. Garden ponds can attract a variety of birds that come to drink and bathe and can also be a good place at which to site a hide.

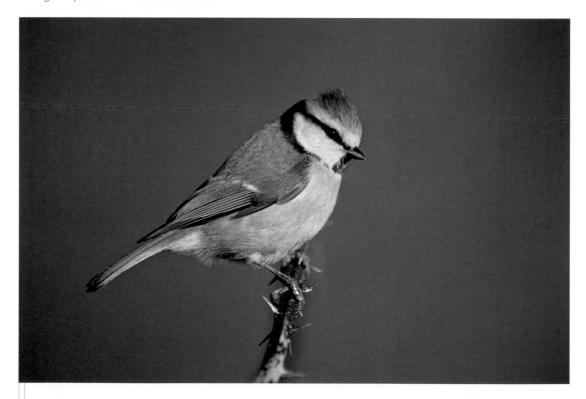

BLUE TIT

This image was taken from my kitchen window. This is a set-up that I use quite often to photograph the birds in my own garden. I hang a dark cloth across the open window to conceal myself and my camera. I have several bird feeders and a series of perches erected about three to four metres (10 to 13 feet) from the window. The sun is behind me for most of the morning, providing three hours of good light for photography. I don't want the bird food to appear in my images so I conceal it behind logs or within holes drilled into the back of perches – this works particularly well when using beef suet to attract woodpeckers. This blue tit was visiting a peanut feeder beside which I had set up a bramble stem as a natural-looking perch. Lyme Regis, Dorset, England.

Canon EOS-1Ds; Sigma 400mm f/5.6 APO Macro lens; 1/500 sec at f/8; ISO 200; AI Servo focus; single manually selected focusing point; tripod with fluid video head.

Photograph seabirds

Seabirds are great subjects to tackle when first starting out in bird photography. They tend to be quite tolerant of human presence and can be relatively easy to approach without causing disturbance. In many locations, an expensive long telephoto lens is not essential. Seabirds spend much of their lives out at sea and it is only during the summer breeding season that you have the opportunity to photograph them on land. Most species nest in colonies, normally in locations such as cliffs and offshore islands. There will be different behaviour to capture throughout the breeding season, from courtship and mating, to feeding young and fledging. Seabird plumage tends to be either black or white or a mixture of both so make sure that you have mastered your metering technique (see page 24). Always take great care when working close to a seabird colony because there are likely to be nesting burrows in the clifftop grassland that can collapse underfoot, trapping birds underground.

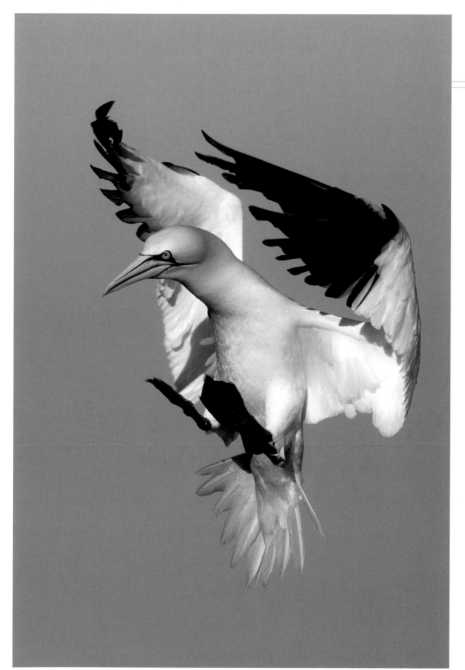

NORTHERN GANNET

Many seabird colonies are comprised of thousands or even tens of thousands of birds, providing a great opportunity to practise action and flight photography. The downside is that it can be difficult to isolate an individual bird from the surrounding clutter. This image of a gannet about to land on its nest was taken late in the afternoon. I had positioned myself with the sun behind me, making sure that I would have a clean background as a succession of birds came in to land on the cliff. I followed this individual through the viewfinder as it prepared to land and used the camera's eight-frames-per-second motor drive to fire off a sequence of images. This increased my chances of capturing an image with a dynamic wing position – always an important consideration when photographing birds in flight. Bass Rock, Fife, Scotland. **Canon EOS-1D MkII; EF500mm lens; EF1.4X extender; 1/2000 sec at f/7.1; ISO 250; AI Servo focus; central focusing point; IS off; tripod with fluid video head.**

58 Photograph shorebirds

Shorebirds (or waders) can be a challenge to photograph well. Fortunately, they tend to be found in open, level and well-lit locations so lighting and background selection is rarely a problem. This allows more time to concentrate on composition and capturing action and behaviour. Some shorebirds can be very approachable, particularly young birds, which migrate south from the arctic having never seen people. Likewise, in harbours and along beaches the birds may be habituated to people. Tidal conditions affect the behaviour of shorebirds and during high tide the birds roost in a favoured location, often in large flocks. Where the birds are more tolerant, roosts can sometimes be approached on foot if sufficient care is taken. Individual birds resting at the edge of the flock provide great opportunities for close-up portraits. Where it is not possible to approach the roost closely, use a telephoto lens to gain distant views of the whole flock. This can provide excellent opportunities when a bird of prey causes the mass of birds to take flight. As the tide recedes, the birds return to the water's edge to feed. This can also be a good time to photograph them as they are preoccupied and may allow you to approach very closely.

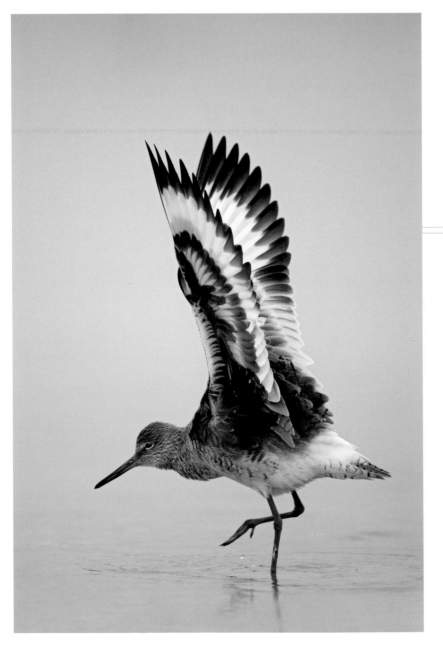

WILLET

Front lighting is preferable when photographing shorebirds. However, this willet was particularly well suited to overcast light due to its almost monotone plumage. By exposing for the bird, I was able to record the surrounding water as a very light tone, which has produced a slightly high-key effect. When photographing individual shorebirds, I like to stay as low as possible both to enable a close approach and to record an intimate eye-level perspective of the bird. I wear chest waders and a long-sleeved shirt to protect my elbows. For this image, I supported my lens on a groundpod – a small metal sledge on which I can fit my fluid video head. Using this set-up, my camera is about 15 centimetres (six inches) off the ground – just high enough to allow me to see through the viewfinder and to pan from side to side easily. I watched the bird bathing and rearranging its feathers and was prepared for the wing stretch, which very often occurs after preening. Fort De Soto, Florida, USA.

Canon EOS-1D MkII; EF500mm lens; 1/1000 sec at f/5.6; ISO 400; AI Servo focus; central focusing point; IS mode 2; groundpod with fluid video head.

Capture a dramatic image

Shooting a dramatic image of a wild animal or bird instantly captures the interest and imagination of the viewer. There are many elements that can combine to add impact to an image, such as subject motion, dramatic lighting, punchy contrasting colours, rare or strange behaviour or an unusual camera angle. Be prepared for dramatic wildlife encounters such as hunting predators or animals aggressively defending their territory from each other. It is important to capture the decisive moment so keep watching through the viewfinder at all times, as the second you look away you can guarantee you'll miss some fantastic action. Knowledge of your subject will help; for example shorebirds invariably stretch their wings shortly before taking flight and most birds take off into the wind. Where possible, shooting at close range from a low vantage point with a wide-angle lens can provide a particularly dramatic perspective.

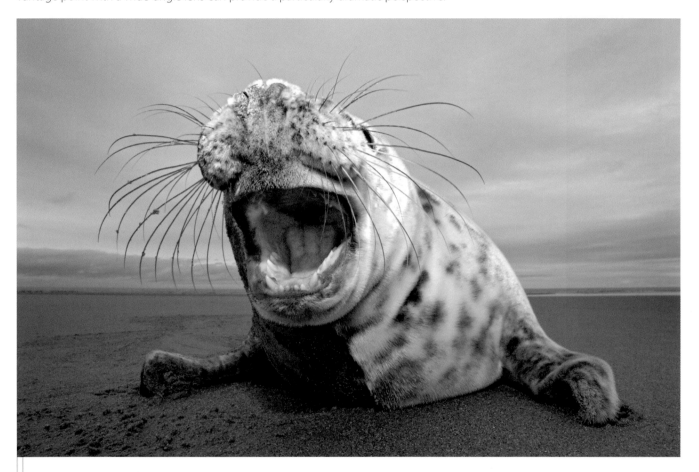

GREY SEAL

Seals have very individual characters, a point made clear when I took this image. I had been using a wide-angle lens to photograph another very cooperative young seal (see page 31) resting on the beach, when this rather grumpy individual made his way towards me. It was an unusual situation as this seal seemed quite agitated by my presence but continued to come closer. I took a few shots of him but in the end his persistent and quite vocal objections meant that my only option was to back off. However, before I was able to move away he reinforced his dislike of me by sneezing all over my lens! When I had moved far enough away he settled down. When I reviewed my images I was pleased that the low shooting angle, open mouth and projected whiskers had come together to make a very dramatic image. Lincolnshire, England.

Canon EOS-5D; EF16–35mm lens; 1/125 sec at f/16; ISO 400; manual focus; Speedlite 550EX at -3 stops; handheld.

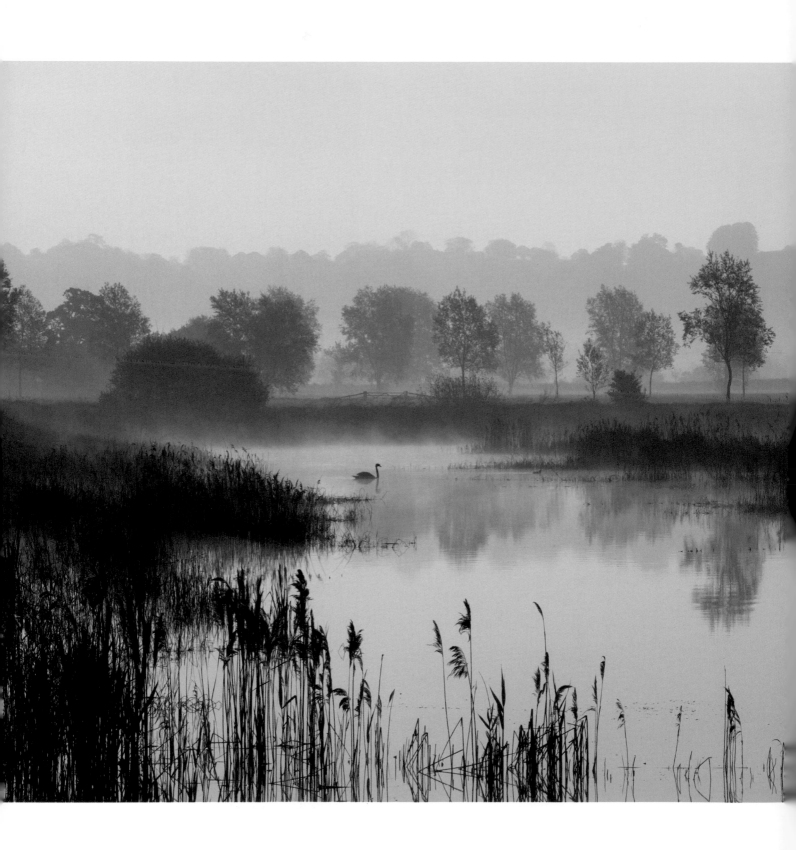

Photograph wildlife in its environment

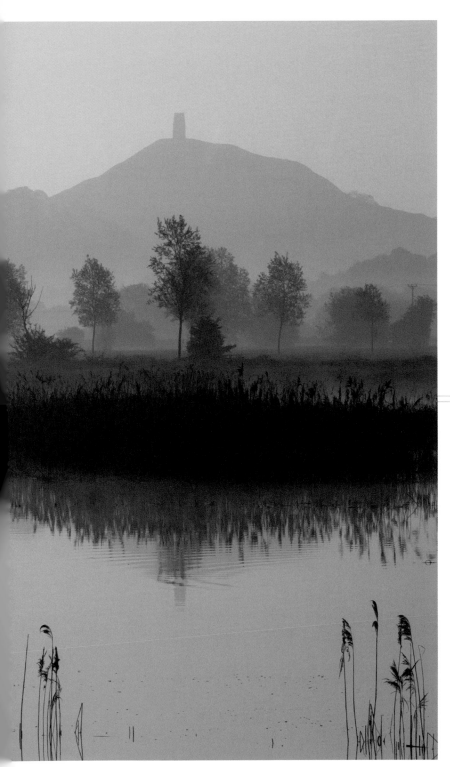

Resist the temptation to fill the frame with your subject on every occasion. Instead, consider including some of the surrounding habitat. By doing this, the image can tell more of a story about the animal and its relationship with the environment. The subject itself may be very small in the frame but this can help to illustrate the scale of the landscape. Composition plays a key role in this type of image so it is important to remember the rule of thirds (see page 53) and place the subject away from the centre of the frame. Zoom lenses in the range of 70–200mm are particularly suitable, as they allow compositional freedom. Wide-angle lenses can work well, providing it is possible to get close enough to the subject. A successful environmental portrait may simply be a landscape photograph where the animal or bird plays a key role in balancing the composition or acting as a focal point.

MUTE SWAN

I had been photographing this view towards Glastonbury Tor across flooded marshland on the Somerset Levels since sunrise. I was about to pack up when I happened to notice a swan appearing through the reeds in the distance. I had not yet moved the camera so I knew my original composition was good. However, I still had the mirror lock-up and self-timer function set on my camera. I had no time to change settings so my only hope was to press the shutter button as quickly as possible. For the best effect, the swan needed to be central in the gap between the reeds so there was a lot of luck involved here. Fortunately, it all came together in the second frame and the swan really helps bring the image to life. The scene is quite strongly backlit so I used my hand to cast a shadow across the front element of the lens to prevent flare from ruining the image. Sharpham, Somerset Levels, England.

Canon EOS-5D; EF70–200mm f/4 lens; 1/60 sec at f/11; ISO 100; manual focus; IS off; mirror lock-up; 2 sec self-timer; tripod with ball head.

Photographing
Flora & Fungi

Photograph wildflowers with a telephoto lens

Telephoto lenses are ideal for photographing many species of wildflower. These lenses allow a much greater working distance from the subject, often enabling you to record the whole plant in sharp focus even at a wide aperture of f/2.8 or f/4. When combined with the magnification of the lens, this produces beautifully diffused backgrounds and foregrounds that help to isolate the subject. Telephoto lenses don't tend to focus very closely but this can be overcome with the use of extension tubes (see page 102). In good light, these lenses permit the use of fast shutter speeds when used at a wide aperture, which can be helpful when the subject is being blown by the wind. Always support a telephoto lens on a tripod or beanbag. When using slow shutter speeds, use your camera's mirror lock-up function in combination with a remote shutter release to minimize camera shake and vibrations. If your lens has image stabilization, use this function instead but only when using shutter speeds in excess of 1/30 sec.

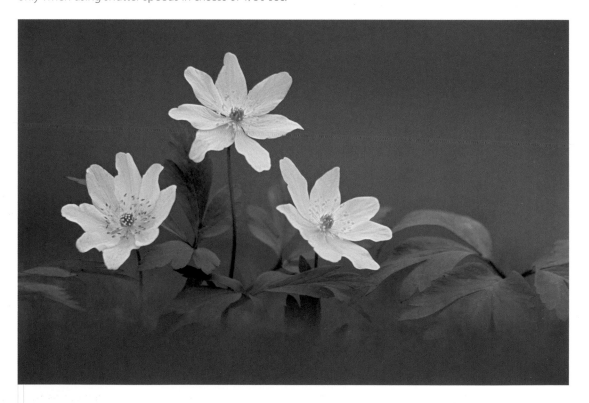

WOOD ANEMONES

I photographed these anemones on a heavily overcast day – perfect conditions for recording detail in white flowers. I used a 300mm lens with a 2X extender to further increase my shooting distance. I shot from ground-level with my lens supported on a hefty beanbag. The low shooting angle allowed me to include some well-diffused vegetation at the bottom of the frame. This helped contain the stems of the wood anemone by letting them gradually blend into the blur of foreground vegetation – I do all that I can to avoid chopping stems off at the edge of the frame. Before I made the exposure, I racked the focusing back and forth while looking through the viewfinder to check for distracting grass stems or debris that may have gone unnoticed due to the limited depth of field, but which would have shown in the final image. Charmouth Forest, Dorset, England.

Canon EOS-1Ds; EF300mm lens; EF2XII extender; 1/8 sec at f/5.6; ISO 100; manual focus; IS off; mirror lock-up; remote release; angle finder; beanbag.

Gain an intimate perspective

Shooting from a very low angle provides an intimate view of the subject. Try to position your camera at the same height as the flowers or fungi you are photographing – even if this means placing the camera directly on the ground. When using a telephoto lens, the surrounding clutter of natural vegetation is thrown well out of focus and can actually be used to frame the subject. With the camera back parallel to the stem or stalk, you should be able to record the whole plant in sharp focus from top to bottom. Obviously, this technique is only possible when photographing species that occur on the ground and only grow to a certain height. Composing an image with the camera so low to the ground can be difficult. An angle finder is the best solution but cameras with a Live View function also simplify the task by allowing you to compose the image on the rear LCD screen. At such a low angle the best form of camera support is a beanbag.

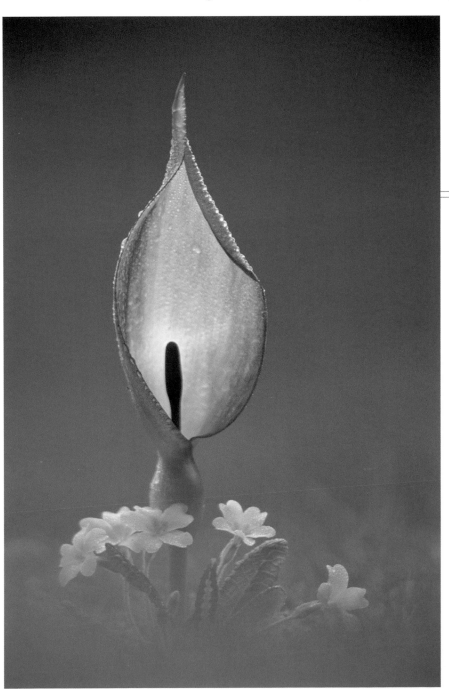

LORDS AND LADIES

This is one of my favourite plants to photograph in spring. This specimen was shot at the edge of a wood, late in the afternoon when the breeze had died down. My lens was resting directly on the ground and I used an angle finder (see page 93) to help me fine-tune composition and focusing without having to lie on the damp ground myself. Lords and ladies have large arrow-shaped leaves that often partially conceal the flower. This particular plant had fewer leaves than normal but they still obstructed my view of the bloom. The solution was to use small sticks to secure the leaves out of shot temporarily. The result is a much simpler, cleaner and aesthetically pleasing composition. I used a small torch to provide a little subtle back lighting to the flower. To prevent a hot spot, the torch was moved in a circular motion during the one-second exposure. Marshwood Vale, Dorset, England.

Canon EOS-1Ds; EF300mm lens; EF2XII extender; 1 sec at f/7.1; ISO 100; manual focus; IS off; mirror lock-up; remote release; angle finder; torch; beanbag.

63 Keep multiple subjects parallel to the camera

When photographing groups of wildflowers or fungi try, where possible, to ensure that the subjects are parallel to the back of the camera – particularly those at the front of the group. This is especially important when using telephoto lenses and when shooting at wide apertures, as any slight angle will result in one or more of your subjects recording slightly out of focus. It can be very difficult to ascertain how well things are lined up. Where possible, look straight down on your camera and the subject to gauge whether they are parallel. Check through the viewfinder by racking the focusing back and forth to see which individual plants come into sharp focus together then adjust your position accordingly. Focus on or just behind the front edge of any flowers or caps rather than on the stems.

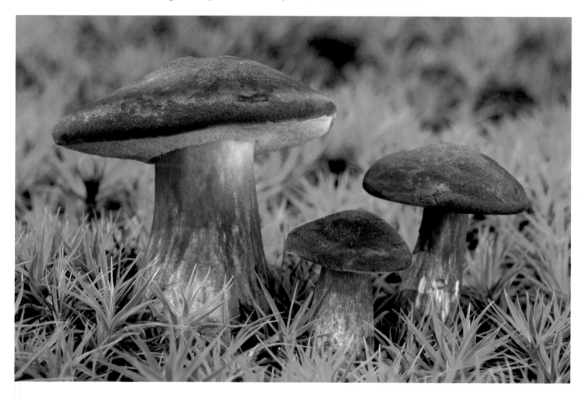

BOLETUS

I found these unusually colourful mushrooms in an ancient broad-leaved forest in southern England. They had emerged from lush green star moss beneath a towering beech tree. The caps of these fungi were five to seven centimetres (two to three inches) across and the stems were recessed almost two and a half centimetres (one inch) from the front edge of the cap. This meant that I needed plenty of depth of field in order to record enough of the fungi in sharp focus. A long telephoto lens was out of the question so I opted to use a 100mm macro lens at a small aperture of f/16. My shooting position was determined by placing a piece of card flush with the front edge of all three mushrooms – just touching the edge of each cap. I then manoeuvred my camera so that the back of it was parallel with the piece of card. I could then be confident of recording each of the three mushrooms in the same plane of focus. New Forest National Park, Hampshire, England.

Canon EOS-1Ds; EF100mm macro lens; 1/4 sec at f/16; ISO 100; manual focus; gold reflector; mirror lock-up; remote release; angle finder; beanbag.

Diffuse strong sunlight

Harsh sunlight is not good for photographing wildflowers. The strong contrast causes loss of detail in highlights and shadows, and colours will appear inaccurate. However, this does not mean that you can't take photographs of flora and fungi during the middle of the day; you simply need to control the lighting. This is best achieved using a translucent diffuser, which will soften the sunlight dramatically. You could use a white sheet or a piece of tracing paper but it is far better to invest in a collapsible diffuser disc that you can keep in your camera bag and use time and time again. The diffuser should be positioned to cast a weak shadow over the subject. Direct sunlight also needs to be kept off the background and foreground elements that appear in your composition – your choice of shooting angle will dictate how easy this is to achieve.

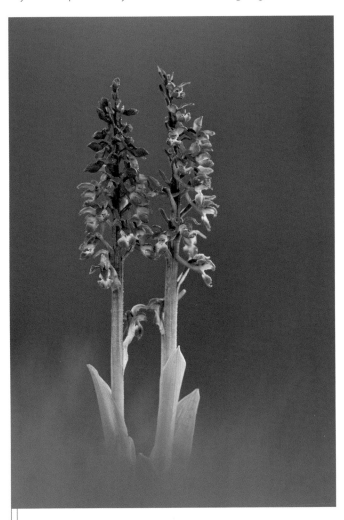

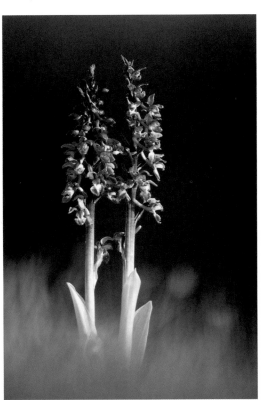

EARLY PURPLE ORCHIDS

The smaller image shows an orchid in perfect condition. However, it is clear to see that the harsh mid-afternoon sunlight has caused loss of detail in the stem and strong shadows on the blooms themselves. The colours are also woefully inaccurate. Compare this to the main image where the sunlight has passed through a translucent diffuser. The colours in the image are truthful, detail has been retained in the stem and the whole composition appears cleaner and simpler due to the much-reduced contrast. The low angle of view meant that I also had to use my camera bag and coat to cast shade on the sunlit areas in the foreground and background. Hardington Moor National Nature Reserve, Somerset, England.
Canon EOS-1Ds; EF500mm lens; EF2XII extender; 1/8 sec at f/11; ISO 100; manual focus; IS off; translucent diffuser; mirror lock-up; remote release; angle finder; two beanbags.

65 Search for the best specimens

When you are intending to show your subject in close-up detail it is important to search for the very best specimen rather than photographing the first example that you come across. There could easily be a much better example just around the corner and it can be frustrating to have wasted your time on a lesser specimen. It is important to consider the position of the subject and whether you can achieve the image you desire. Can you isolate it against a clean background? Is the lighting acceptable? Does any surrounding vegetation detract from the subject? All these questions need to be considered when selecting a suitable subject. If you are not entirely happy then search the area for alternatives. There are, of course, exceptions where you may not wish to photograph a pristine example, such as some types of fungi where an element of decay may be beneficial to the image.

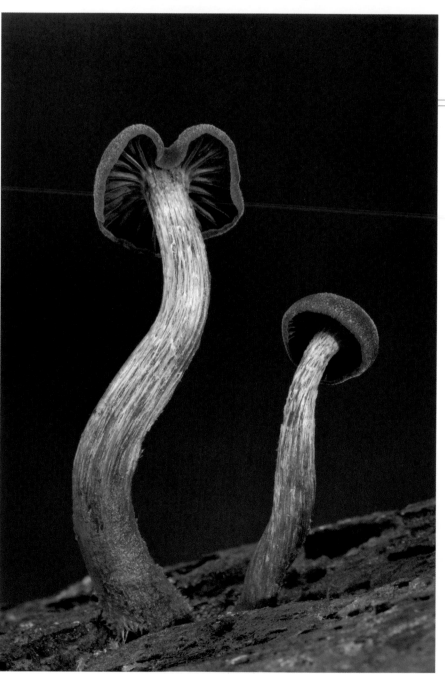

AMETHYST DECEIVERS

I found this fantastic display of toadstools under the dark canopy of a beech wood in early autumn. Although colourful, these fungi are surprisingly difficult to spot among the dark leaf litter through which they appear. I scoured the area for 20 minutes looking for good specimens and eventually found these two emerging from a heavily decayed branch on the ground beneath a mighty beech tree. I particularly liked the twisting shape of the stalks and the fact that I could see the gills beneath the caps. They were on top of a small bank, which enabled me to include a dark and nicely diffused background. I used my tripod with its legs spread to their lowest possible position. An angle finder (see page 93) helped me to fine-tune focusing and composition without having to lie on the damp woodland floor. Lewesdon Hill, Dorset, England.

Canon EOS-5D; EF180mm macro lens; ½ sec at f/11; ISO 100; manual focus; mirror lock-up; remote release; silver reflector; tripod with ball head.

Invest in an angle finder and a bubble level

An angle finder is an accessory that attaches to the viewfinder of your camera to provide a 90-degree viewing angle. This is a great help when shooting from a low angle as it enables you to compose your image while looking down through the angle finder, rather than straining your neck to see through the viewfinder when it is very close to the ground. A bubble level is an essential and inexpensive accessory that slots into your camera's hot shoe to show whether the camera is level. It can be surprisingly difficult to judge this when working low down, as you can't position yourself to look straight through the viewfinder. When photographing long-stemmed plants it is vital to make sure the stems are straight – a bubble level will enable you to do this easily.

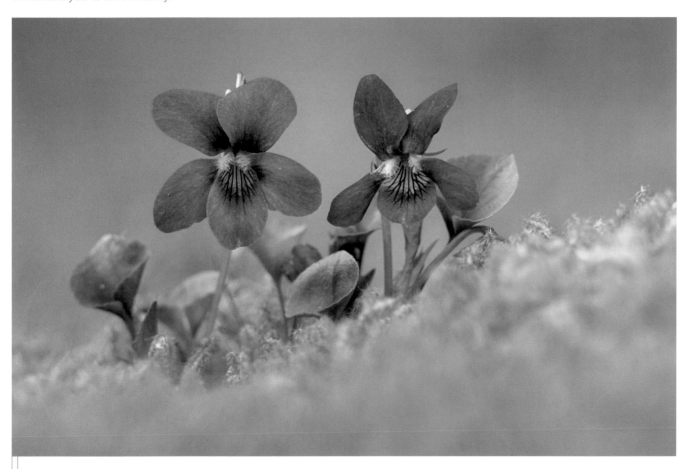

COMMON DOG VIOLETS

This shot was taken with the camera supported on a beanbag very close to the ground. When working in this way, I always use an angle finder. Not only does this make composition and focusing easier but it also saves straining my neck to look through the viewfinder at awkward angles, which, after a long day's macro photography, will inevitably lead to a headache. If your photographic creativity is to flow you must remain comfortable so an angle finder is an essential piece of kit. I keep a bubble level attached to my camera at all times (except when the hot shoe is being used for flash) so it was easy to confirm that the camera was perfectly level before making this exposure. Even though this image was taken in overcast light, a white reflector still managed to inject a surprising amount of soft light – helping to reveal extra detail in the lower parts of the flowers. Marshwood Vale, Dorset, England.

Canon EOS-1Ds; EF300mm lens; EF25mm extension tube; 1/10 sec at f/16; ISO 100; manual focus; IS off; white reflector; mirror lock-up; remote release; angle finder; beanbag.

67 Use a mirror to reflect sunlight

Traditional white, silver and gold reflector discs are very useful in nature photography. On sunny days when the light is harsh they can be used to reduce contrast by filling in shadows, while on overcast days they will subtly inject light and warmth into darker areas of the image. However, if you really want to flood your subject with light then a mirror provides much more powerful illumination. A mirror is best used under cloudy skies where it provides a much stronger source of reflected light than a normal silver reflector disc. A mirror can also be used when working in a woodland environment in dappled light. The mirror can be placed within a pool of sunlight and angled to illuminate subjects in shady areas some considerable distance away. I normally carry a 25 x 20cm (10 x 8in) mirror in the outside pocket of my camera bag so that it is easily accessible should I come to need it.

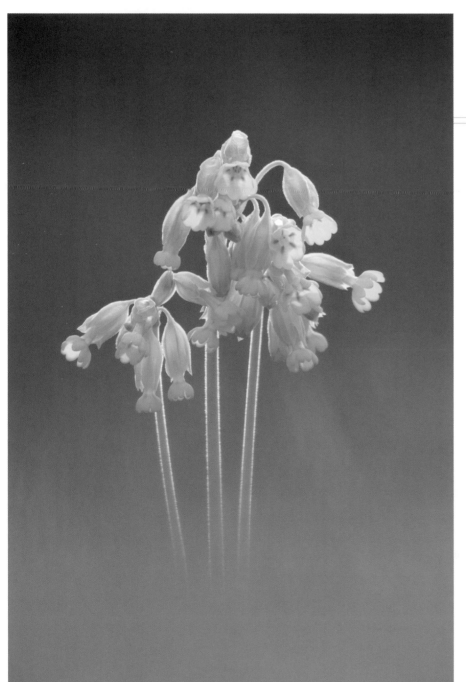

COWSLIPS

When I photographed these cowslips there was very weak sunlight filtering through thin cloud cover. I placed a mirror just out of sight behind the plants to reflect light up, giving the impression of natural back lighting. I also used a white reflector disc to bounce light back into the blooms. It was important to keep an eye on the position of the mirror because, as the sun moved across the sky, the reflected light quickly moved off the subject. I had to keep adjusting the position of the mirror to maintain the maximum amount of back lighting. I used a 500mm lens with 2X extender to throw the surrounding vegetation completely out of focus, as I envisaged this shot being used on a magazine cover in the future. With this in mind, I placed the subject fairly centrally in the composition with plenty of space around it for text and titles. Powerstock Common, Dorset, England.

Canon EOS-1Ds; EF500mm lens; EF2XII extender; 1/60 sec at f/11; ISO 200; manual focus; IS off; mirror reflector; white reflector; mirror lock-up; remote release; angle finder; two beanbags.

Shoot in wet weather

Don't let rainy days restrict your photography. Water droplets and falling rain can add a great deal of atmosphere to images of wild flora. The best conditions are persistent light drizzle, as this will cause droplets to form on every surface giving the appearance of heavy dew. Look for water drops that have collected on the underside of fallen leaves, in cobwebs and on the hairy leaves of some plants. Many modern cameras are weather-sealed to some extent but it is still advisable to give your camera some form of additional protection from the elements. This may be a specialist camera cover or simply a plastic bag and an elastic band. Carry a waterproof sheet in your camera bag to enable you to kneel or lie on the wet ground. Waterproof trousers are also a good idea. During the autumn months there will be an abundance of fungi during and after wet weather. It is also possible to replicate some of the effects of light rain using a water spray to apply a fine mist of water droplets to your subject.

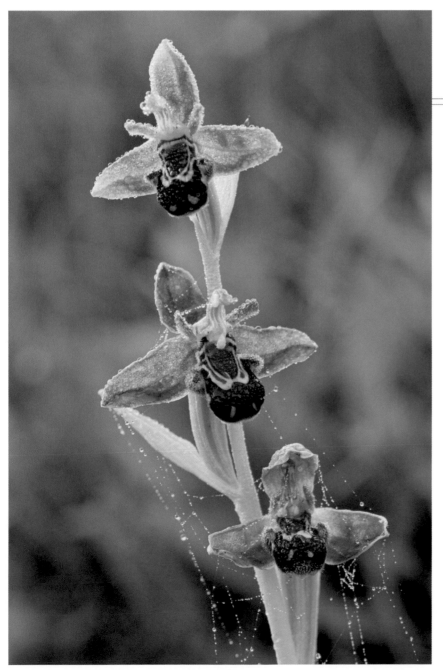

BEE ORCHID

Undeterred by the weather, I went exploring for orchids on a chalk grassland nature reserve in early June. The heavily overcast conditions produced beautifully even lighting — perfect for recording fine detail in the cobwebs and water droplets adorning this bee orchid. Wet surfaces reflect a lot of light so colours can appear muted. The solution is to use a polarizing filter, which will cut through reflections, especially on wet leaves. This helps to saturate colour, especially that of green foliage. Using a Manfrotto clamp, I attached a small clear umbrella to the leg of my tripod to keep the rain off my camera and lens. This is only advisable in still conditions, as an umbrella can catch the wind and transmit vibrations through your tripod. Martin Down National Nature Reserve, Hampshire, England.

Canon EOS-1Ds; EF100mm macro lens with polarizing filter; 1/30 at f/11; ISO 100; manual focus; white reflector; mirror lock-up; remote release; umbrella and clamp; tripod with ball head.

69 Remove distracting debris

Removing debris and other distracting elements from your chosen composition is known as 'gardening'. It is a practice frowned upon by some, and rightly so when photographing particularly sensitive subjects. However, when photographing wildflowers it can be justifiable, providing it is kept to a minimum and you do not damage the plant's habitat. The grasses and vegetation surrounding a plant often create an important microclimate that helps it to survive. Therefore, it is always best to tie back annoying blades of grass and twigs temporarily, rather than cut or break them off. Sometimes flowers have dust on their petals that can spoil the otherwise pristine appearance of the bloom; this is easily removed with a blower brush. You have to decide exactly where to draw the line though. For example, fungi may have dust and soil on their caps from when they pushed through the ground. This may spoil the aesthetics of your image but it does illustrate the natural life cycle of the fungi so should, perhaps, remain.

GLISTENING INK CAPS

These fungi were photographed in deciduous woodland where they had appeared from the roots of a fallen beech tree. I used the long end of a 100–400mm zoom lens to help throw the background forest well out of focus. A 25mm extension tube enabled me to focus close enough to virtually fill the frame with this group. I removed a few dead twigs from directly behind the fungi and used a blower brush to get rid of some debris on the caps. There was dappled sunlight hitting the woodland floor in places but my subject was in shade. Therefore, I placed a mirror in a pool of sunlight and angled it to provide strong back lighting. I then used a gold reflector to bounce warm light back on to the fungi themselves. New Forest National Park, Hampshire, England. **Canon EOS-5D; EF100–400mm lens; EF25mm extension tube; 1/15 sec at f/8; ISO 100; manual focus; IS off; mirror reflector; gold reflector; mirror lock-up; remote release; tripod with ball head.**

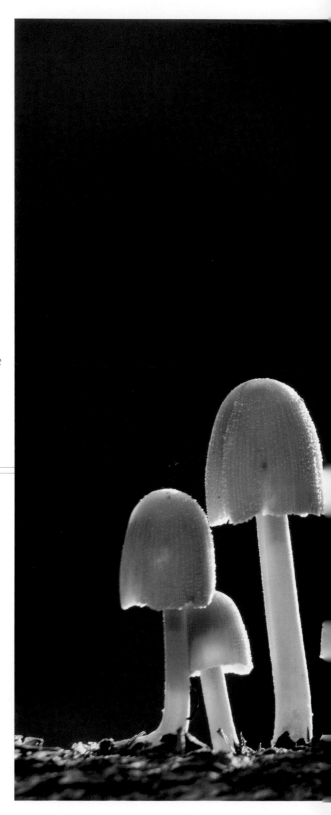

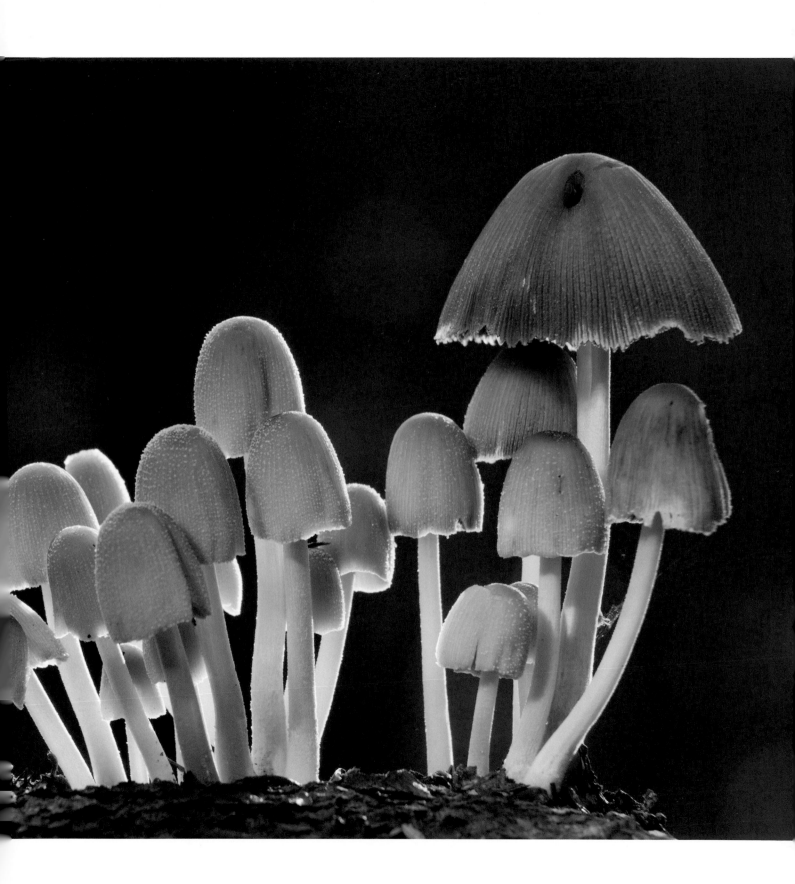

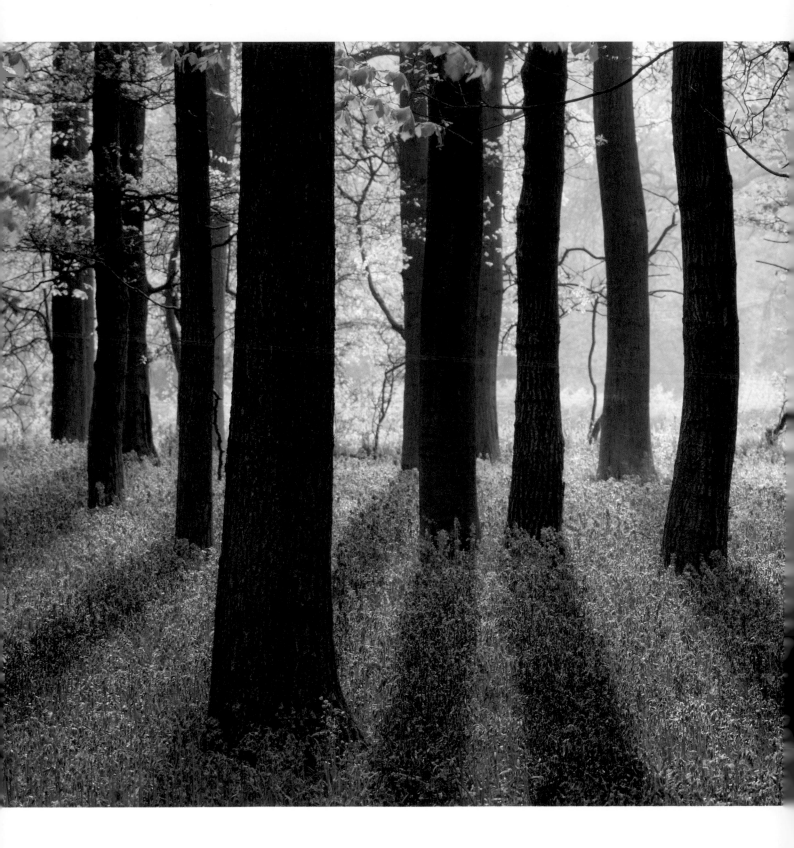

Photograph wildflowers in their environment

It isn't always necessary or desirable to photograph wildflowers and fungi in close-up detail. Explore the location and consider whether it might be possible to use a wide-angle lens to record them within their habitat. It may be possible to photograph one particular plant in a way that provides a sense of its scale and position within the environment. In areas where flowers such as bluebells and lupins grow in profusion, there will be excellent opportunities for wildflower landscapes using a wide-angle lens to fill the foreground with colour. When photographing masses of flowers, overcast light is preferable although back lighting can be very effective early and late in the day. It will be necessary to use a small aperture to obtain sufficient depth of field to record all the flowers in sharp focus from foreground to background.

BLUEBELL WOODLAND

Bluebells are characteristic of the English countryside in springtime. This small beech wood displayed a thick blue carpet for a couple of weeks in May. I had already taken images in the centre of the wood where contrast was low, as direct sunlight was unable to penetrate due to the canopy of fresh green foliage. I had also taken many close-ups of individual blooms and groups of flowers. The sun was low in the sky when I came across this scene at the edge of the wood, where rays of warm sunlight were bursting through and casting dramatic shadows across the carpet of bluebells. When shooting woodland scenes, I like to avoid tree trunks overlapping, as they tend to merge together so I found a position where the trunks appeared nicely spaced out. I used a short zoom lens set to 50mm and manually focused about one-third of the way into the scene. Ashridge, Hertfordshire, England.

Canon EOS-5D; EF24–105mm lens with polarizing filter; 1/8 sec at f/16; ISO 100; manual focus; IS off; tripod with ball head.

Close-Ups in Nature

71 Use extension tubes

You don't have to own a macro lens in order to photograph close-ups in the natural world. Many standard zoom lenses will focus close enough to photograph natural patterns, groups of wildflowers and larger insects. When photographing smaller subjects, it is possible to use extension tubes or bellows to increase the close-focusing abilities of most lenses. Bellows are the best choice for extreme close-ups but for most of my work I prefer extension tubes, as they weigh very little and are quick and easy to use. I frequently use them with my 500mm, 300mm and 70–200mm lenses. Extension tubes are simple metal tubes with no glass inside, which, when attached between the lens and the camera body, increase the close-focusing capabilities of the lens with no effect on optical quality. Electrical contacts between the camera and lens remain so your camera's metering system will continue to work. Autofocus is still possible with some lenses but can be unreliable, so it is always best to focus manually.

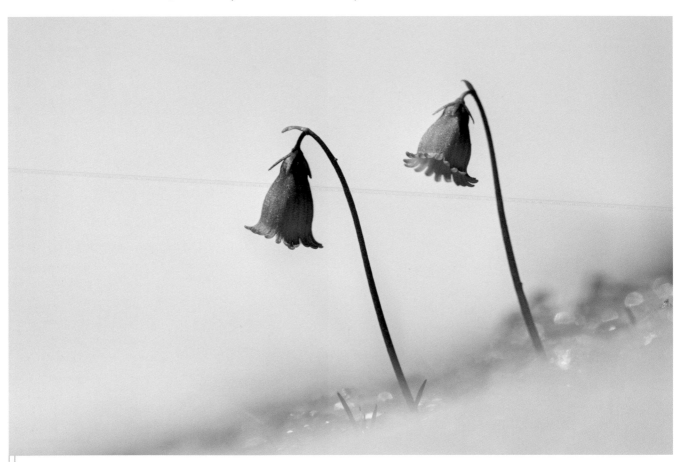

ALPINE BLUEBELLS

I found these bluebells while photographing landscapes in the Julian Alps in Slovenia. Hundreds of them were emerging around the edges of the last remaining snow patches. I was not exactly kitted out for wildflower photography but, as extension tubes weigh very little, I normally have one in my bag. I attached a 25mm extension tube to my 70–200mm lens to achieve the necessary magnification. When I had determined the best shooting position to get both flowers in sharp focus, I made a small snow bank on which to support the camera. It was extremely bright, which was a bonus as it allowed me to set a very fast shutter speed to freeze the movement of the flowers as they blew around in the strong mountain breeze. I took lots of shots to increase my chances of getting an image with both flowers in the same plane of focus. The snow acted as a giant reflector, reducing the contrast of the harsh midday sun by reflecting light on to the underside of the flowers. Mangrt, Triglav National Park, Julian Alps, Slovenia.

Canon EOS-5D; EF70–200mm lens; EF25mm extension tube; 1/2500 sec at f/8; ISO 100; manual focus; IS mode 1; camera and lens resting on ground.

Use a supplementary close-up lens

It can be impractical to carry macro equipment with you at all times. When I am travelling a long distance on foot or working in physically challenging terrain, I like to keep the amount of equipment I carry to a minimum. However, I never know when I might come across a subject for which macro equipment would be required. My solution in these situations is to carry a supplementary close-up lens. This is a magnifying lens that screws on to the front element of any lens to facilitate close focusing while adding very little weight or bulk to your kit. It looks like a traditional screw-in filter and does not affect your camera's metering or autofocus operations. Canon makes a very good quality two-element close-up lens that can be used with any manufacturer's lenses without causing a significant decrease in image quality. Close-up lenses work particularly well on telephoto zoom lenses. They cannot be left on the lens for normal shooting as the focusing range is severely restricted and the lens will be unable to focus on distant subjects.

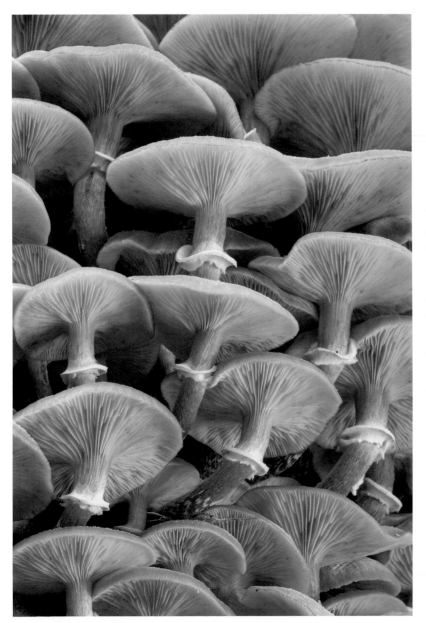

HONEY FUNGUS

I found this beautiful display of fungus on the edge of a wood while hiking across a moor in search of red deer. I had my heavy 500mm lens with me so, in order to restrict the weight I was carrying, the only other lens in my bag was a 70–200mm zoom. I wanted to record an overall pattern by shooting up at the gills of the mushrooms but, by itself, the zoom lens was unable to focus close enough to completely fill the frame with the fungi. Thankfully, I always keep my close-up lens in a pocket in my photographer's vest. By attaching this to the zoom I was able to achieve the composition I wanted. I only have a 77mm close-up lens but I can attach it to lenses with smaller diameter filter threads using inexpensive step-down rings. A silver reflector was used to bounce light on to the underside of the fungi. Exmoor National Park, Somerset, England.

Canon EOS-1Ds; EF70–200mm lens; Canon 500D close-up lens; 2 sec at f/16; ISO 100; manual focus; silver reflector; mirror lock-up; remote release; tripod with ball head.

73 Invest in a macro lens

The greatest benefit of true macro lenses is that they provide at least life size (1:1) magnification without the inconvenience of having to add accessories like extension tubes or bellows. There is not a huge choice when it comes to selecting a macro lens but you will need to decide which focal length suits you best. Shorter 50mm macro lenses have limited use as they force you to set up very close to your subject, which is not always practical. Mid-range 100mm lenses are probably the most versatile and cost-effective choice. Those in the range of 150mm to 200mm allow greater working distance from the subject and can be used to produce a more diffused background if required. Macro lenses are designed to provide the best possible optical quality at close-focusing distances. However they still produce excellent results when focused to infinity, which increases their versatility.

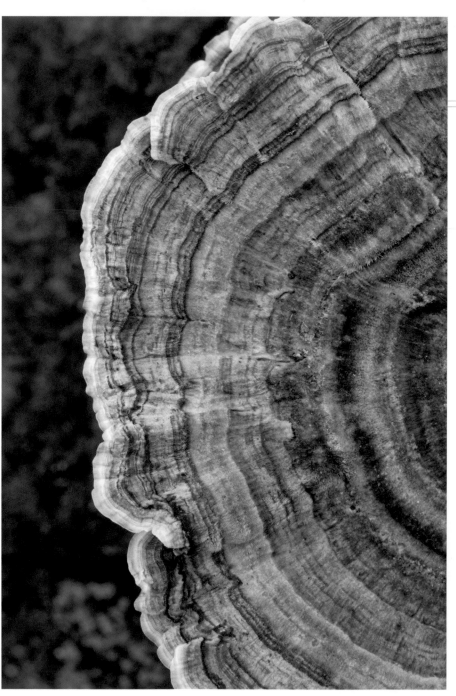

POLYPORE

Rather than photograph the whole of this fungus, I decided to use a macro lens to compose tightly around the most attractive section of it. This allowed me to show the patterns and colours in fine detail. I set up directly above the subject and positioned my camera so that the camera back was parallel with the almost-flat surface of the fungi. Working so close to the subject meant that even slight undulations in its surface could appear out of focus – the solution was to use a small aperture of f/22. Macro lenses can be expensive but independent manufacturers such as Sigma and Tamron make some excellent examples at a reasonable price. I have used a Tamron 90mm macro lens for many years and it continues to be one of the sharpest optics in my camera bag. It is also very compact and lightweight, which means it stays in my bag most of the time. New Forest National Park, Hampshire, England.

Canon EOS-1Ds; Tamron 90mm macro lens; 2 sec at f/22; ISO 100; manual focus; mirror lock-up; remote release; tripod with ball head.

Use depth of field creatively

When shooting close-ups, your proximity to the subject has an enormous effect on depth of field – the closer you are, the less depth of field is available. You may wish to use a wide aperture in order to isolate your subject from a cluttered background or to achieve an abstract effect. However, the chances are you will need to use a small aperture simply in order to record enough of your subject in sharp focus, particularly when working at life-size (1:1) magnification or greater. Try to position your camera so that the most important elements of your subject lie within the actual plane of focus. With a 100mm macro lens focused to achieve 1:1 magnification, there will only be about 5mm of acceptable sharpness. Be aware that light becomes diffracted at very small apertures and this can cause a significant drop in image quality. Therefore, use of the very smallest lens aperture should be kept to a minimum.

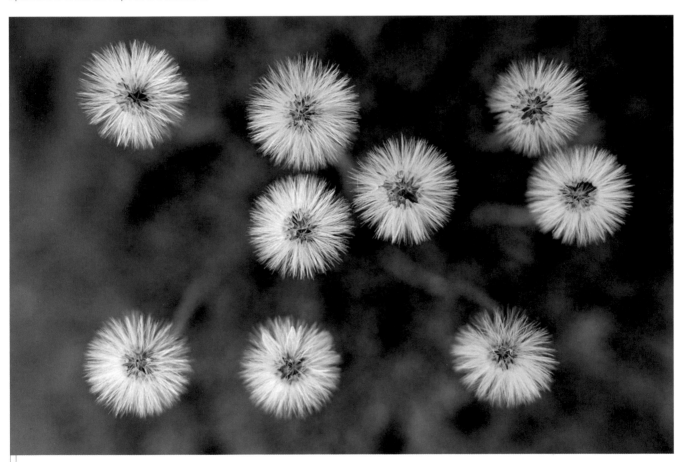

HAWKWEED SEED HEADS

I found these hawkweeds growing from the top of a low wall. When considering the best composition, I noticed that the seed heads were all roughly the same height – about 20 centimetres (four inches) from the top of the wall. I attached a 90mm macro lens and climbed on to the wall so that I could look straight down on the seed heads. I could see potential so I reached for my tripod and set it up rather precariously on top of the wall. Using the lens at its widest aperture, I was able to throw the background moss well out of focus and isolate the seed heads. By shooting straight down most of the stems are hidden from view, creating an abstract effect. The relatively fast shutter speed, which resulted from using a wide aperture, helped to freeze any movement caused by the wind. Colyton, Devon, England.
Canon EOS-1Ds; Tamron 90mm macro lens; 1/250 sec at f/2.8; ISO 100; manual focus; mirror lock-up; remote release; tripod with ball head.

75 Shoot abstracts

The natural world offers enormous potential for the creation of abstract imagery – the choice of subject matter is seemingly endless. Abstracts are something that you tend to come across rather than go out to photograph specifically. The subject does not need to be recognizable; by composing an image in this way you are not necessarily challenging the viewer to identify the subject, rather you are hoping that they appreciate the aesthetics of the image purely from a design point of view. This is best achieved by presenting the subject, or part of it, in an unfamiliar way. Compose your image tightly on the most visually appealing part of the subject. Look for dynamic lines, contrasting colours, interesting textures, interplay of light and shade and repetitive patterns. Pay attention to detail and exclude any elements that do not contribute to the design of the image – in particular carefully check for any intrusions around the edges of the frame.

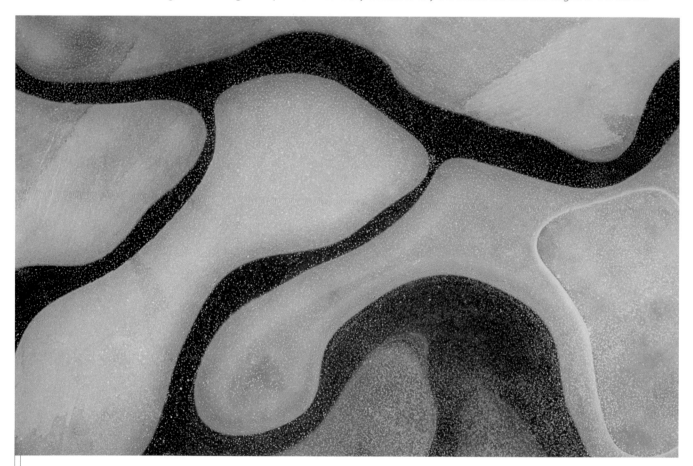

ICE PATTERNS

This image shows a close-up from a section of frozen water in a puddle. The shapes were formed by air trapped beneath the surface of the water as it froze. I used a 90mm macro lens to compose quite tightly around the most interesting section of the pattern. I made sure that the back of my camera was parallel with the surface of the ice by using a hot shoe-mounted bubble level (see page 93). This enabled me to use a medium aperture of f/8, which provides the best optical quality with maximum resolution and contrast. Although the puddle was in shade, the blue sky above caused quite a strong blue colour cast. I decided not to correct this by changing the white balance (my white balance is always set to Daylight) as I felt it provided an accurate representation of the cold winter conditions in which I took the photograph. Loch Morlich, Cairngorms National Park, Scotland.

Canon EOS-1Ds; Tamron 90mm macro lens; 1/8 sec at f/8; ISO 100; manual focus; mirror lock-up; remote release; tripod with ball head.

Use an artificial background

A cluttered distracting background can ruin an otherwise successful image, as the full impact of the subject is often impaired. One solution might be to introduce an artificial background. In the past I have used painted boards, camouflage netting and coloured sheets as artificial backgrounds and, providing they are positioned well behind the subject, the results have been good. However, a technique that I discovered fairly recently produces far more natural results. I use a neutral-density filter to increase the exposure time to over a second. I then hold a handful of natural material (grass, bracken or leaves) directly behind the subject and move it around during the exposure. The resulting blur produces a smooth, featureless but natural-looking background. Caution needs to be taken not to create a draft that will move the subject during exposure so make sure you hold the material at least one metre (three feet) behind the subject. Make sure you cover the entire background by taking a test shot and examining the LCD screen on the back of your camera.

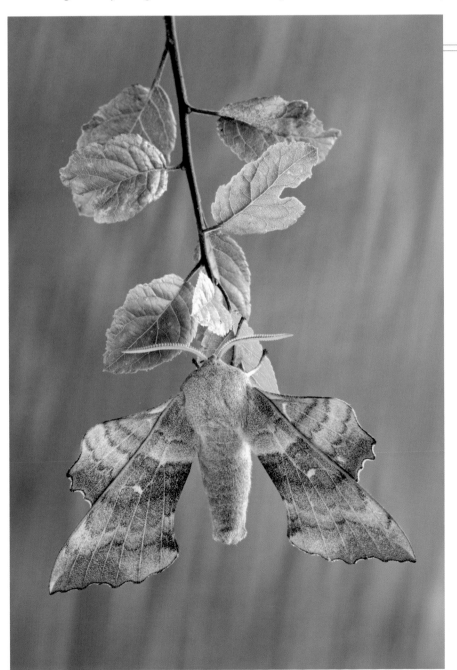

POPLAR HAWK MOTH

This large moth holds its wings away from its abdomen when at rest. This creates a problem for close-up photography due to the overall depth of the insect – there is a lot to get sharp. The obvious solution was to use a small aperture. Unfortunately the background was a mass of branches. Stopping down to f/22 created a very confusing image where the edges of the moth's wings merged with the highly detailed background. The solution was to increase the exposure time to several seconds by fitting a 3-stop neutral-density filter to the lens. I then grabbed a big handful of vegetation – enough to completely fill the frame when held a short distance behind the moth. The vegetation was moved in slow circles throughout a four second exposure. The resulting blur created an artificial but nicely diffused background that isolated the moth perfectly, while the small aperture also enabled me to record the whole of the moth in sharp focus. Isle of Portland, Dorset, England.

Canon EOS-5D; EF180mm macro lens with 3-stop neutral-density filter; 4 sec at f/22; ISO 100; manual focus; mirror lock-up; remote release; tripod with ball head.

77 Photograph greater than life size

Magnifying your subject greater than life size requires the use of some very careful and precise techniques. There are several options for achieving greater than life-size or 1X (1:1) magnification. Canon users are fortunate to have the MP-E65mm lens that is capable of magnifying up to 5X (5:1). Other options include the use of extension tubes and bellows, usually in combination with a macro lens (see pages 102 and 104). When working at such high magnification there are several problems to deal with. The severely restricted depth of field means that you will be working with a small aperture most of the time. This will lead to long exposure times where camera shake and subject movement can cause image softness. In many cases the solution will be to use a ring flash or macro flash system as your main source of illumination, permitting the use of significantly faster shutter speeds. When working at high magnification, fine focusing adjustments are much easier to achieve with the use of a focusing rail rather than the focusing ring on the lens.

BRACKET FUNGUS

I found this unusual fungus on the trunk of an oak tree in my garden. At first it did not appear very photogenic, as illustrated by the small record shot (below). However, on closer inspection I noticed the potential for a close-up abstract image created by the droplets of liquid seeping from the edge of the bracket – this is the way the fungus sheds its spores. I examined the edge of the fungus closely and eventually settled on a particular group of droplets to form a composition. The droplets were very small so I needed to magnify them to greater than life size in order to achieve a frame-filling image. I used a 180mm macro lens with a 2X extender, which provided twice life-size (2:1) magnification, while allowing me to work at a reasonable distance from the fungus. This was important as I wanted to use natural light and if I had been too close, the lens itself would have cast a shadow over part of the subject. Lyme Regis, Dorset, England.

Canon EOS-5D; EF180mm macro lens; EF2XII extender; 8 sec at f/32; ISO 100; manual focus; white reflector; tripod with ball head.

Capture a sharp image

Coping with subject movement due to wind disturbance is one of the greatest challenges in close-up photography. Ideally, you should choose a day with little or no wind. Unfortunately, even the slightest breeze can cause enough movement to render your subject blurred. One solution is to use flash as your main source of illumination, as this will allow you to set a fast shutter speed along with a small aperture. Used well, this can provide excellent results and can be the best method when working at greater than life-size (1:1) magnification. When using natural light in the field, it is sometimes possible to erect a temporary wind break in the form of a small tent or screen of white or transparent material. I prefer to use an accessory called a Wimberley Plamp, which is particularly useful when photographing wildflowers and insects resting on long grass stems. This is simply a flexible arm that attaches to a tripod leg and can then be carefully positioned to hold your subject steady in front of the lens.

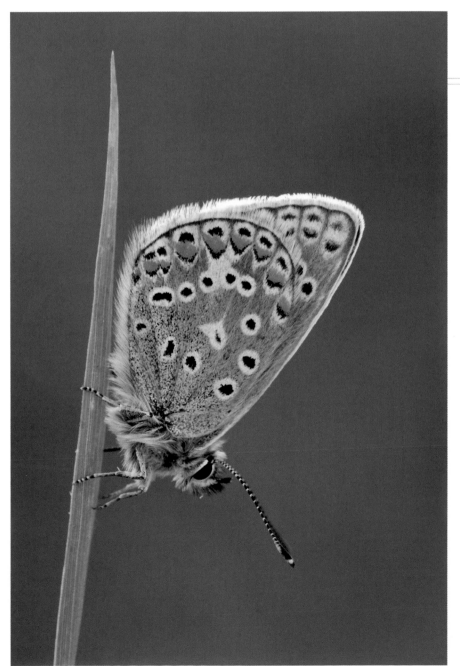

COMMON BLUE

I found this butterfly roosting on a long grass stem early one evening in late June. The air seemed still but once I had framed the insect through a macro lens, it soon became apparent that there was still a very slight breeze moving the grass stem – enough to cause severe blur at this magnification with an exposure time of one second. There were brief periods of complete calm but, to be on the safe side, I carefully positioned my Wimberley Plamp to hold the grass stem a little way below the butterfly. By stabilizing the stem in this way, it was no longer affected by the breeze and I was confident that my image would be sharp. The sun had set and the sky was clear so I used a gold reflector to inject some warmth into the butterfly, compensating for the blue colour cast that would otherwise result. Badbury Rings, Dorset, England.
Canon EOS-5D; EF180mm macro lens; EF2XII extender; 1 sec at f/11; ISO 100; manual focus; IS off; gold reflector; mirror lock-up; remote release; Wimberley Plamp; tripod with ball head.

79 Keep shooting to fine-tune composition

When you have found a good subject, do your best to extract every bit of potential from it. With the camera handheld, begin by exploring your subject from all sides, view it through different focal length lenses and consider how best to light it. When you have a composition you are happy with, attach your camera to a tripod and take some images. Review these on the rear LCD screen of your camera and consider how they could be improved. Your tripod now provides a support from which to further fine-tune your composition. Try going in a little tighter or backing off to include more of the subject. Try both vertical and horizontal formats. Try using different lens apertures. Try placing the focal point in different places to see how it affects the balance and flow of the composition. Very small movements can have a dramatic effect on your composition when shooting close-ups. Don't just give up once you have an image you are happy with – continue to explore the subject for more possibilities.

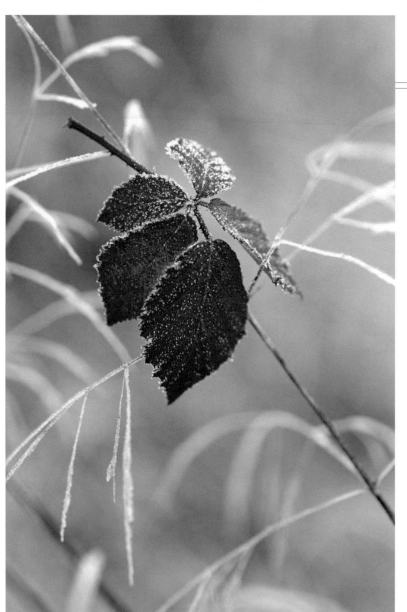

FROSTED BRAMBLE LEAF

On a cold winter's morning I found this bright red bramble leaf on the side of the path. I picked it up using tweezers to prevent the heat from my hand removing or damaging the frost that had formed on it. I then carefully placed it among some nearby frosted grasses. My first thought was to photograph the grasses, with the red leaf acting as a small focal point, using a telephoto lens and shooting against a dark background of conifer trees. That worked well, but I knew I would be able to extract more from this subject so I switched to a 90mm macro lens and hunted for further possibilities. I settled on this particular composition and took a couple of images using an aperture of f/16. These looked OK, but a little cluttered. I then opened the lens aperture up to f/2.8 and re-shot. The result was a much simpler and cleaner composition with a more diffused background. Powerstock Common, Dorset, England.
Canon EOS-1Ds; Tamron 90mm macro lens; 1/60 sec at f/2.8; ISO 100; manual focus; mirror lock-up; remote release; tripod with ball head.

Shoot early and late in the day 80

The best time to carry out close-up photography is early and late in the day when the quality of light is better and when there is less chance of wind movement spoiling your images. Early in the morning, the air can be very still but a breeze will often pick up during the day. It can become quite windy by the afternoon but, as the sun starts to sink towards the horizon, the breeze often dies down and around the time of sunset it may be calm again. There are, of course, rare days when there is no wind movement at all and these days should be exploited to the full. Insects tend to be less active around dawn and dusk so this can be the only time it is possible to photograph some species. When photographing butterflies in the early evening, you need to observe where they choose to settle as they quickly descend into long grass to roost and are then impossible to find yet alone to photograph. Bear in mind that some species of wildflowers do not fully open their petals unless the sun is striking them directly.

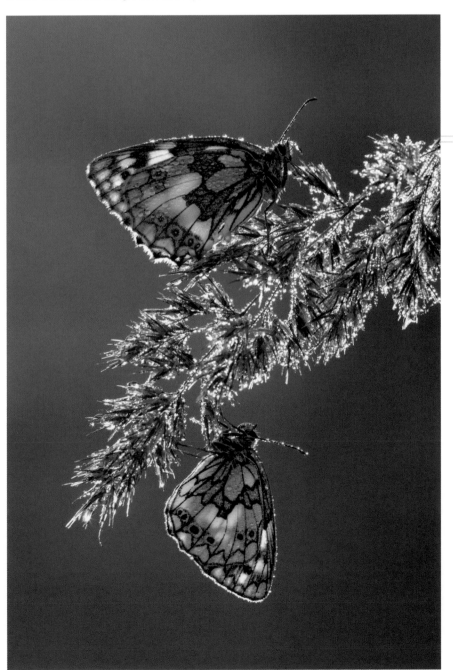

MARBLED WHITES

During a period where a high-pressure system was centred over my home region, I spent several days photographing butterflies. The still air created perfect conditions for capturing them at rest, even on long slender grass stems. I was hunting for marbled whites on a local nature reserve one afternoon when I found this pair. I observed them for some time and waited until they settled down in the long grass for the night. I decided not to take any pictures of them right then. Instead I very carefully coaxed them on to the tip of my finger and placed them on a nearby grass seed head. There was no breeze to disturb them and no rain was forecast so I left them there. I returned in the morning just before sunrise and soon found them again, but now they were covered in dew. I set up and waited for the first rays of sunlight to provide back lighting. I made my exposures and within minutes both butterflies were on the wing again. Powerstock Common, Dorset, England.
Canon EOS-5D; EF300mm lens; EF1.4X extender; EF25mm extension tube; 1/60 sec at f/11; ISO 100; manual focus; IS off; white reflector; mirror lock-up; remote release; tripod and ball head.

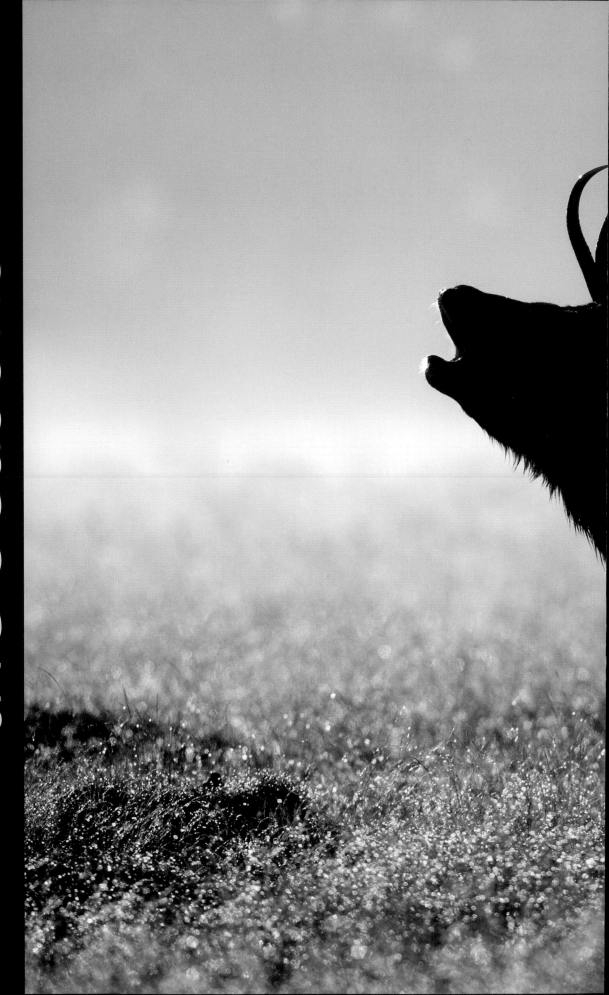

Photographing
the Seasons

81 Follow the seasons

The changing seasons and the yearly life cycles of animals and plants enable you to photograph a series of images throughout the year, which tell a story about the particular subject, habitat or location. Seasonal changes differ throughout the world with some areas displaying the four well-defined seasons of spring, summer, autumn and winter, while others simply have a dry season and a wet season. Wherever you are in the world, seasonal influences mean that most subjects will offer the best photographic opportunities at a particular time of the year, so it is important to research your subject to make sure you are prepared and in the right place to capture the best images possible. As a long-term project, try to shoot a sequence of seasonal images depicting the same scene or subject, such as a lone tree in a meadow or a woodland view. Choose a subject where the main elements do not change and try to maintain a common link or focal point in each image.

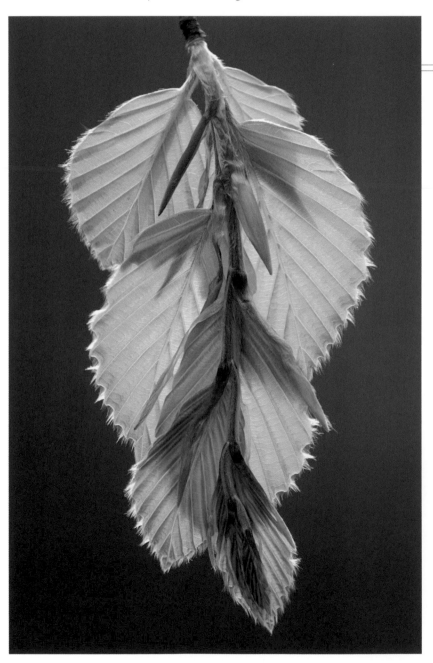

BEECH LEAVES

I photographed these leaves in early May in a forest close to my home. I had visited the trees daily, waiting for the stage where the fresh lime-green foliage cascades from the buds. It is a phase that does not last long so it was important not to miss it. I used a 400mm lens at a wide aperture of f/5.6 to achieve a nicely diffused background. A single extension tube allowed me to focus the lens close enough for a frame-filling image. The setting sun provided subtle back lighting that highlighted the hairs around the edges of the leaves. An occasional light breeze was causing the branch to sway slightly, so I set up a second tripod to one side of the branch and attached the flexible arm of a Wimberley Plamp (see page 109). The clamp held the branch in position while the exposure was made. Marshwood Vale, Dorset, England.

Canon EOS-1Ds; EF400mm lens; EF25mm extension tube; 1/8 sec at f/5.6; ISO 100; manual focus; white reflector; mirror lock-up; remote release; Wimberley Plamp; tripod with ball head.

Shoot spring flowers

Some of the first wildflowers to bloom each spring occur in deciduous woodland. There is a brief period in which to photograph them as they hurry to push up their leaves and flower before the canopy closes overhead, blocking out sunlight for the next six months. Be ready to capture the flowers when they are in pristine condition. Bright but overcast conditions are best, as the flowers will be fully open and diffused light will help you to record fine detail and accurate colour. Wildflowers on roadsides and hedge banks also flower early, followed by those in meadows and on coastal cliffs and islands. When photographing wildflowers, take care not to damage surrounding vegetation, which may form a microclimate for your subject plant. Where there are masses of wildflowers, consider using an exposure time of around one second to capture movement as the blooms sway in the breeze. You may need to use a neutral-density filter to achieve the necessary slow shutter speed. Make several exposures, as the effect will be different each time.

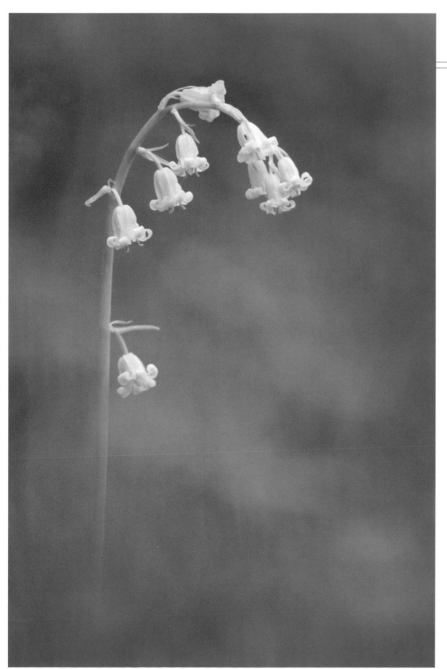

WHITE BLUEBELL

I found this single white bluebell surrounded by a dense patch of normal bluebells in a small beech wood in early May. I wanted to isolate the flower among the surrounding blooms so I used a 300mm lens with a 25mm extension tube. Bluebell plants have very delicate foliage that is prone to damage by trampling so I took great care not to squash nearby plants when setting up. The telephoto lens helped me achieve this by allowing me to shoot from a nearby path. The overcast light enabled me to record plenty of detail in the white flower and I used a white reflector to bounce light on to the underside of the blooms. The colour of bluebells was notoriously difficult to record accurately on transparency film. Thankfully, with digital technology you are now able to fine-tune colour in post-production (see page 132) to match the natural tones of the plant. Ashridge, Hertfordshire, England.

Canon EOS-5D; EF300mm lens; EF25mm extension tube; 1/60 sec at f/4; ISO 100; manual focus; white reflector; mirror lock-up; remote release; tripod with ball head.

83 Photograph migrant birds

During spring and summer, migrant birds that have spent the cold winter months further south move north to breed in areas where there are rich supplies of food for their chicks. Species such as arctic terns, swallows and wheatears provide good opportunities for photography. Towards the end of summer, autumn migration begins and these birds and their young make the journey south to warmer climes. This can be a great time to photograph wading birds such as knots and godwits, especially individuals that have yet to lose their colourful breeding plumage. In some locations, huge numbers of migrating wading birds roost en masse, with flock sizes reaching over 100,000 birds when the highest tides occur. From September onwards, flocks of geese move south to escape the harsh conditions further north, and during the winter months migratory thrushes such as redwings and fieldfares can be attracted to feeding stations with windfall apples and pears.

Photographing the Seasons

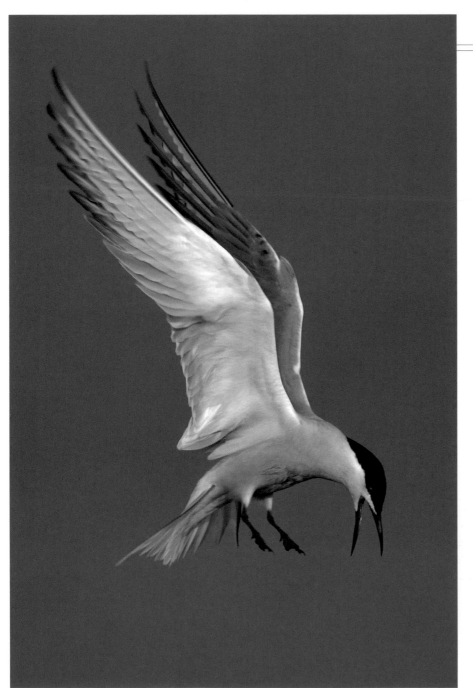

COMMON TERN

This tern was photographed at the start of the breeding season in early April. The birds were very active, with plenty of courtship and mating taking place in the colony. The terns were nesting on an island in a large coastal lagoon and I was able to set up on the roadside just a short distance away. Because the island and road are separated by a narrow strip of water, the birds remain relaxed in the presence of birdwatchers and photographers. This particular bird was just about to land near its nesting site and was calling loudly to its partner. Terns can be difficult to follow in flight, particularly when they are so close. Therefore, I decided to handhold my camera and 500mm lens as I find it easier to follow fast or erratically moving subjects this way. To prevent my arms from getting tired, I rested the lens on top of my tripod between shots. Texel, Holland.

Canon EOS-1Ds; EF500mm lens; 1/1600 sec at f/5.6; ISO 250; AI Servo focus; central focusing point; IS mode 2; handheld.

Shoot wildlife in winter

Photographing wildlife in winter can be a challenge as conditions can be harsh, both for photographer and subject. The winter months can create beautiful conditions for nature photography with ice, frost and snow producing a pristine environment in which to work. Snow can conceal unwanted elements, often resulting in wonderfully simple compositions. It can also reflect light from the sky, illuminating the underside of your subject – particularly useful when photographing birds in flight. Setting the correct exposure in such conditions can be tricky, especially if you are working in an automatic exposure mode, as the bright snow will confuse the exposure meter, resulting in an underexposed image. The solution is to set your exposure manually, taking a meter reading from the snow and increasing the camera's suggested exposure by 1½ to 2 stops. Freezing conditions can make it difficult for animals and birds to find food and water, so a feeding station can produce great results at this time of the year. Maintain feeding throughout the period of cold weather and make sure there is a supply of unfrozen water available as often as possible.

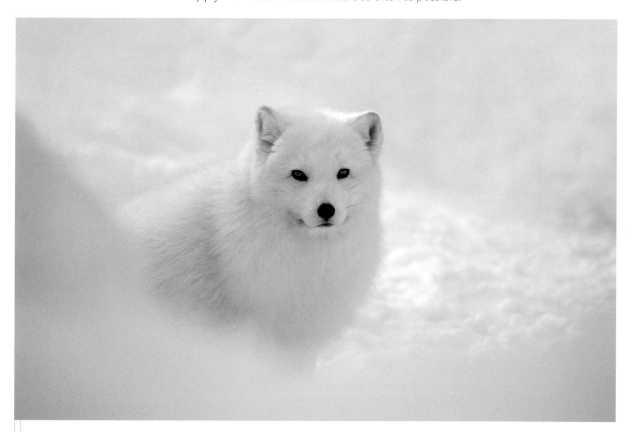

ARCTIC FOX

This image was taken in a wildlife park in Finland. Fortunately, the large enclosure and recent heavy snowfall helped to disguise any evidence of the animal's captivity. The fox was curious and kept its distance to begin with. When I remained still, its inquisitive nature led it to investigate a little closer. I used a 500mm lens with the aperture wide open at f/4, using the shallow depth of field to help conceal a distant fence. When the fox appeared from behind a large snow bank I made several exposures. The fox looked alert, holding both ears erect, and was framed on all sides by pure white snow. The resulting symmetry led me to compose the image with the subject right in the centre of the frame, staring down the lens. Ranua Wildlife Park, Finland.
Canon EOS-1D MkII; EF500mm lens; 1/250 sec at f/4; ISO 250; one-shot AF; central focusing point; IS mode 1; tripod with fluid video head.

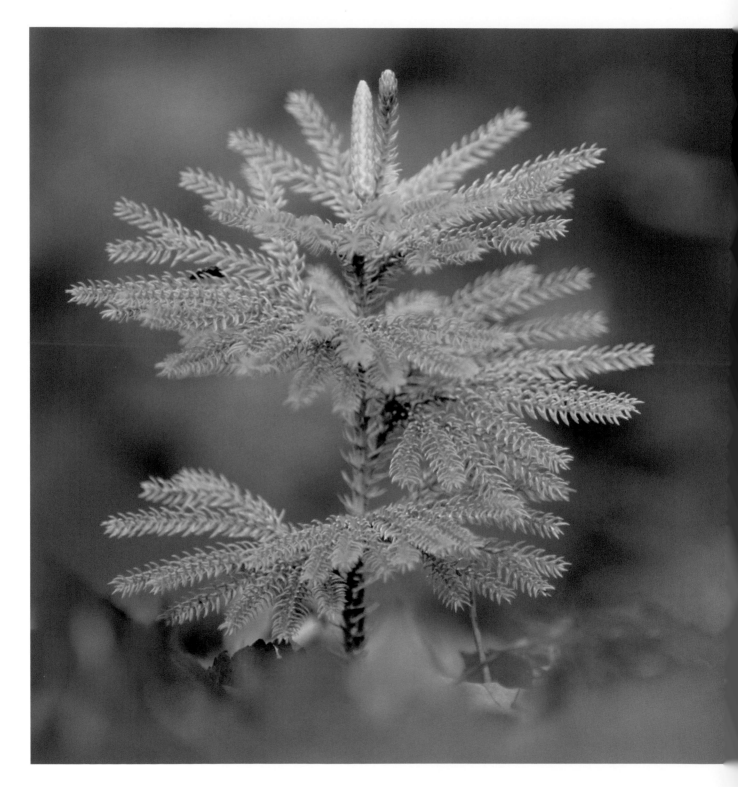

The autumn months provide some of the most intense colours in nature. Deciduous trees withdraw chlorophyll from their leaves, revealing vibrant red, orange and yellow pigments. This provides plenty of scope for photographing woodland scenes and close-up details. The colours can also be used as a dramatic backdrop to images of wild animals and birds. Some years ago, I planted several maple trees in my garden. I now use these as a backdrop to a temporary feeding station, which I set up to photograph garden birds every autumn. New England is particularly famous for its colourful autumn foliage but, in good years, deciduous forests throughout the northern hemisphere can put on equally impressive displays. In mountainous areas, larch trees turn the hillsides golden, while in arctic and sub-arctic regions the low-growing vegetation of the tundra becomes a patchwork of stunning colours. Autumn begins in the far north and the colours slowly spread south. A similar effect occurs on mountainsides, with the tree line turning gold and the colour gradually spreading down into the valleys. Autumn is a short season so make a list of good locations and be prepared for a few weeks of frantic photography.

CLUBMOSS

Autumn is a great time to photograph close-up details using colour as a major element. I discovered this clubmoss under a large red maple tree at the end of a trip to photograph the fall foliage in New England. It was late October and vibrant red leaves covered the ground beneath the tree. Using a telephoto lens and shooting from a very low angle, I was able to completely fill the frame with red colour. A wide aperture meant that only the subject and a few red leaves in the same plane of focus appeared sharp. The light was diffused by an overcast sky, helping me to record the rich colours without excessive contrast and I used a polarizing filter to saturate the hues further. The clubmoss would have been present a few weeks earlier but without the fallen leaves there is no way that I would have been able to capture an image with so much impact. White Mountains National Forest, New Hampshire, USA.

Canon EOS-1Ds; Sigma 400mm f/5.6 APO Macro lens with polarizing filter; 1/15 sec at f/5.6; ISO 100; manual focus; mirror lock-up; remote release; angle finder; beanbag.

86 Photograph young animals

The endearing qualities of young animals can produce very successful photographs. Try to capture playful activity as young animals interact with parents and siblings. Back lighting can work particularly well, as it highlights fur and soft down. The young of some species can be approached fairly closely, depending on how accustomed they and their parents are to humans. A good knowledge of your subject is essential, as you need to know when their offspring are likely to emerge – for most species though this is the spring. Some animals will desert their young if they notice human scent around them – for this reason you must never touch the young of any wild animal. Don't spend too long photographing one particular young animal, as you may be preventing its parents from returning to feed it. Always be wary of nearby adults, as many species will aggressively defend their territory and their young. Back off immediately if your approach causes any aggravation whatsoever.

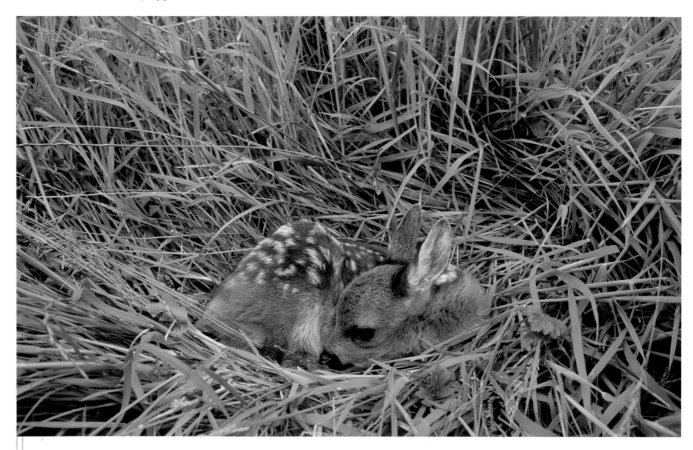

ROE DEER FAWN

I discovered this fawn by chance hidden in the long grass of a hay meadow while I was out photographing landscapes. Roe deer leave their young hidden in long grass while they feed during the day. They are very prone to desertion of their fawns if they suspect any human interference. It was essential for me to move on quickly and to leave as little scent as possible. Fortunately, I already had my camera and wide-angle lens attached to my tripod so I simply leant over and took two frames. I was close to the fawn for no more than a minute. The exaggerated perspective of the wide-angle lens caused the grass to radiate out towards the edges of the frame, helping to draw attention in towards the fawn while illustrating its concealed position in the long grass. I had a polarizing filter attached to the lens, which helped to saturate the colours by removing reflections from the shiny blades of grass. Marshwood Vale, Dorset, England.

Canon EOS-1Ds; EF17–40mm lens with polarizing filter; 1/8 sec at f/16; ISO 100; manual focus; mirror lock-up; remote release; tripod with ball head.

Work in cold climates

There are excellent opportunities for nature photography to be found in cold climates. It can be difficult for some animals and birds to find food so they are easily attracted to bait at feeding stations. Areas of unfrozen water will attract large numbers of water birds to congregate in small areas. When working in cold conditions, steps need to be taken to protect your camera equipment. The main problem is moisture, which forms when camera equipment is taken from a cold environment into a warm environment. This is best avoided as much as possible but when there is no option you should always place your camera bag inside a tied plastic bin liner before bringing it indoors. Allow the bag to heat up to room temperature before opening it. Moisture then condenses on the inside of the bin liner rather than on your camera equipment. Take your camera bag outside well before you need to take your equipment out of it, otherwise condensation can form on the glass elements. If this freezes it can be very difficult to remove. When travelling to a location in a vehicle, have the heating switched off and wear your coat and gloves instead.

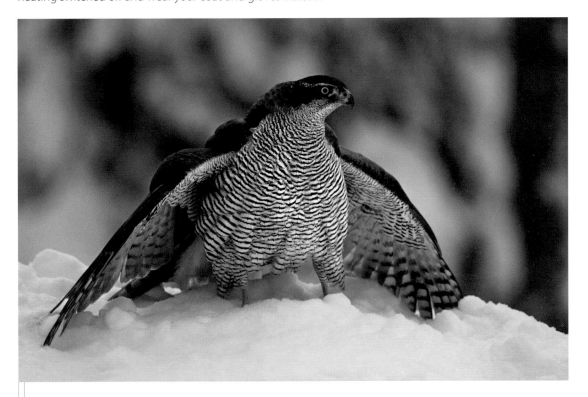

GOSHAWK

This image was taken from a permanent hide in a remote area of forest. To make absolutely sure that the birds would not see me, I entered the hide well before dawn and did not leave until it was dark. The temperature was around -20°C during the day. Even though I had done my best to keep my camera equipment as close to the outside temperature as possible, the front element of my lens still fogged over when I first set up. Thankfully, it was still dark and by the time the goshawk appeared the lens had acclimatized and the condensation had gone. My camera batteries held up well while in the hide but when working outside the previous day, I noticed that they lost their charge quickly in the extreme cold. Spares were kept warm in my inside coat pocket. Kouvola, Southern Finland.
Canon EOS-1D MkII; EF500mm lens; 1/250 sec at f/5.6; ISO 400; AI Servo focus; IS mode 2; tripod with fluid video head attached to shelf in hide.

88 Photograph leaves and seeds

In the autumn and winter months, the previous summer's vegetation has died back to reveal the skeletal remains of plants such as hogweed, teasel and clematis. Some trees will hang on to their dead leaves until they are pushed from the twigs by fresh buds. Other leaves will decay on the ground leaving just the structural leaf skeleton behind. All of these are interesting subjects to photograph, providing attractive graphic shapes and textures as well as illustrating a natural process. The first frosts of winter transform these decaying structures into spectacular icy decorations. It can prove difficult to isolate these subjects from the cluttered surroundings in which they are normally found, such as hedgerows and among woodland undergrowth. However, there is no harm to be done by moving fallen leaves or seed heads to a more photogenic location if necessary.

HOGWEED SEED HEADS

I found this frosted seed heads at the base of a hedge. My main aim was to isolate the seed head from the cluttered background as much as possible. For maximum impact each floret needed to be clearly defined against the dark ground beneath the hedge. This result would not have been possible had I used a 50mm macro lens because I would have been forced to set up much closer to the seed head in order to obtain a frame-filling composition. With its relatively wide angle of view this lens would have included a large area of background. By using a 180mm macro lens instead, I was able to fill the frame from further away and the much narrower angle of view meant that I only included a small portion of background. This made it much easier to eliminate any elements that would have been obtrusive in the composition. Lyme Regis, Dorset, England.
Canon EOS-5D; EF180mm macro lens; ½ sec at f/8; ISO 100; manual focus; tripod with ball head.

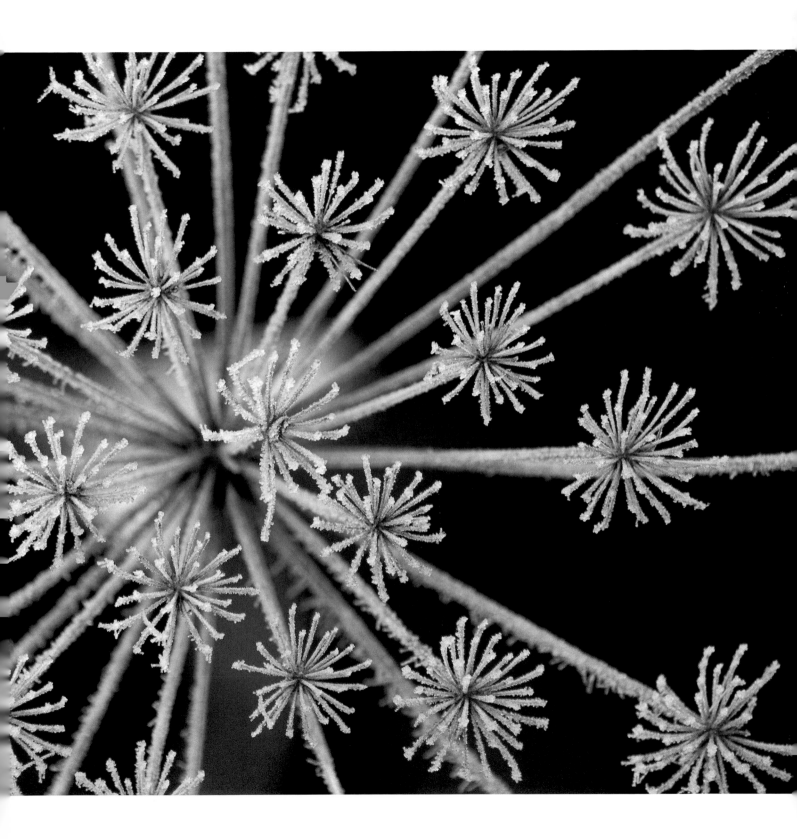

89 Work in hot, dry climates

In hot, dry locations animals and birds will be attracted to waterholes. These can be great locations for photography, as rivals, predators and prey will be drawn together, creating opportunities to capture both action and interaction. Dust can be a major concern when working in these environments so avoid changing lenses any more than is absolutely necessary. Check your camera's sensor daily by taking a shot of the sky with a wide-angle lens at an aperture of f/22. Zoom into the image on your camera's rear LCD screen (or on a laptop if you have one) and check for black spots. If the sensor needs cleaning, do it in a dust-free environment. My preferred method of sensor cleaning is to blow loose dust from the sensor using a large bulb blower and then polish the sensor using a Sensorklear Lenspen. During the day, atmospheric heat distortion can result in poor image quality especially when using long telephoto lenses. Therefore, it is best to work as much as you can around dawn and dusk when the quality of light is better and the temperature is more bearable.

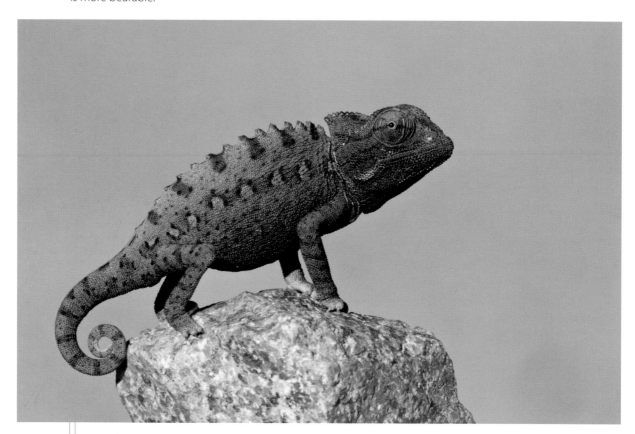

NAMAQUA CHAMELEON

Chameleons are a common sight in some parts of the Namib Desert. I spotted this one perched on a small boulder by the side of the road. It was early evening and although the temperature was beginning to fall, the gravel surface of the road was still blisteringly hot. The chameleon had changed its skin colour to dark brown in order to absorb the last rays of warm sunlight before the cold desert night set in. I supported my 500mm lens on a beanbag and used an angle finder to avoid having to lie down on the scorching ground. The very low shooting angle provided an eye-level perspective while also eliminating several distracting white rocks that would otherwise have appeared in the background. I set up with the sun directly behind me so that the chameleon was evenly lit. The eyes of a chameleon are quite deeply recessed so I had to wait for some time until it looked in exactly the right direction to show a catchlight. Namib-Naukluft National Park, Namibia.
Canon EOS-5D; EF500mm lens; EF25mm extension tube; 1/1250 sec at f/8; ISO 200; one-shot AF; single manually selected focusing point; angle finder; beanbag.

Photograph ponds, lakes and waterways

Freshwater habitats are particularly rich in wildlife. They tend to be heavily influenced by the seasons, resulting in new photographic opportunities throughout the year. Rivers will be home to a variety of insect life such as dragonflies, damselflies and mayflies, all of which are best photographed early or late in the day when they are at their least active. Birds such as kingfishers and goosanders prefer the flowing water of a river. The still water of a lake attracts birds such as great crested grebes, moorhens and various species of ducks. These can be a real challenge to photograph well because the best shooting angle is at the bird's eye level. This can sometimes be achieved from the shore of the lake but on occasions a floating hide may be the only option. Ponds, whether in private gardens or public parks, are one of the easiest freshwater habitats in which to take photographs, as the wildlife is contained in a relatively small area.

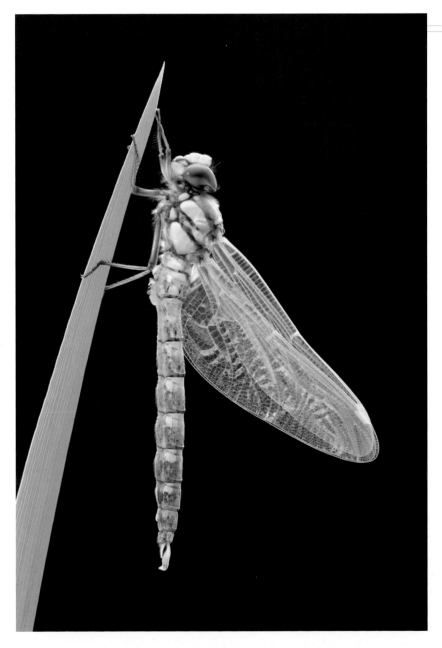

SOUTHERN HAWKER

There is a small pond in my garden that has a healthy population of aquatic life. There are subjects to photograph in and around the pond throughout the year. Hundreds of frogs and toads spawn there in early spring. In midsummer some of the larger dragonfly larvae climb out of the water and on to the stems of water plants – usually in the late afternoon. I watch for this occurrence as, early the next morning, there will be a brief opportunity to photograph the newly emerged dragonflies before they take to the air. This southern hawker was photographed in late July just before sunrise. The larvae had crawled up the leaf of a yellow flag iris where it had hatched overnight into this beautiful dragonfly. The insect has to pump fluid around its body and wings before it can fly, providing some time to take photographs. I used two mirrors in front of and behind the insect to provide reflected illumination. Lyme Regis, Dorset, England.

Canon EOS-1Ds; EF300mm lens; EF25mm extension tube; ½ sec at f/11; ISO 100; manual focus; two mirror reflectors; mirror lock-up; remote release; tripod with ball head.

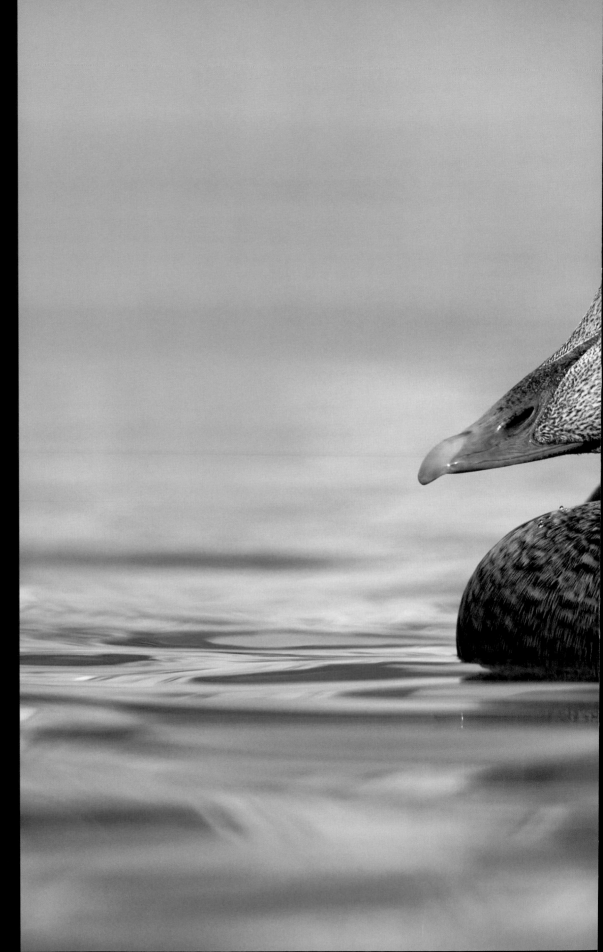

Digital Cameras &
Post-Production

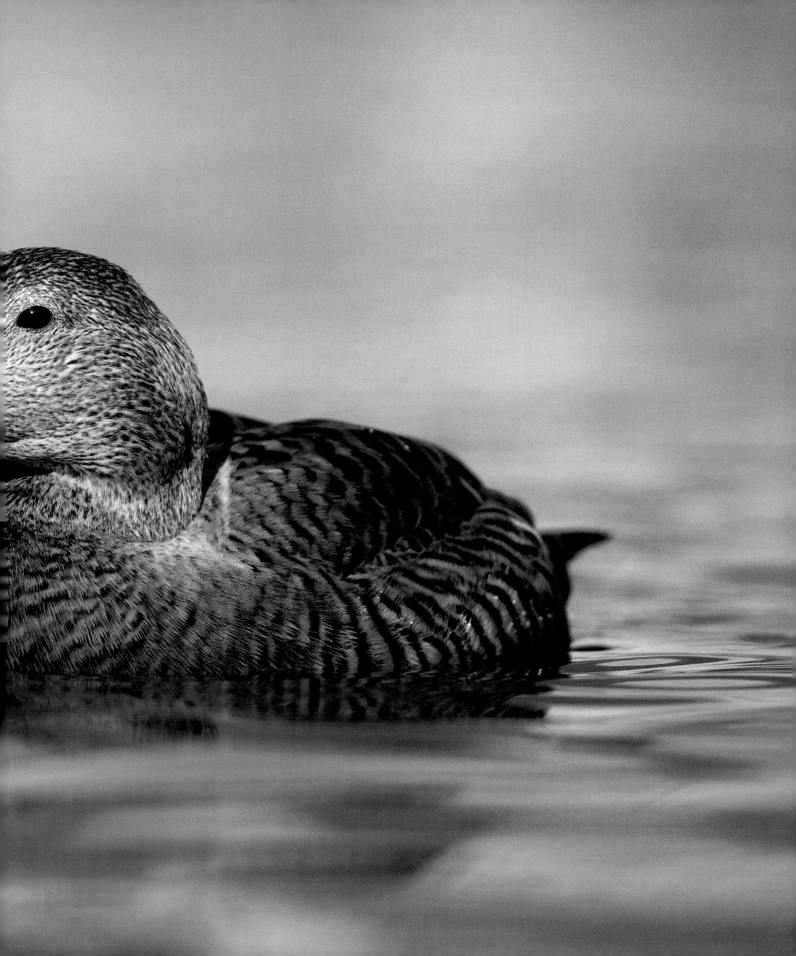

91 Recognize the advantages of digital capture

Digital cameras provide many advantages over shooting on film. The greatest benefit is the instant feedback provided by the rear LCD screen. It is now possible to check exposure, composition and sharpness in the field. Being able to make any necessary changes and re-shoot immediately means that you can be confident you have secured a satisfactory image before moving on to another subject. After the initial purchase of a digital camera and memory cards, there are very few ongoing costs. This frees you up to make good use of your camera's motor drive, increasing your chances of capturing great action and flight images. With high-capacity memory cards there will be no more missed opportunities due to changing films every 36 frames. You also have the ability to change ISO settings between shots to compensate for changing light levels, something that was impossible on film.

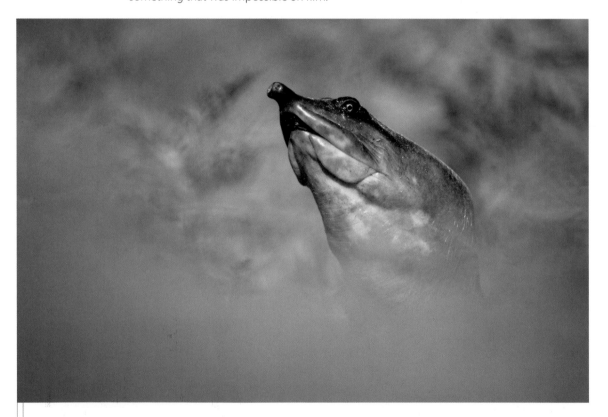

FLORIDA SOFTSHELL TURTLE

This turtle was photographed in dense vegetation with sticks and debris all around. By reviewing the image on my camera's rear LCD screen I was able to determine just how to overcome the problem. I kept re-shooting from lower and lower viewpoints until I was happy that I had achieved a clean composition. Eventually, I switched from a tripod to a beanbag to achieve the lowest possible shooting angle, which eliminated all the distracting twigs in the background. Digital files are free from the grain of transparency film and this becomes all the more evident in images that include sky or large areas of diffused vegetation, as in this shot. Even at relatively high ISO settings, digital noise is barely noticeable, enabling you to obtain sharp images in dim lighting conditions and facilitating the reproduction of large prints. J. N. 'Ding' Darling National Wildlife Refuge, Sanibel Island, Florida, USA.

Canon EOS-1Ds; EF500mm lens; EF25mm extension tube; 1/1600 sec at f/4; ISO 100; one-shot AF; single manually selected focusing point; angle finder; beanbag.

Choose between RAW and jpeg

Both RAW and maximum-quality JPEG file formats will record very good quality images. The problem with JPEGs is that settings vital to image quality, such as exposure, white balance, contrast and colour saturation, are rigidly set in-camera. Small adjustments can be made to a JPEG file in Photoshop without noticeably affecting the image quality, but there is a limit to how much can be done. A poorly exposed JPEG file can rarely be salvaged successfully. RAW files on the other hand have no set parameters. RAW conversion software enables you to fine-tune image colour and exposure very precisely while maintaining maximum detail and image quality (see pages 131–132). There is still a limit but a poorly exposed RAW file has a far greater chance of being successfully rescued. RAW files retain 12 or 14 bits of data, whereas JPEG files are saved with only 8 bits of data, which can result in poor graduation of tone and visible banding, especially when significant adjustments are made in Photoshop. JPEGs take up less space on your memory card but the flexibility of a RAW file offsets any benefits a JPEG file might provide the nature photographer.

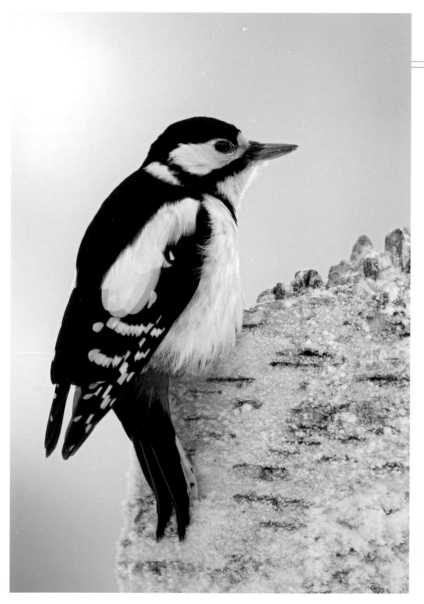

GREAT SPOTTED WOODPECKER

I shoot all my images in RAW format only. I don't shoot RAW + JPEG as this takes up more room on my memory card. I use Breezebrowser software to review my RAW files and to perform an initial edit, as it loads RAW file previews very quickly. Retained files are then re-edited in Adobe Bridge before being processed into 16-bit TIFF files using Adobe Camera RAW. Here I make fine adjustments to exposure, white balance, contrast and colour saturation. The TIFF files are then opened in Photoshop for further adjustment before being saved to a hard drive and backed-up for security. This image was taken in low winter light. Using Daylight white balance meant that the image recorded with a blue colour cast. This was easily corrected in Adobe Camera RAW, where I also extracted extra detail from darker parts of the bird's plumage. Oulanka National Park, Kuusamo, Finland. **Canon EOS-1D MkII; EF500mm lens; 1/125 sec at f/5.6; ISO 400; AI Servo focus; single manually selected focusing point; IS mode 1; fluid video head attached to shelf in hide.**

93 Ensure correct camera set-up

In order to obtain the best possible results from your digital SLR there are a few settings that should be checked before you start. These are all based on shooting RAW image files. In the camera's main menu, select the Adobe RGB colour space. Turn off the 'Shoot without card' option to avoid the embarrassment of taking a sequence of great images only to find there was no memory card in your camera. Turn off 'Long exposure noise reduction' as it extends the in-camera processing time of long exposures and digital noise is best dealt with in post-production anyway. The default settings of most cameras include an audible beep to let you know when focus has been acquired or a new function set. This irritating beep should be turned off so as not to disturb your subject or other photographers.

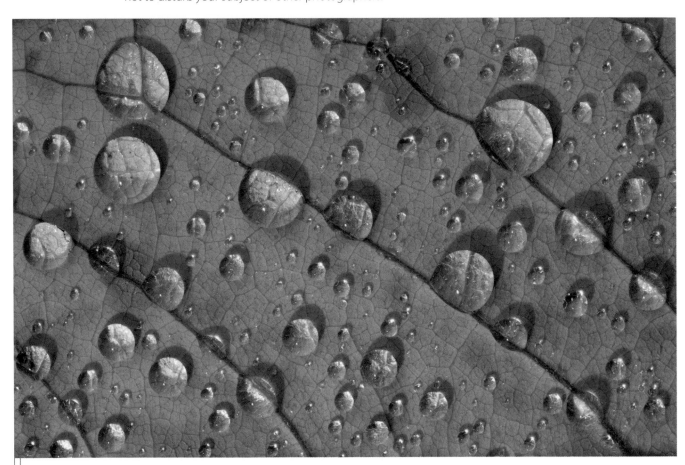

DEW DROPLETS

This image of a fallen magnolia leaf covered in dew was lit with a mixture of ambient daylight and tungsten torchlight. The ambient light was changing slightly all the time and I was moving the position of the torch between shots. If I had set the camera to Auto white balance (AWB) each frame would have recorded with a slightly different white balance, determined by the camera. For this reason, I leave all my camera bodies set to Daylight white balance at all times. This is simply to provide consistency when reviewing images at the initial editing stage – all similar images have the same white balance and can be easily judged against each other. As I shoot in RAW file format, the white balance of each image will be independently fine-tuned and set during conversion of the RAW file. Lyme Regis, Dorset, England.

Canon EOS-5D; Tamron 90mm macro lens; 1 sec at f/11; ISO100; manual focus; mirror lock-up; remote release; torch; tripod with ball head.

Fine-tune exposure

Never rely on the brightness of the image displayed on your camera's rear LCD screen to determine the correct exposure – always review the detailed information shown by the histogram (see page 25). A good in-camera exposure will provide you with more scope to retain or recover highlight and shadow detail in post-production. Use RAW conversion software to fine-tune the exposure of your image as precisely as possible. Sliders allow the recovery of detail in shadow and highlight areas where necessary. It is also possible to enhance the contrast of an image using either sliders, or curves if you need more control. The resulting TIFF file can then be opened in Photoshop where there are further tools available, including Levels, Curves and Shadow/Highlight, to fine-tune exposure, either to the whole image or selectively via layers or selections.

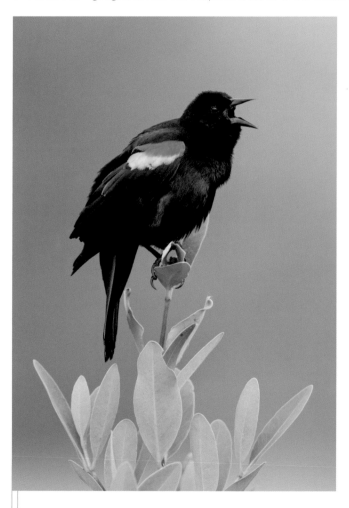

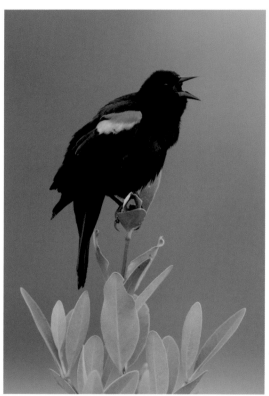

RED-WINGED BLACKBIRD

This bird was photographed in overcast light. This is not a particularly high-contrast image and all the image data was contained well within the histogram, making it relatively easy to process. Nevertheless, the RAW file still appeared quite flat and dull (small image), which is often the case. However, with a few minor adjustments to exposure and contrast the image can be brought to life. In Adobe Camera RAW, I increased the exposure by ½ stop and increased contrast by applying an S-shaped curve. I also used the Fill Light slider to reveal more detail in the bird's black plumage. The resulting image has much more impact as a result (main image). I keep a close eye on the histogram at all three stages of image production – when taking the image, during RAW conversion and in Photoshop. All data must remain within the histogram graph or the image will suffer from loss of detail in the shadows, the highlights or both. Fort De Soto, Florida, USA.

Canon EOS-1D MkII; EF500mm lens; EF1.4X extender; 1/800 sec at f/5.6; ISO 250; one-shot AF; central focusing point; IS mode 1; tripod with fluid video head.

95 Fine-tune colour

The colour and tone of digital images can be fine-tuned very precisely using RAW conversion software such as Capture One or Adobe Camera RAW. White balance can be adjusted to remove colour casts and provide images with a warm, cool or neutral tone as required. Individual colour channels can be adjusted independently, which can be useful if you wish to darken a blue sky or saturate green foliage without affecting the rest of the colours in the image. Make as many adjustments as possible in the RAW conversion software before saving the image as a 16-bit TIFF file. Further adjustments can be made in Photoshop, either to the image as a whole or selectively using layers or selections, using functions such as Color Balance and Hue/Saturation found under the Image>Adjustments menu. The ability to control colour so precisely enables you to produce images that exhibit very accurate, natural colours – an essential requirement for images of the natural world.

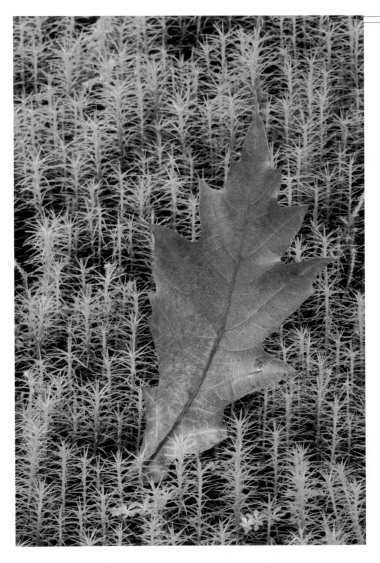

RED OAK LEAF IN STAR MOSS

This image was taken in the shade on a cloudless day. The clear sky above was causing a strong blue colour cast, sapping colour from the red leaf (small image). When shooting transparency film I would have used a warm-up filter to correct this colour cast, but with digital capture it is far easier to make corrections to the RAW file in post-production. This way, maximum image quality is retained by not placing an extra piece of glass or plastic in front of the lens. There is also the added benefit of not having to carry as many filters in the field. On this occasion, I did use a polarizing filter to remove reflections from the shiny surfaces of both the leaf and the moss, which helped to enhance overall colour saturation. When converting the RAW file in Adobe Camera RAW, I simply increased the colour temperature and tweaked the tint slider until I achieved a result that matched the colours I saw at the time (main image). Loch Lomond and the Trossachs National Park, Scotland. **Canon EOS-1Ds; Tamron 90mm macro lens with polarizing filter; ISO 100; ½ sec at f/16; manual focus; mirror lock-up; remote release; tripod with ball head.**

Recover lost highlight detail

When shooting in RAW image format it is sometimes possible to recover detail in overexposed highlights during conversion of the RAW file. This is best achieved by converting the RAW file twice. First, covert the file with settings optimized for the highlights – reduce the exposure to the point where the histogram shows that there is detail in the brightest areas and use the Highlight Recovery slider to extract further detail. Then convert the same RAW file again, but this time with settings optimized for the rest of the image. Open the two resulting 16-bit TIFF files in Photoshop. Select the second image and paste it on top of the first by clicking Edit>Select All>Copy then Edit>Paste (or Command-A, Command-C, Command-V). This automatically creates a second layer. Click 'Add Layer Mask' at the bottom of the Layers palette. Now select the Eraser tool and set a soft brush to the appropriate size for the area you will be working on. Set the brush Opacity to 25% and paint over the overexposed areas to reveal detail from the darker image beneath. When you have finished, flatten the layers (Layer>Flatten Image) and save the final image.

ATLANTIC PUFFIN

This puffin was photographed in bright late afternoon sunlight. By making sure the sun was directly behind me, I was able to keep the contrast to a minimum, as all parts of the image are evenly lit. However, the highly reflective white plumage on the bird's breast appeared a little washed out (small image). When processing the image I made two conversions of the same RAW file, as described above, which helped me to reveal sufficient detail in the white plumage. Once the two layers were flattened, I selected the brightest areas of the image by clicking Select>Color Range>Highlights. I feathered this by 15 pixels (Select>Modify>Feather Selection) and then used Photoshop's Shadow/Highlight function (Image>Adjustments>Shadow/Highlight) to extract even more definition from the white feathers (main image). Isle of May, Firth of Forth, Scotland.
**Canon EOS-1Ds; EF500mm lens; 1/1000 sec at f/8; ISO 250;
AI Servo focus; single manually selected focusing point;
tripod with fluid video head.**

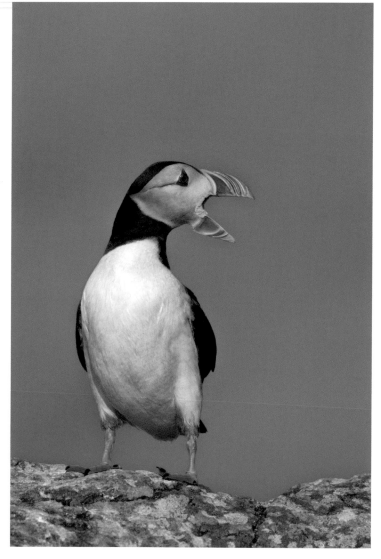

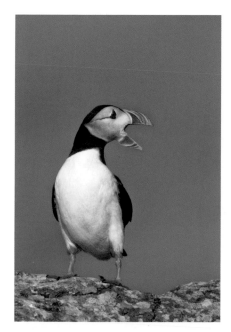

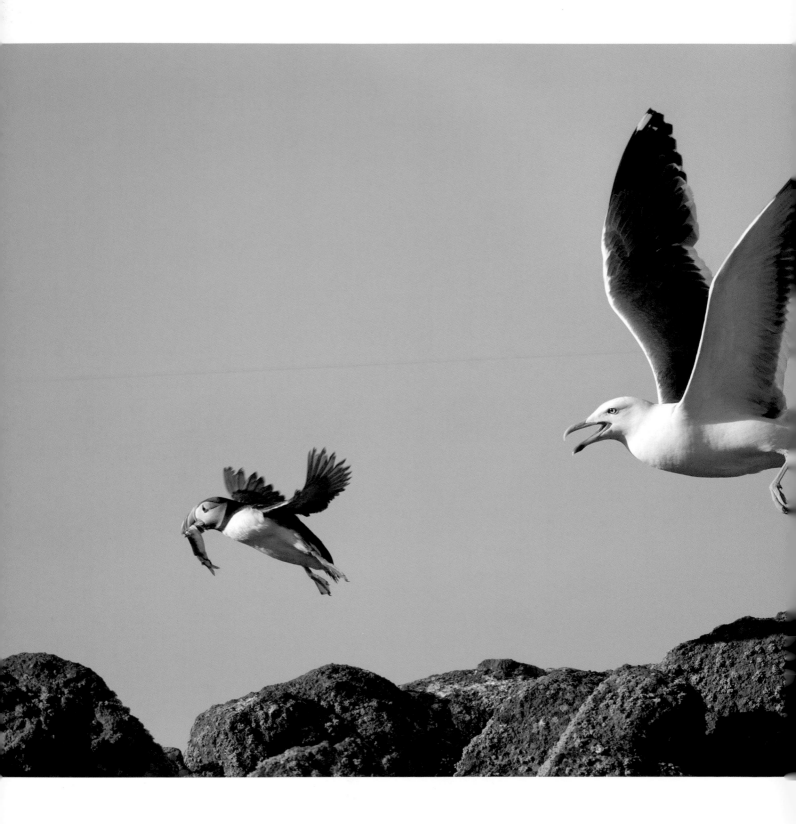

To clone or not to clone?

Cloning is something of a contentious issue in nature photography. Most photographers aim to record nature and natural events as truthfully as possible. Therefore, should you really remove elements from an image simply to improve the aesthetics? Perhaps you should limit cloning to the removal of sensor dust?

In my view, Photoshop simply continues the creative process beyond actually taking the photograph. Cloning tools enable you to improve upon the image you have taken subtly by copying an area of similar colour and texture from a different part of the image and painting the copied pixels over the area you wish to remove. In most cases, photographers will strive to get everything right in-camera, and with subjects such as wildflowers and fungi this should be achievable. However, when photographing wild animals in action and birds in flight there will inevitably be occasions where the odd stray wing tip or branch will detract from an otherwise successful shot. You have to make the decision whether to enhance the image by cloning or to be content with an image that is aesthetically less then perfect but entirely truthful in content.

PUFFIN AND LESSER BLACK-BACKED GULL

I had to react fast to capture this shot of a puffin being chased by a gull. Unfortunately, I also caught the tail of a second puffin on the left edge of the frame (small image). This was very distracting and spoiled an otherwise successful image. Therefore, I had no issue about cloning out the offending bird (main image). My personal view is that, providing the natural history aspect of the image is unaffected, cloning out distracting elements is acceptable. When photographing fungi I will not clone out marks or debris as they form an important, illustrative element of the subject and its habitat. Birds very often have dirt on their beaks from feeding and while this is a natural occurrence it can spoil an otherwise perfect bird portrait. So, I will sometimes use the Clone tool in Photoshop to clean up a bird's beak where this is an issue. At the same time, I can fully appreciate the view of those who would not. Isle of May, Firth of Forth, Scotland.
Canon EOS-1D MkII; EF500mm lens; 1/2500 sec at f/4; ISO 250; AI Servo focus; 45 active focusing points; tripod with ball head.

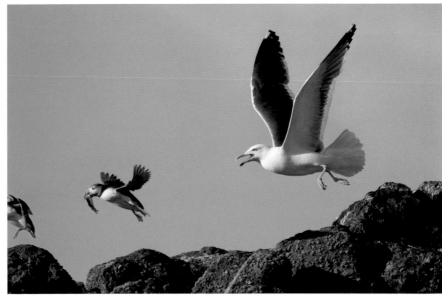

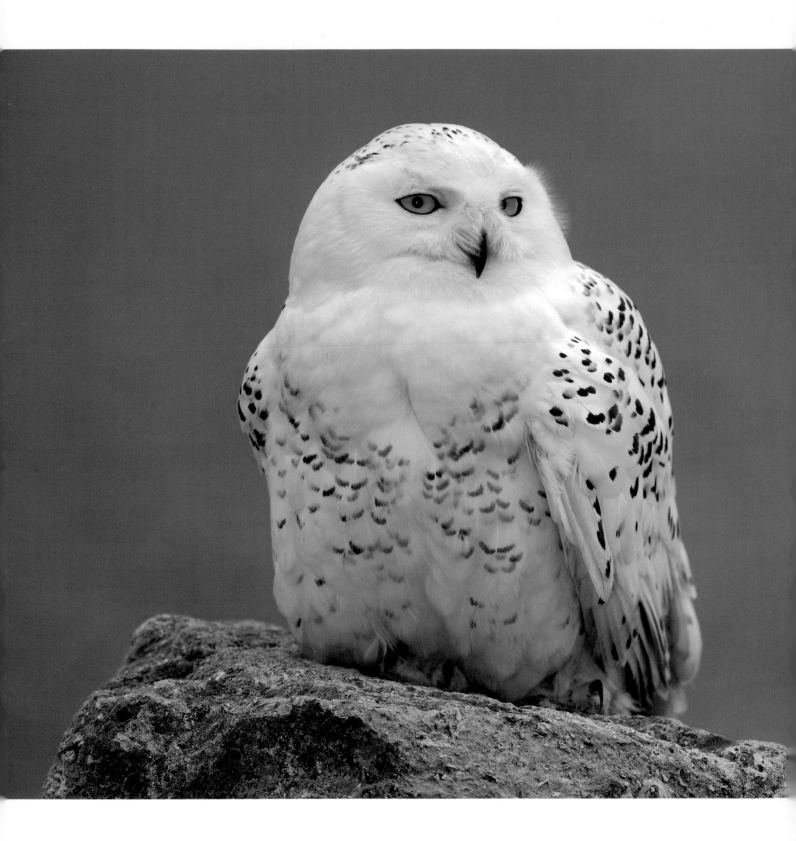

Brighten the eyes of your subject

The eyes of a subject are normally the first place you look when viewing an image, so they need to be bright and clear. Dull eyes result in a lifeless image. Unfortunately, the eyes of many subjects can record quite dark depending on the lighting conditions at the time. However, Photoshop allows you to overcome this problem by selectively brightening parts of an image. Even when there is no catchlight, there will still be light reflected in the eyes and this can be enhanced. Use the Freeform Pen Tool to draw carefully around each eye. Go to Window>Paths and select 'Load path as a selection'. Go to Select>Modify>Feather Selection and set a Feather Radius of 1 pixel. You can now adjust the brightness and contrast of the eyes using Levels (Command-L) or Curves (Command-M). You may wish to boost the saturation of the colour of the pupil a little as well (Image>Adjustments>Hue/Saturation, or Command-U). Always apply equal adjustments to each eye, even if one is darker than the other. Don't overdo your adjustments or the manipulation will be noticeable.

SNOWY OWL

This captive-bred owl was photographed on a beach. The tethers were concealed by its dense white plumage. The conditions were heavily overcast so I used a weak burst of fill-in flash to inject some light into its eyes. However, they did not sparkle as much as I had hoped so I brightened them in Photoshop. The crops below show the eye before (left) and after (right). When making selective adjustments to an image I always work on a duplicate layer, enabling me to fine-tune the result simply by adjusting the Opacity of that layer. This image was taken at ISO 400 and I increased the brightness of the eyes by about 1 stop. This resulted in quite visible colour noise showing in the eyes. The solution was to desaturate unwanted colours independently using Hue/Saturation (retaining the yellows) and then apply a little noise reduction via Filter>Noise>Reduce Noise. West Bexington, Dorset, England.

Canon EOS-1D MkII; EF500mm lens; 1/250 sec at f/8; ISO 400; one-shot AF; IS mode 1; Speedlite 550EX at -3 stops; tripod with fluid video head.

99 Use tone mapping to reveal texture

Capturing textural detail in birds and animals with very dark plumage or fur can be difficult. The best method I have found of enhancing textural detail in dark subjects is to use a process known as tone mapping. This is a method normally associated with high dynamic range (HDR) photography, but it can also be utilized with any 16-bit digital image via a Photoshop plug-in available from HDRsoft (www.hdrsoft.com). Tone mapping decreases overall image contrast while enhancing local contrast and shadow detail. Begin by opening your 16-bit TIFF file in Photoshop and creating a duplicate layer (Layer>Duplicate Layer) set to Luminosity mode in the Layers palette. Open the tone mapping plug-in via the Filter menu, set the method to Details Enhancer and run using the default settings. When tone mapping is complete, apply a medium contrast curve (Image> Adjustments>Curves>Preset>Medium Contrast). The result can be fine-tuned by adjusting the Opacity of the duplicate layer.

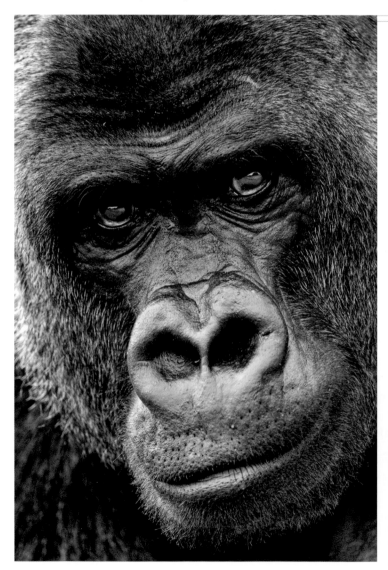

SILVERBACK GORILLA

I photographed this gorilla in a wildlife park. Although he was in a large enclosure, it was still difficult to avoid including evidence of his captivity. Using the longest focal length I had, I composed a tight crop of his face in the hope of capturing some character and expression. I was shooting into the light and it proved difficult to record even textural detail. The resulting RAW file looked very dull and flat (small image). Fortunately, the image was rescued by the use of tone mapping, which revealed a huge amount of textural detail from the TIFF file (main image). Tone mapping can greatly increase noise in an image, so it can be beneficial to apply the tone mapping selectively by erasing its effect from areas that show no benefit. In this particular image, I removed the effect from the gorilla's eyes by erasing this area of the duplicate layer, as this was the only place that the increased noise was obvious. Port Lympne Wild Animal Park, Kent, England. **Canon EOS-1D MkII; EF500mm lens; EF2XII extender; 1/500 sec at f/11; ISO 400; one-shot AF; IS mode 1; tripod with fluid video head.**

Manipulate your digital images

Digital manipulation is a very contentious issue when it comes to nature and wildlife photography. Software provides many ways to alter and improve images but should you really be doing this? I spent 15 years shooting transparency film where I had to get everything just right in-camera and this philosophy generally continues now I am shooting with a digital camera. However, I have fully embraced the benefits of being able to control and enhance colour, tone and contrast in my digital images, especially when I am able to achieve a more accurate final image. I never perform any major image manipulation that changes the natural history aspect of the subject in a way that might deceive the viewer. Ethically, all significant image manipulation should be disclosed whenever appropriate. You need to consider where manipulation strays from the concept of photography into the realms of digital art. It is up to the individual photographer to decide where to draw the line.

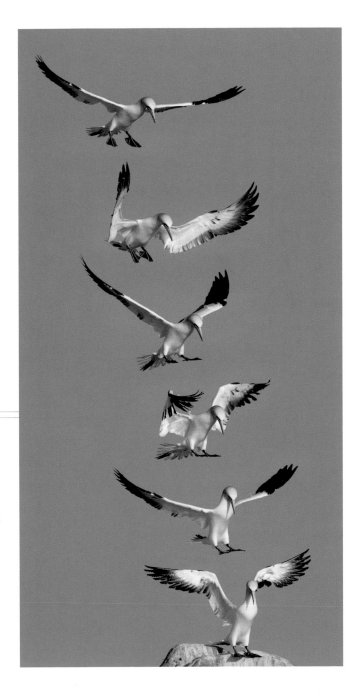

NORTHERN GANNET

Digital manipulation provides techniques that can help to illustrate animal behaviour in a way that was impossible when shooting film. This image shows a single northern gannet landing on a rock close to its nesting site. The sequence of six images was taken with a motor drive firing at eight and a half frames per second. In order to keep the bird in focus, I relied on my camera's most accurate central focusing point. This meant that I had to keep the bird in the centre of the viewfinder while following its flight path. The sequence of images was stitched together manually by merging six separate layers in Photoshop. The resulting composite is clearly the product of digital manipulation, but it succeeds in illustrating the gannet's aerial control as it manoeuvres into position over the rock. Saltee Islands, Co. Wexford, Republic of Ireland.

Canon EOS-1D MkII; EF500mm lens; 1/2000 sec at f/5; ISO 250; AI Servo focus; central focusing point; IS off; tripod with fluid video head.

Gallery

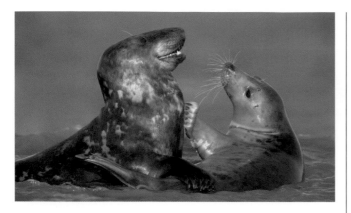

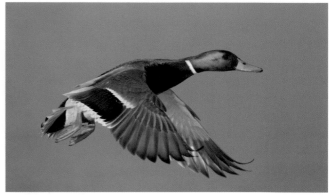

GREY SEALS PLAYING ON SHORE

Lincolnshire, England.

Canon EOS-1Ds; EF500mm lens; 1/1250 sec at f/6.3; ISO 250; AI Servo focus; single manually selected focusing point; IS mode 2; tripod with fluid video head.

MALLARD IN FLIGHT

Lodmoor RSPB Reserve, Weymouth, Dorset, England.

Canon EOS-1D MkII; EF500mm lens; 1/2500 sec at f/5.6, ISO 400; AI Servo focus; central focusing point; IS off; tripod with fluid video head.

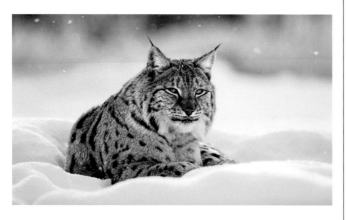

EURASIAN LYNX

Ranua Wildlife Park, Finland.

Canon EOS-1Ds; EF500mm lens; 1/1000 sec at f/5.6; ISO 250; one-shot AF; central focusing point; IS mode 2; tripod with fluid video head.

EUROPEAN GREY WOLVES

A digital composite where the original unattractive background has been replaced with an image of distant trees. The wolves were captive. Highland Wildlife Park, Kincraig, Scotland.

Canon EOS-1D MkII; EF500mm lens; EF2XII extender; 1/125 sec at f/11; ISO 400; one-shot AF; central focusing point; IS mode 1; tripod with fluid video head.

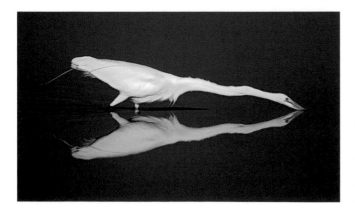

GREAT EGRET

J. N. 'Ding' Darling National Wildlife Refuge, Sanibel Island, Florida, USA.

Canon EOS-1D MkII; EF500mm lens; EF1.4X extender; 1/1600 sec at f/5.6; ISO 200; AI Servo focus; single manually selected focusing point; IS mode 2; tripod with fluid video head.

HIGH-TIDE WADER ROOST WITH OYSTERCATCHERS AND KNOTS
Snettisham, Norfolk, England.
Canon EOS-1D MkII; EF500mm lens; EF2XII extender; 1/60 sec at f/22; ISO 400; one-shot AF; manual focus; IS mode 1; tripod with fluid video head.

MUSK THISTLE
Rihemberk, Vipava Valley, Slovenia.
Canon EOS-40D; EF180mm macro lens; 2 sec at f/22; ISO 400; manual focus; white reflector; tripod with ball head.

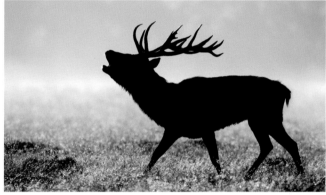

PHEASANT PLUMAGE IN THE RAIN
Exmoor National Park, Somerset, England.
Canon EOS-1Ds; Tamron 90mm macro lens; 1 sec at f/22; ISO 100; manual focus; white reflector; tripod with ball head.

RUTTING RED DEER STAG
Bushy Park, London, England.
Canon EOS-1D MkII; EF500mm lens; 1/1600 sec at f/4; ISO 200; AI Servo focus; central focusing point; IS mode 2; tripod with fluid video head.

EIDER DUCK IN COLOURFUL HARBOURSIDE REFLECTIONS
Seahouses, Northumberland, England.
Canon EOS-1D MkII; EF500mm lens; 1/1000 sec at f/7.1; ISO 250; AI Servo focus; central focusing point; IS mode 2; groundpod with fluid video head.

Index

About the Author

Guy Edwardes has a background in nature conservation but has been a professional nature and landscape photographer for 11 years. He studied at Salisbury College in England and graduated with a Degree in Photography in 1998. He supplies five leading picture libraries including Getty Images and NHPA. His work has appeared in numerous calendars, books and magazines. In 2007 he was commissioned to supply the images for Canon's prestigious corporate calendar. He gives regular presentations of his work throughout the UK and leads photographic workshops in many European locations. His first book, *100 Ways to Take Better Landscape Photographs* was published by David & Charles in 2005 to critical acclaim. For more information and to view more images visit his website at **www.guyedwardes.com**

Acknowledgments

A book like this requires assistance from many people. In particular I would like to thank Emily Rae and Ame Verso for their editorial assistance, Jo Lystor who handled the layout and design and Neil Baber for commissioning the book in the first place. I would especially like to thank my parents Kay and Kim who have provided invaluable help and support over the years, which has enabled me to make a successful career doing the work that I am so passionate about. For that I will be eternally grateful.

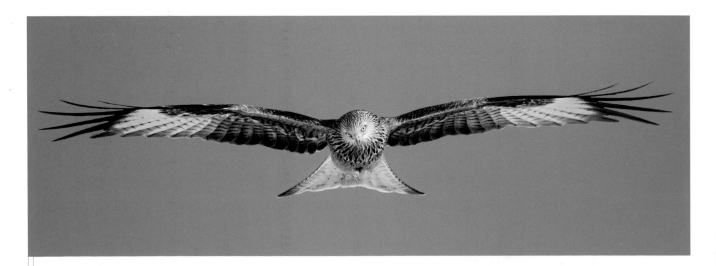

RED KITE
Gigrin Farm, Rhayader, Powys, Wales.
Canon EOS-1D MkII; EF500mm lens; 1/1600 sec at f/5.6; ISO 250; central focusing point; AI Servo focus; IS off; tripod with fluid video head.